Experimental Education of Intercultural Visual Communication Design

马振龙
Zhenlong Ma

张跃起
Yueqi Zhang

杨秀玲
Xiuling Yang

编著
Compile

中美两国高校平面设计教育交流实录
A Record of the Visual Communication Design Education Research Between China and U.S.A.

中国建筑工业出版社
China Architecture & Building Press

图书在版编目（CIP）数据

跨文化艺术设计教育尝试　中美两国高校平面设计教育交流实录/马振龙，张跃起，杨秀玲编著．—北京：中国建筑工业出版社，2010
ISBN 978-7-112-12166-3

Ⅰ．①跨… Ⅱ.①马…②张…③杨… Ⅲ．①艺术－设计－教育－国际交流－中国、美国－文集　Ⅳ．① J06-4

中国版本图书馆 CIP 数据核字（2010）第 104124 号

责任编辑：唐　旭　李东禧
责任设计：赵明霞
责任校对：刘　钰

跨文化艺术设计教育尝试
中美两国高校平面设计教育交流实录
马振龙　张跃起　杨秀玲　编著
*
中国建筑工业出版社出版、发行（北京西郊百万庄）
各地新华书店、建筑书店经销
北京嘉泰利德公司制版
北京方嘉彩色印刷有限责任公司印刷
*
开本：787×1092 毫米　1/16　印张：10$\frac{1}{2}$　字数：262 千字
2010 年 6 月第一版　2010 年 6 月第一次印刷
定价：78.00 元
ISBN 978-7-112-12166-3
　　（19422）

版权所有　翻印必究
如有印装质量问题，可寄本社退换
（邮政编码 100037）

前言
Preface

文化是一个极为广泛的概念。从某种意义上讲，文化是一种社会现象，是某一社会群体在某一特定空间环境下长期创造、逐渐形成的共有行为规范和思维模式；文化又是一种凝聚着时代演变的历史现象，是社会历史珍贵的沉淀物，它涵盖了一个国家或民族的历史、地理、风土人情、传统习俗、文学艺术、生活方式、行为规范、思维模式、审美观、价值观和世界观等。

文化主要由四个方面构成：物质文化、规范文化、行为文化和精神文化。物质文化是指某一社会群体生产力和产品的总和，是具有物质实体的、可触知的文化事物。规范文化是指某一社会群体在长期社会实践中形成的社会规范。行为文化是指某一社会群体内约定俗成的礼仪、民俗和习俗等在人际交往中的行为方式。精神文化是文化的核心，是指某一社会群体在社会意识活动中普遍形成的世界观、价值观、审美观和思维模式等主观因素。

文化又被分为三个主要层次：第一个层次为由哲学、文学、艺术和宗教所构成的高雅文化（High Culture）；其次为由包括人际关系在内的生活方式和行为规范等构成的通俗文化（Popular Culture）；最后是由世界观、价值观、审美观、道德观和思维模式等构成的深层文化（Deep Culture）。三个层次相互作用、相互影响、相辅相成。高雅文化和通俗文化基于深层文化，而深层文化的某一理念可能以一种习俗或生活方式反映在通俗文化中，或以某种艺术形式或文学主题在高雅文化中得以体现。

文化的差别在民族、地域、宗教和语言上进行区分会准确地映射出其背后不同的渊源和传统。同样，人类文化因地域原因不可避免地形成了复杂性和多样性，这不仅仅丰富了人类文明，同时也成为不同族群赖以生存的精神理念和情感支柱。不可否认的是各族群的文化差异隐形地阻碍了族群间的有效交流，所以，跨文化的深层次思考和研究在日益全球化的今天就显得尤为重要。

设计师是文化的传播者。设计师设计意识的定位和对目标受众文化背景以及人文理念的分析、研究是一个设计作品成败的关键。

本书是一个在力求专业、公正、客观和严谨的基础上，从跨文化艺术设计教育的角度，以中、美两国艺术教育中的人文理念培养为课题所进行的平面设计教学交流实录，并以视觉语言向读者展现了中、美两国三校学生富有代表性的原生态文化主题作品。希望本课题成果能够给读者带来一些启示、思考或帮助，这也将是本课题组全体成员的最大心愿。书中如有贻笑大方之处，还望读者海涵和不吝赐教。

作者
2010年1月5日

Culture is a concept with many different dimensions. In a sense, culture is a social phenomenon, a behavior standard and thinking mode formed through a long history and shared by a certain social group in a specific space and environment. On the other hand, culture is an historical phenomenon, a crystallization of changes over time, the unique precipitation of history and society. In sum, it covers, among other things, various aspects of a nation and its people, such as history, geography, local conditions, traditions and custom, literature and arts, life styles, behavior standards, thinking modes, aesthetic views, values and world outlook.

Culture is composed of four aspects, including material culture, standard culture, behavior culture and spiritual culture. Mate-

rial culture refers to the sum of productivity and products of a social group, a palpable culture with physical objects as its carriers. As for standard culture, it involves the social standards which have been formed during a long period of social practice and shared by a certain social group. Behavior culture relates to social behaviors and manners including the accepted etiquette, folk-custom and traditions. Finally, there is spiritual culture, the core of the culture concept, which refers to subjective factors such as weltanschauung, values, aesthetic views and thinking modes developing in conscious activities within a certain social group.

Culture is also divided into three levels, the first of which is High Culture, including philosophy, literature, arts and religion. The second layer is Popular Culture formed by life styles and behavior standard with interpersonal relationships included. Finally there is Deep Culture constituted by weltanschauung, values, aesthetic views, moral views and thinking modes. These three levels are interrelated and interactive with each other. High Culture and Popular Culture have their roots in Deep Culture, while the concept of Deep Culture may be reflected through a tradition or life style which belongs to Popular Culture, or a certain art and literature theme in High Culture.

Cultural differences in terms of nation, region, religion and language will precisely indicate the differences in origins and traditions. Human culture inevitably reserves the characteristics of complexity and diversity, which does not only enrich human civilization but serves as spiritual belief and emotional support that different groups rely on. However, it cannot be denied that cultural differences will hinder effective communication between different communities. And that is why a deep cross-cultural thinking and research is so important within the framework of globalization.

A designer is a disseminator of culture. The designer's consciousness positioning, together with the analysis and research of the target audience's cultural background and related humanistic ideas is the key to the success of a design work.

Based on a professional, impartial, objective and rigorous foundation, this book is a record of visual communication design teaching in the perspective of cross-cultural art design education, with the cultivation of humanistic idea in Chinese and American arts education as its theme. Representative designs of students from three universities of China and America relating to original ecology cultures will be presented to readers in visual language. The aim of this book is to give some inspiration and help to readers, which is also the ultimate wish of all the members of this project. Finally please forgive us if there are any errors in this book. We welcome any corrections, advices, and suggestions.

The Author
January 5, 2010

作者简介
Author Introduction

马振龙 教授
Professor Zhenlong Ma

毕业于天津美术学院，结业于第三期全国平面设计高级研修班。现为全国高教管理协会会员，天津市包协设计委员会副秘书长，天津理工大学艺术学院教授，硕士生导师。主要从事现代平面广告设计与理论研究、视觉传达设计与教育教学研究。

He graduated from Tianjin Academy of Fine Arts and studied at the 3rd National Senior Postgraduate Program of Graphic Design. He is now a member of National Higher Education Management Association, deputy secretary-general of Design Committee of Tianjin Packaging Association, professor at Arts College of Tianjin University of Technology, and also advisor of graduate students. He is mainly interested in advertisement design and related theoretical research, visual communication design education and teaching research.

作者简介
Author Introduction

张跃起 教授
Professor Yueqi Zhang

天津美术学院毕业，美国赛格那谷州立大学多媒体传播艺术硕士（MA）和萨凡纳艺术设计学院平面设计美术硕士（MFA）。先后任教于中国天津商学院、美国南卡罗来纳大学、南犹他大学，现任教于普渡大学卡鲁梅特分校。多年来一直致力于概念设计理论以及交叉文化背景下视觉传达设计方法的教学和研究。

He earned his MFA in Graphic Design from Savannah College of Art & Design in Georgia, MA in Multimedia & Communication from Saginaw Valley State University in Michigan and BFA in Graphic Design from Tianjin Academy of Fine Arts in Tianjin, China. He has taught Graphic Design at Tianjin Commerce University, China, University of South Carolina Upstate, and Southern Utah University. Recently he is teaching at Purdue University Calumet. His research areas include conceptual design theoretic and methodology of visual communication design by using the multi-cultural background.

作者简介
Author Introduction

杨秀玲
Xiuling Yang

南开大学分校图书情报系毕业。现为天津市戏剧家协会会员,天津市历史学学会艺术史专业委员会会员。天津市艺术研究所副研究馆员,信息资料中心主任。主要从事艺术理论、戏剧、影视等艺术门类的研究。

She graduated from the branch School of Nankai University majoring in Library and Information Science. She is now a member of Tianjin Dramatists Assassination and the Art History Committee of Tianjin History Institute, associate research fellow of Tianjin Art Institute, and also director of Information and Data Center. She is mainly engaged in research on artistic theory, drama and movie etc..

中美文化交流
Culture Exchange of China and America

Experimental Education of Intercultural Visual Communication Design

目录
Table of Contents

跨文化艺术设计教育尝试

前言 Preface	III
作者简介 Author Introduction	V
◎ 第一部分 Part one　课题综述 Project Summary	1
◎ 第二部分 Part two　中国艺术设计教育实录 A Record of Art Design Education in China	7
壹 Section1　教育教学模式（中国）Education Mode & Teaching Style (China)	8
贰 Section2　课题说明（中国）Project Guideline (China)	10
叁 Section3　学生作品及陈述与教授点评（中国）Work of Student, Narrative and Professor's Evaluation (China)	12
肆 Section4　设计交流 Design Communication	86
◎ 第三部分 Part three　美国艺术设计教育实录 A Record of Art Design Education in America	89
壹 Section1　教育教学模式（美国）Education Mode & Teaching Style (America)	90
贰 Section2　课题说明（美国）Project Guideline (America)	92
叁 Section3　学生作品及陈述与教授点评（美国）Work of Student, Narrative and Professor's Evaluation (America)	94
肆 Section4　设计交流 Design Communication	154
参考文献 A List of References	156
后记 Postscript	157

Experimental Education of Intercultural Visual Communication Design

Part

one

Project Summary

第 一 部 分 · 课 题 综 述

跨 · 文 · 化 · 艺 · 术 · 设 · 计 · 教 · 育 · 尝 · 试

课题综述
Project Summary

—— 兼论中美两国高校艺术设计教育中的人文理念培养
Comparative Analysis of the Humanistic Idea Cultivation in the Art Design Education between Chinese and American Universities

设计师的设计意识定位以及对目标受众文化背景的研究是一个设计师永恒的课题，细心的剖析、敏锐的切入和准确的视觉陈述是有效视觉传达的保证。

在中美两国院校视觉传达的教学过程中，作者深刻地体会到，由于设计所涉及的范围极为广泛，内容纷繁，目标受众背景构成复杂，单凭学生现有的经历及阅历难以表现信息传达的准确性和功能性，这正是本课题的设计起因和动力。要想使学生强化主题和目标受众文化背景的专业研究意识并养成一种良性的思维习惯，就必须设计相应的教学内容对学生进行有效训练。经过多次的研究探讨设计产生了本课题，并分别在中国天津理工大学、美国南犹他大学和普渡大学卡鲁梅特分校的相应课程中实施。为了使课题更具有可操作性，根据三校学生的具体情况对课题内容及要求进行了适当的调整。本课题最终确认的目标是，着重训练学生对已知信息的分析、提纯和对未知信息的搜集、提炼，分别从当事人和旁观者的两个角度，针对相同或相似事件作出合理判断，同时使之形象概念化，以视觉对话的形式探讨对于中美文化差异的特别印象，并以有效的方式传达给目标受众。课题每单次实施周期为四周。

由于学科的特点，中美高校在艺术设计教育中均注重从不同角度对学生人文理念的培养。从学生作品中可以看出中美两国学生所受到的两种不同人文理念的影响，从不同的角度可以反映出对于人文理念培养的侧重点。在改革开放前，中国学生的知识结构中，民族传统的文化知识占有较大比例。改革开放后，中国对外域文化的吸收与融合以及对及时信息的有效传播，拓展了学生的视野，丰富了学生的人文知识，在传统的基础上又增加了人文理念的国际化理解，使得学生的知识结构体现出多层次、多视角的特点。

美国是一个多种文化融合的国度，不同族群在各自文化背景下形成不同的亚文化圈，相互之间既有隔阂又能够和平相处。受主流文化的影响，这些亚文化与其域外母文化源有着较大的区别。由于美国主流媒体对于外域文化传播介绍的信息有限，有时甚至带有明显的意识形态色彩，使学生对不同文化的欣赏、理解和吸收产生了一定的局限性，但是只要提供机会和正确引导，学生们就会发挥主观能动性，通过系统、深入的研究和分析，产生兴趣去理解和欣赏不同文化，并得出客观的结论。这些在美国学生作品中得到了体现。

文化因地域原因形成的复杂性和多样性，不仅仅丰富了人类文明，同时也是不同族群赖以生存的精神理念和情感支柱。随着社会的发展，不同族群之间的交往、交流日渐频繁，由于各族群文化的差异和不同的价值观，隐形地阻碍了具有不同文化背景的族群之间的有效交流，甚至引起误解、愤恨和积怨。究其原因，都是由于文化差异以及人们习惯于以自己文化中的习俗和标准去衡量和评判另外一种文化，而不是抱着平和的心态去欣赏，从而使之丧失了从不同文化源泉中汲取精华的机会和自我文化发展的动力和空间。

针对这一点，本课题要求学生以一个设计师的身份，站在中立的专业立场上，以一个全新的我尽力做到公正研究、探索、分析、归纳不同文化及其现象的真实性和独特性，从专业设计流程出发，逐步形成能代表中美文化的个性理念识别，找寻目标受众在其不同文化背景下所能接受的设计创意，通过相

课题综述
Project Summary

人文理念培养
The Humanistic Idea Cultivation

应的具有符号性的视觉元素体现设计理念，强化视觉传达效果。

本课题的性质不单单是对学生提出了很高的要求，同时对教授来讲也是一个挑战，所以必须考虑到打破常规，用一种积极有效的教学方法强化学生的主观能动性和自我掌控能力。本课题的指导原则是：对学生的设计过程不做任何硬性干涉，强调独立研究，教授不表述对于不同文化的个人见解，强化辅导研究方法和技术支持，着重于主题的力度与深度的探索，在不限定主题表现形式的前提下，引导学生进行创造性的思维。一开始布置课题时，由于课题的新鲜感和挑战性，激发了学生强烈的创作冲动，同样由于课题的独特性也给予了学生极大的思想跳跃空间和机遇。

在研究环节进行过程中，每个学生都根据自己搜集到的相关信息，进行了深入的探索与分析，逐渐形成了各自的设计理念和设计方向，准确地找到了各自的切入点，从而体现了学生的独立研究能力和独立思考的真实性。研究进度时间表根据每个学生的不同情况进行了合理的调整，引导学生逐步从最初获取的切入点进行深度与广度的相关研究，从而达到一个由感性到理性的升华，大部分学生都达到了这一要求。在每次课题点评中，每个学生都从其他人所发布的信息中得到了启示，无论是在学生之间还是在学生与教授的互动中都本着相互尊重、平等交流的专业态度，积极地营造一种宽松、健康的学术气氛。在本课题中，被作为重要的教学环节的课堂点评和课堂讨论，对整个设计流程的有效实施起到了不可或缺的推进作用。

在普渡大学卡鲁梅特分校实施本课题时，作者适当地调整和修改了课题方案，把主题延伸定位在"文字作为图像"上，基于不同文化背景，利用解构法重新诠释文字的表形和表意，并选择思想单纯、接受能力强、没有过多设计语言和技术方法束缚的低年级学生进行实施。

从完成作品上看，学生们以各自独特性的选题，准确的切入点和多样的表现形式，多侧面、多角度地体现了中美文化背景下的不同理念。大部分同学遵循了创意驱动下的设计定位，采用理念延伸和隐喻的设计手法，有效地诠释了抽象概念。其中在中国学生唐帆的"中、美饮食文化"和孙萍萍的"印象中国"、"印象美国"招贴系列设计中，美国学生 Kristie 的"水"和 Cami 的"路"的作品主题都强调了一种概念延伸；中国学生刘书振的"美国饮食"、"印象美国"和孙铭徽的"之乎煮也"、"西部文化"的设计作品，美国学生 Jessica 的"球"系列、Lisa 的"饮食"以及 Zeck 的"马"主题均采取了轻松愉快的卡通直叙式；中国学生邱菁的"食新春"、王春梅的"印象中国"和美国学生 Erik、Katie 的"春节"、Ariel 的"婚礼"以及 Aubrey 的"日历"作品主题则采用民俗特征的切入法；中国学生程驰的"开饭喽"、"肯德基"和李磊的"中国印象"、李霞的"餐具"设计作品，美国学生 Jacob 的"货币"、Joe 的"兵马俑"以及 Ivan 的"龙"主题进行了不同文化价值观的深层次探索；中国学生王晓庆和姚可心的"印象中国"、"印象美国"系列设计作品，美国学生 Laura 的"美"以及 Jackie 的"舞蹈"等主题描述了在现代生活中不同文化背景下的审美观。两国学生均在设计中理念明确，创意新鲜、独特有效，极具思想性。部分同学在设计表现技巧上略显生涩，因而减弱了理念传达的效果。

从学生的设计陈述中可以看到，通过本课题，学生们不仅仅强化了在设计流程中研究环节的训练，也使他们理解到研究环节在整个设计流程中的不可替代性。针对不同文化背景下的目标受众，深刻地理解其文化内涵，选取适当的视觉元素，遵循其文化习俗中的约定作为设计定位是有效视觉传达的基本保证。作为一个设计师，不仅要提升自我的文化素养，而且还要了解多种文化的特征，排除任何偏见，从不同文化中探寻受众的心理感受和情感需求，通过精炼设计语言来提升设计技巧，从而步入一个较高的专业设计境界。

本课题的产生、实施及成果印证了作为一个设计专业的学生，在全球化大语境下进行多种文化研究的必要性和可行性，这将对他们今后的职业生涯和设计理念产生重要的影响和作用。

Ever-present issues for a designer are how to aim and express his or her philosophy and approach to designing and how to study the cultural background of the target-audience. Effective visual communication can be guaranteed only by careful analysis, sharp perception and accurate visual-presentation.

As an instructor of "Visual Communication Design" who has long been teaching in Chinese and American universities, the author has experienced that the most students often cannot concisely convey the intended function of communication information in their works, because their present life experiences are quite limited while designing touches a wide range of subjects and extremely complex target backgrounds. We have developed this project in order to study and better understand this problem.

To strengthen students' research awareness of the designing themes and the target culture backgrounds as well as to help form good habits of thinking about different approaches to designing, they must be trained effectively by correspondingly designed lessons.

After many different efforts, including a number of research projects and discussions with others, a systematic plan of teaching and study for this was developed. It was then successfully implemented in related courses in Tianjin Polytechnic University, Southern Utah University and Purdue University Calumet. In order to make the topic more easily implemented, the author has made corresponding adjustments in the topic contents and related requirements according to different student conditions in each university.

The ultimate goal of this project is to intensify students' practices of analyzing and distilling the already known information and collecting and extracting the essence of the unknown information, making reasonable judgments in both identical and similar affairs from both the perspective of insiders and outsiders, and at the same time conceptualizing the design image and discussing through visual dialogues the particular impressions of the cultural differences between China and America and effectively communicating them to the target audience. Courses for such a project will last for four weeks.

Both Chinese and American art design schools, according to the nature of this discipline, emphasize on cultivating students' humanistic ideas from different perspectives. From the works of Chinese and American students, we can find that Chinese and American students are affected by different humanistic ideas. Different teaching emphasis in students' humanistic idea cultivating in China and America can be reflected from different angles.

Before the reformation and opening up program, Chinese students were mainly imparted with Chinese culture while after the program, China began to absorb and integrate foreign cultures and also transmitted updated information, and students' horizons were broadened and their knowledge enriched. They know more about the international humanistic concepts on the basis of the traditional education, and therefore make their education form a multi-dimensional and multi-perspective structure.

America is a country mixed with multiple cultures with different sub-groups having different sub-cultures. Among these sub-groups are both conflicts and peaceful co-existence. Affected by the main-stream American culture, these sub-cultures are distinctive from foreign cultures. American mainstream media has limited coverage of the alien cultures and what's worse, if any, usually paint a obviously ideological color, this result in students' limitations in appreciating, understanding and absorbing foreign cultures. However, as long as guided correctly, American students can give their initiatives into full play and have interests in understanding and appreciating foreign cultures through systematic and thorough researches and analysis, and on the basis get an objective conclusion about foreign cultures. This has actually been reflected in their works.

The complexity and the diversity of different cultures in different areas have not only enriched the all human civilizations but also formed various mental concepts that different ethnic groups have emotionally depended on in their lives. The mutual communications and exchanges between different ethnic groups are becoming more and more frequent. However, the great gaps among different cultures and values have invisibly impeded the effective communication among people of different culture backgrounds, and what's worse, have even caused misunderstanding, hate and rancor. Why has that occurred? The reason is that people of different cultures are used to measuring and judging other cultures by the standards and the conventions of their own cultures, rather than to appreciating them with a calm and balanced attitude. Consequently, they have lost the precious opportunity to extract mental essences from other cultures and to improve their own understanding. Different cultures often express the same underlying themes and philosophies, but do it in different ways. The more we can understand, appreciate, and implement these different ways, the more our own ability to express what we can to express can be enhanced.

This study aims to require students as professional designers to do their best to study, explore, analyze and summarize the authenticity and the uniqueness of different cultures and phenomenon with a neutral and impartial stand, freer from the constraints of thinking only within the framework of their home cultures. When starting the professional design process, we gradually form two kinds of unique conceptual identities embodying Chinese and American cultures respectively, determining creative design methods acceptable to the target audience of different backgrounds, using visually symbolic elements to

课题综述
Project Summary

indicate the designing concepts and on that basis to reinforce the visual communication effect.

The nature of this project does not only create higher requirements for the students but also poses a challenge for the professors. The old-fashioned rules and conventions should no longer be rigidly followed and a new teaching method better able to intensify students' initiatives and self-commanding abilities should be adopted. The guiding principles of this project are as follows: 1) never interfere in the students' designing processes; 2) let students do independent research without professors' giving them any personal opinions during that research; 3) improve the assisting methods and technical support for students; 4) ask the students to make deep and broad explorations rather than superficial appraisals; and 5) guide the students to develop creative thinking ways without limiting the representing forms. The students' composing desires have been stimulated when first assigned with fresh and challenging topics; similarly the unique topics have offered them sufficient room for their free and unbounded thinking.

Before approaching the whole study process, the students first explore deeply in and analyze thoroughly the related information they have collected, and then gradually form their respective designing concepts and directions and decide their research focuses. This can certainly show their independent research and thinking abilities. The schedule of the broad and deep research for each student is precisely adapted to his or her specific conditions after each finds his or her own research focus, and consequently helps their studies evolve from perception to rationality. This has been accomplished by most students. Every single student has been inspired by ideas given from other students during the project critique period. All the individuals in each class have shown mutual respect and equalities in the academic interactions demonstrating professional manners and behavior while at the same time building a kind of relaxing and healthy academic atmosphere. The class critique and discussion are valuable parts of the teaching/learning process and play an indispensable role in enhancing the effective realization of this whole project process.

When doing the project in the Purdue University Calumet, thae author adjusted and revised the project guideline appropriately, extending the subject to the concept of "word as an image," based on different cultural backgrounds, to reinterpret Hieroglyph and Ideograph by using a deconstruction method, and intentionally arranged junior students whom are natural, receptive, less constrained by having been focused on specific technical skills and design methods to implementing the project.

Students have finished their works in various forms according to their own chosen topics and specific discussing focuses. In their works, they have represented different concepts between Chinese and American people owing to their different cultural backgrounds. Most students determine their design patterns by "concept-driving" and then effectively represent some abstract concepts by adopting certain design tactics such as concept extending and metaphor applying.

For example, "Chinese and American Diet Culture" by Tang Fan, "Impression of China" and "Impression of America" by Sun Pingping, "Water" by Kristie and "Road" by Cami all highlight a kind of abstract-concept extension. "American Diet Culture" and "Impression of America" by Liu Shuzhen, "Zhi Hu Zhu Ye" and "West Culture" by Sun Mingwei, "Ball Series" by Jessica, "Food" by Lisa and "Horse" by Zeck adopt cartoons to make entertaining and vivid descriptions. "Chinese New Year Food" by Qiu Jing, "Impression of China" by Wang Chunmei, "Spring Festival" by Katie, "Marry Ceremony" by Arie and "Calendar" by Aubrey take folklore customs as discussing points. "Dinner is Ready!" and "KFC" by Cheng Chi, "Impression of China" by Li Lei, "Tableware" by Li Xia, "Currency" by Jacob and "Terra Cotta Warriors" by Joe probe deeply into different cultural values. "American Diet Culture" and "Impression of America" by Wang Xiaoqing and Yao Kexin, "Beauty" by Kaura and "Dance" by Jackie describe how different ideas of perceived beauty reflect different cultural backgrounds. The students have clear design concepts. Their creating ideas are fresh, unique, and effective and also involve their profound thoughts. Some students, however, have adopted comparatively awkward techniques which consequently weaken the conveying effects of their design concepts.

Judging from the students' design narratives, we can clearly find that they have not only intensified practices of doing research but also realized the absolutely essential role of the research phase in the whole design process. A designer can effectively convey the visual design information by following such a process: first thoroughly understanding the cultural connotation, then choosing the proper representing element, and finally set the design content conforming to the specific cultural conventions. As a designer, we should draw from both the domestic and foreign culture tastes, discover psychological conditions and emotional needs of people in different cultures without any biases from our home cultures, improve our designing techniques through refined languages and finally promote ourselves to a higher professional designing stage.

The formation, realization and achievement of this project has confirmed the necessity and feasibility for a professional designer to conduct multi-cultural research in the context of the globalization and will have an important effect on their future career and design concepts.

Experimental Education of Intercultural Visual Communication Design

Part
two

A Record of Art Design Education in China
第二部分·中国艺术设计教育实录

跨 · 文 · 化 · 艺 · 术 · 设 · 计 · 教 · 育 · 尝 · 试

壹 教育教学模式(中国)
Section 1
Education Mode & Teaching Style (China)

艺术设计是一门实践性很强的专业，不管是环境艺术设计、视觉传达设计、产品设计还是服装设计，每一领域都要求毕业生能够面对实际业务，在实践中去解决问题。

由于我国现代艺术设计教育起步较晚，而且都是在传统工艺美术教育的思维模式下逐渐建立起来的，所以一直以来我国的艺术设计教育思维与模式都是沿用原来工艺美术教育的现成格式。国内艺术设计院校的招生模式是由各省市首先进行专业联考，考试内容包括：素描、速写和色彩等，学生考试合格后再参加学生所选院校的专业课考试，各院校根据考生所掌握的专业知识有选择地设置考试内容，主要包括：绘画基础和设计基础等专业内容的考试，学生达到学校的考核标准后，参加全国文化课的统一高考。各院校根据本院校专业课和全国文化课统一考试成绩，择优录取。

对于开设艺术设计专业的院校的评估是由教育部制定评估标准，组织专家评估组进入到各院校进行实地检查和考核，并给出评估结果。

目前国内的艺术教育模式主要分为三个层次：专科、本科和研究生。以本科为例，目前各高校的艺术设计学生主要来源于应届和往届高中毕业生，而且大多都是文科生。国内的本科教育实行的是弹性学分制，一般在3~6年完成，课程结构分为三部分：由教育部规定的必修公共课占三分之一左右，主要课程包括：大学英语、大学语文和高等数学等课程，主要是在前两个学年完成；与此同时进行专业基础课的学习，专业基础课包括：素描、色彩、中外美术史、设计史、平面构成、立体构成、字体设计、图形创意和版式设计等核心课程；完成专业基础课的学习后进行专业课的学习阶段，专业课的核心课程根据不同的专业设置有所不同，以视觉传达设计方向为例，课程包括：包装设计、书籍装帧、CI识别设计、插画设计、新媒体设计、平面广告设计和毕业设计等专业必（选）修课程。各院校对专业设置名称有所不同，但都遵循着平面、三维和新媒体设计三个方面来设置专业必（选）修课程。以上所述三个阶段各占总学分的三分之一左右，除了教育部所规定的必修公共课、专业基础课外，对于专业课程设置，各院校根据自身教学设施、学生自身条件和社会需求增减相应的专业课程。

专业课程的教学模式主要分为两种：工作室制和课堂讲授制。工作室制主要在导师规定具体课题下由导师指导学生完成教学任务，整个指导贯穿于课题开始到课题评估的全过程。导师对学生在各个环节上的表现和最终课题完成情况打分评估，以培养学生的动手能力和实际操作能力。课堂讲授制是以教师课堂讲授专业理论知识为主，结合课堂辅导、讨论和答疑，以培养学生理论知识体系为主，结合动手实践来达到课程的要求，最后在教师规定的课程设计条件下，由学生根据课堂所学理论知识和技法完成教学任务，教师根据学生完成学习任务的情况来打分。有些课堂讲授的课程，教师将社会委托设计课题融入课堂教学中，使课堂教学与社会需求接轨。在具体的教学方式上，教师在教授理论知识的同时，结合所授理论知识运用课堂讨论、作品赏析、答疑和点评等方式，使学生更好地掌握所学专业知识。

正如前面所提到的，由于我国现代艺术设计教育起步较晚，教育思维与模式是沿用原来工艺美术教育的格式，讲究按部就班、循规蹈矩、规范化的课程和固定的教学方法，或多或少地抹杀了教与学的个性发展，使得设计学习与市场需求存在着一定的差距，甚至理论与实践脱节，从而影响了学生的毕业质量。这种状况已经引起业内的广泛重视，并在逐渐改善中。相信在不久的将来，我国的现代艺术设计教育一定会建构一个既具有中国特色又与国际接轨的、崭新的教育教学模式。

教育教学模式(中国)
Education Mode & Teaching Style (China)

中国艺术设计教育实录
A Record of Art Design Education in China

Art design education is a major involving a lot of practices, whether it is environmental art design, visual communication design, product design or fashion design. And each area requires graduating students to solve problems in specific practices when faced with different tasks.

The art design education modes in China have consistently adopted the existing mode originally applied in craft art education, because the modern art design education in China emerged relatively late and had been gradually established by following the traditional mode in the craft art education. Students will first take an art design exam provincially or municipally held by art design institutions. The exam will cover the following contents: drawing, sketching, painting and related skills. Those who have passed the exam will proceed to have an exam held by the schools to which they apply. The content in these exams will be selected and decided according to the professional knowledge commanded by students. That will mainly include professional knowledge about basic skills such as drawing and designing. Those who in turn pass these exams will have the nationally unified university (or college) entrance examination and students will then be admitted according to their scores until the permission number is met.

The evaluation criteria for founding an art design institution are set by the Ministry of Education. Expert teams will be organized and sent to each institution to conduct an on-site inspection and investigation and on that basis give an evaluation result.

Students of the present art education can be divided into three levels: associate degree, undergraduates and graduates. Taking undergraduates for example, the art design students are mainly from senior school fresh graduates and former graduates, mostly those of liberal arts.
The undergraduate education, three to six academic years long, adopts a flexible credit system. The courses consist of three parts: with one third being the compulsory courses required by the Ministry of Education. The general education courses — college English, college Chinese and advanced math — will be finished in two academic years. Generally, in the meantime, students will begin basic professional courses, which include such core curricula as drawing, painting, foreign and domestic art history, design history, two-dimensional composition, three-dimensional composition, typeface design, graphics creative design, layout design and similarly focused courses. Students will proceed to professional courses after finishing the basic professional courses. The core professional courses vary according to different majors. The visual communication design, for example, includes both professional required and elective courses like package design, book design, corporate identity design, illustration, new media design, print ad design, and senior seminar. Majors are differently named in different institutions but they are all similarly categorized into three areas: two-dimensional design, three-dimensional design and new media design, each with about one third of the total credits. Institutions must set all the compulsory courses required by the National Education Commission, but otherwise they can increase or reduce related professional courses according to the accessible teaching facilities, students' learning conditions of, as well as the needs of the real world.

Professional courses are either held in studios or in classrooms. In the first case, instructors will first choose a specific topic and then guide students to finish their tasks involved in the specific topic through the whole process from the very beginning to the evaluation phase. Instructors will evaluate and grade students' performances and the qualities of their finished works so as to encourage their operative abilities. Theory courses, mainly held in the classroom, are usually combined with practices such as problem-solving, discussion and counseling. This mode enables students to better grasp what is required in the courses by emphasis both on theory learning and operation practicing. Finally students will complete their learning tasks under the conditions set by their teachers who will thereafter give them grades according to their specific performances. Some professors will even introduce into their lectures some topics about the society asked by other people outside their schools, hoping to make their teaching content more closely connected to the real world. Based on the theory content, professors will apply various modes such as seminars, work appreciation, counseling and evaluation to help students have a good command of professional knowledge.

As mentioned above, emerging relatively late, art education in China had copied the stereotypical teaching styles which are originally used in craft art education and which are characterized with fixed curriculum and mechanistic teaching methods. These modes have in turn overlooked the nature of individuality both in teaching and learning, create a gap between the art design education and the needs of the social markets, and what's worse, prevent some students from getting diplomas owing to their isolating theory from practice in education. This phenomenon has been widely noticed and paid great attention to by some figures in this field, and there has been gradual improvement in this respect. We strongly believe that in the near future an innovative art education mode and teaching style will appear which will reflect the Chinese characteristics while closely keeping pace with the changes that come with increasing globalization.

Section 2

课题说明(中国)
Project Guideline (China)

课题 / 主题招贴设计
Projects / Themes Poster Design

马振龙 教授 / 视觉传达系
Professor Zhenlong Ma / Visual Communication Department
E-mail: zhenlongma@263.net

课程简介
在现代平面设计中，版面设计是一个建立在准确主题定位与功能诉求基础之上，以有效传播为导向的视觉传达艺术。它通过将图、文、色等基本设计元素进行富有形式感及个性化的编排组合，将主题诉求转化为一种能与受众直接沟通的、具体的视觉表现形式，从而有效地实现传播宗旨。

本课程通过对版面设计从理论到实践探讨的学习过程，系统地对现代平面版式的创意思维与创新设计进行较为深入的研究与探索，使学生在熟练掌握版面设计方法与技巧的基础上，同时具备较强的现代设计理念、创新思维与设计制作能力。

本课程将针对当今平面设计的发展特点，对现代版面设计从版面的创意设计表现及不同媒介的整合应用进行深入学习，通过讲授、答疑、研讨、设计实践和理论研究等相结合的教学方法展开进行，使学生熟练掌握版面设计的各种创意方法与制作技巧。同时，通过计算机辅助设计的训练，让学生具备熟练运用现代设计手段，充分实现其创意构想的制作能力。

教学手段
在教学过程中，将采用多媒体教学方式进行课程讲授，结合优秀设计作品赏析、专业技法及创意思维训练等多种教学手段授课，针对不同学生采用课堂辅导的方式进行实际动手能力的训练，并辅导学生运用电脑辅助设计，最终制作完成其设计作品。

课题简介
本课题应完成版面设计的基础设计创意训练与应用设计制作训练。媒体限定为招贴广告，招贴广告的应用设计课题为："民以食为天"和"印象中国、印象美国"。饮食是人类生存的根本所需，不同国家、不同民族的饮食文化都有其自身的特点与风俗，同时也就产生了不同的理解与印象。以"进餐"为创意主题，根据自身对中国和美国进餐习俗和不同的印象，并隐喻其不同文化理念，延伸其文化特征，分别完成以图形设计为主的招贴广告设计作品。

设计要求
1. 创意设计主题表达准确，习俗特点突出，元素运用合理，版式编排应新颖、独特，表现形式及色彩不限。
2. 创意方案不少于三种，优选其中一种方案推敲制作完成，并撰写出作品的创意设计陈述。
3. 最终作品尺寸为A4，电脑制作，打印分辨率不低于300dpi，作品与创意设计陈述需打印装裱，并将原文件和JPG格式的图形电子文件CD或DVD同时提交。

时间安排
第一周
课程讲授，课题布置。
设计前期准备：确定主题，调研并收集、整理资料，认真研读课题要求、分析优秀设计案例，完成主题定位、提炼设计元素。
第二周
设计构思：按照主题表达的要求充分发挥联想与创想的能力，勾画每项课题不少于3种的创意草图方案后，与班上5个以上同学进行交流、研讨，将讨论意见记录下来并对创意草图方案加以改进。
课堂研讨：将创意草图方案在课堂上与全班同学及老师进行展示交流，在得到同学的建设性意见和老师的点评后，充分修改与完善创意草图方案。
第三周
在完善的创意草图方案中，选择或综合优化一种设计方案以确定作为正式作品的设计制作稿并完成创意设计陈述。
第四周
电脑辅助设计制作课题作品及撰写创意设计陈述并准备课题答辩。
结题
答辩、老师讲评。

Course Introduction

In contemporary graphic design, page layout is a visual communication art based on accurate theme positioning and design functional appeals with effective communication as its orientation. It is through arranging and combining various basic design elements such as graphics, texts, and colors that the layout is finally realized with unique form and composition. It then in turn transforms the thematic appeals into concrete visual forms so as to achieve effective communication by conveying the design information to the audience directly.

This course deeply and systematically researches and probes into creative ideas and innovative layout in modern graphic design from both theoretical and practical perspectives. With a good command of layout design methods and techniques, students are trained to master the modern design concepts and abilities of creative thinking, planning and operating.

Catering to the present features of the modern graphic design, this course will make a comprehensive and deep investigation into the creative representation of layout design and integrated applications of multiple media. Various methods will be included in this course including lectures, consultation, research, and theory and practice studies. Furthermore, with computer aided design training and practice, students will finally be able to realize their design creativity by using such modern design methods.

Teaching Methods

This course will use multi-media and will be presented in various forms, for example, examination and appreciation of excellent examples of work by others, professional techniques and creative thinking training and other ways to broaden the perspectives of students.Individualized instruction will be given during class time to train students' practical design abilities. Computer-aided design will also be applied to facilitate for their design practice.

Project Introduction

This course focuses on practice of innovative thinking in the basic layout design and practice of operating in applicative design. The medium is restricted as poster advertising with the topic of "Food –the First Necessity of Man" and "Chinese Impression, American Impression." Food, as the basic need for human survival, has different characteristics and customs in different countries and different ethnic groups, also produces different understanding and impression. With "diet" as the theme, students will, on the basis of their own understanding and impressions of Chinese and American diet cultures, complete two posters by mainly using graphics. And their designs should imply distinctive diet concepts and connotations between different cultures.

Design Requirements

1. The design creativity should be presented accurately; custom features shown prominently; elements used properly; layout arranged innovatively; forms and colors adopted freely.
2. Students should conceive more than three creative programs, then choose and focus on the best one to finish their designs and finally write a design narrative.
3. Students should develop and produce their designs on computers and print their final products with A4 paper and with a print resolution no less than 300dpi. Final designs and creative design instructions should be illustrated with pictures; the original files and CD or DVD recorded with electronic JPG graphic documents should be submitted at the same time.

Schedule

The first week
Professors give lectures and assign topics to students.
Design preparation: identifying the design theme, making surveys, collecting and integrating information, carefully reading the related requirements, analyzing samples exhibiting excellent design, determining the design topic and selecting proper representing elements.

The second week
Conceiving the design: students should first, in accordance with the requirements of the theme, conceive at least three creative design programs by giving full play to their creative imagination and composing abilities, then make exchanges and discussions with more than five other classmates and write down discussion results and finally make improvements of their design programs.
Seminars: Students show their designs to the whole class and the instructor and then revise and optimize their design sketches based on the constructive advice given by their classmates and evaluating comments of their teachers.

The third week
Choose or integrate one optimized design program from the improved design programs as the final version for their designs and then finish the creative design narratives.

The fourth week
Students should begin to design their works with the help of the Computer-aided design, write the narratives of creative designing and at the same time prepare for the oral defense for their projects.

Conclusion

Design defense and evaluation.

Section 3

学生作品及陈述与教授点评(中国)
Work of Student, Narrative and Professor's Evaluation (China)

孙萍萍 | Pingping Sun
2008级硕士研究生
Graduate Student, 2008

设计陈述：

中、美饮食文化主题设计陈述

每个国家都有各自的饮食特色、习惯和理念。在这次的主题设计中，我以"聚"与"独"来体现中美饮食习惯上的差异。

在中国，"团圆"是人们所追求的。吃饭是中国人"相聚"的时刻，人们喜欢聚在一起享受欢乐的气氛。在招贴中，我用筷子与人影正负交融的图形去展现这一理念，牵手的人影用艳丽的色彩去填充，一方面是使画面活泼，另一方面使形式上更具现代感，中式的字体排版和窗格符号的排列，都增添了画面的装饰感和整体感。

在我的印象中，美国饮食偏于"独立"，美国人更习惯分餐，快速，简洁，满足自我。"守在自己的叉子中"，我用这样的画面来体现美国人独立的进餐习惯。为了保持视觉的统一性，我同样采用了人物与餐具交剪影的元素，色彩上使用单纯的黑白对比，营造个体和自我的氛围。

印象中国、印象美国主题设计陈述

在中、美印象的招贴设计中，我仍然选择"食文化"这个主题，以"物质文明与精神文明之间的结合方式"为中美印象对比的诉求点。

在中国，古人说："书中自有千钟粟"，这是文化与饮食最切合的联系。在招贴设计中，我采用中国的主食——大米作为设计元素，将其拼装成一本书，并采用了中国传统的、

设计陈述	孙萍萍
Design Narrative	Pingping Sun

具有代表性的线装书造型，书名就是主题，表达了精神食粮与物质食粮的结合。

在印象美国招贴设计中，我采用西餐中比较常见的三明治作为主题元素，运用元素替代的形式，将其与现代美国常用的书装形式相结合，书的主题是心灵鸡汤，与整个"精神食粮"的主旨契合。

Design Narrative:

Chinese and American Diet Culture Design Narrative

Different countries vary in their diet features, habits and concepts. In this design, I will show the differences between the Chinese and American diet cultures by the concepts of "gathering" and "alone".

In China, people pursue a sense of gathering. They can get together at dinner; therefore they like the pleasant atmosphere at a dinner party. In this poster, this gathering concept of Chinese people is presented through a figure formed by images of chopsticks and people. Bright colors are selected to paint the hand-in-hand shadow figure so as to enliven the whole picture and meanwhile make the form more modern-looking. The composition in a Chinese style and arrangement of the grid signs successfully polish the whole picture and also make all its elements an integrated unity.

In my impression, American people prefer to be alone while eating. They prefer speed and simplicity and a sense of individual satisfaction. This diet habit of Americans is shown by a poster called "Clinging to My Own Forks". An integrated image of people and cutlery is adopted to keep consistent with the former Chinese diet culture poster, while the contrast between black and white creates a sense of individuality in American diet culture.

Chinese and American Impression Design Narrative

"Diet culture" is also the theme of posters of Chinese Impression and American Impression, with "the way that material civilization and mental civilization are integrated" as the basic point of comparison between the Chinese and American impressions.

There is an old saying in China that "you can find abundant rice in your books" ("books can feed one with abundant mental food"), a reflection of the close connection of food and knowledge in Chinese peoples' minds. Therefore, rice, the main food in China, is chosen as design element. Rice is made into an image of a book, to be exact, a traditional thread-bounded with distinctive Chinese flavor, to represent the integration of material food and mental food. The title of the book is also the theme of the poster.

In the American Impression poster, a common Western food sandwich is chosen as thematic element. With the method of element replacement, this sandwich is combined with American modern books to conform to the theme of "mental food". The theme of this book is called "Chicken Soup for the Souls".

设计陈述
Design Narrative

孙萍萍
Pingping Sun

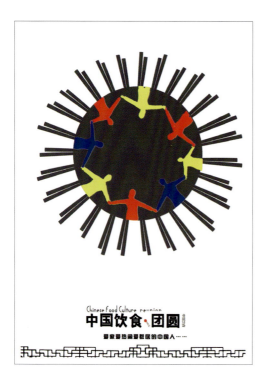

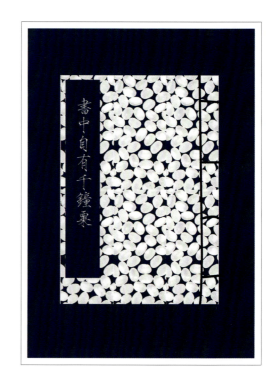

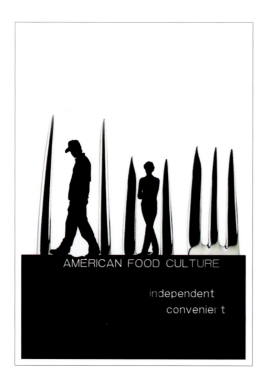

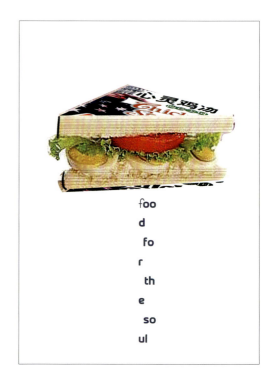

教授点评
Professor's Evaluation

学生作品及陈述与教授点评(中国)
Work of Student, Narrative and Professor's Evaluation (China)

地理位置、文化背景、生活方式的不同导致了饮食习惯的差异。作者以中美的饮食特性"聚"与"独"为设计主题，以餐具与人物剪影的共性视觉元素为相互呼应的条件，采用了颇具现代感的排版方式，使两张招贴在主题、表现内容不同的情况下又保持着风格、视觉的统一。但是，相对于美式饮食中孤独氛围的营造，在中国饮食的招贴中只表现出了中式聚餐的"形聚"，忽视了对精神方面的表达。

在印象中国、美国的文化招贴设计中，中国作品上的米粒、古书以及美国作品上的三明治、胶状彩印书的运用，从形式上比较形象地表现了"物质文明与精神文明结合"的主题设计理念。设计的精彩之处在于书的主题选择，"书中自有千钟粟""心灵鸡汤"充分表达出了中美文化间的共同与差异。

Differences in geographical features, cultural backgrounds and life styles result in different diet habits. The designer adopts the concepts of "gathering" and "alone" as the theme and the cutlery and figure shadows as the echo elements and she has also applied modern-looking layouts for the two posters. Consequently, she manages to keep the two posters, while different in themes and content, nevertheless consistent in design styles and visual effects. However, the Chinese diet culture poster, compared to the American one, has succeeded in representing the concept of formal gathering concept in Chinese dinner but overlooked the concept of spirit.

In the posters for Chinese and American impressions, the designer has managed to represent the design concept of "material and mental civilization integration" by applying rice and a Chinese ancient book in the Chinese Impression poster as well as sandwich and a brightly-painted colloidal book in American Impression poster. The highlight of the design is the choice for the theme of the two books—respectively as "you can find abundant rice in your books" ("books can feed one with abundant mental food") and "the chicken soup for the souls" which fully display the similarities and differences between Chinese and American cultures.

Section 3

学生作品及陈述与教授点评(中国)
Work of Student, Narrative and Professor's Evaluation (China)

唐 帆 | Fan Tang
2008级硕士研究生
Graduate Student, 2008

设计陈述：

中国饮食文化主题设计陈述

中国是一个餐饮文化大国，由于气候、地理、历史、物产及饮食风俗的不同，经过漫长历史演变而形成了以鲁、川、苏、粤、闽、浙、湘、徽八个菜系为主的多种菜系。中国"八大菜系"的烹调技艺各具风韵，其菜肴之特色也各有千秋。该招贴将八大菜系与中国传统的八卦联系起来，将八大菜系比作八卦的八个卦象，表现出八大菜系的变化无穷，以此诠释中国餐饮文化的博大精深。另外，该招贴还加用文字组成了中国特有的筷子，而盘子也采用了中国特色的瓷器，背景用了笔墨衬托，使得整个招贴中国味十足。

美国饮食文化主题设计陈述

快餐是典型的美国饮食文化，十分普及。随着生活节奏的加快，美国式快餐逐渐风靡世界。该招贴设计的出发点是快餐的快捷，由此我联想到"飞"是最快的方式，进而联想到给汉堡插上翅膀。之后又将汉堡比作丘比特，"汉堡丘比特"射向世界的不是箭，而是代表快餐食品的薯条，以此表现快餐食品迅速风靡全球。

Design Narrative:
Chinese Diet Culture Design Narrative

China is a great nation in terms of diet culture. Due to the differences in climate, geography, history, products and

设计陈述
Design Narrative

唐　帆
Fan Tang

diet custom, Chinese cuisine has developed into many cuisine systems over a long history, dominated by Eight Cuisines including Shandong, Sichuan, Suzhou, Guangdong, Fujian, Zhejiang, Hunan, and Anhui cuisines. The Eight Cuisines have their own distinctive cooking methods and the dishes therefore have their own distinctive flavors. This poster makes a connection between the Eight Cuisines and the Eight Diagrams in traditional Chinese mythology. The Eight Cuisines are compared to Eight Diagrams to show their variation and the profoundness of Chinese diet culture. Besides, words are used to compose chopsticks which are peculiar to Chinese culture while the plate is represented by china with Chinese characteristics. As for the background, ink is used to give the poster a Chinese flavor.

American Diet Culture Design Narrative
Fast food is a typical American diet culture which is popular all over the United States. With an ever increasing life pace, the American fast food has gradually swept the whole world. The intentions for this poster is to show the speed and convenience of fast food, which reminds me of flying, so I give wings to a hamburger and compare it to Cupid. What this hamburger Cupid fires at the world are not arrows, but chips, a representative of fast food. This shows the fact that fast food is taking over the world in an inexorable way.

教授点评
Professor's Evaluation

学生作品及陈述与教授点评(中国)
Work of Student, Narrative and Professor's Evaluation (China)

在中国进餐文化招贴设计中，作者将中国的八卦与中国的八大菜系巧妙地结合到了一起，在盘子上呈现了八卦的卦象和八大菜系，借八卦变化无穷之意表现出了中国菜肴特色丰富、中国饮食文化的博大精深之意，并用文字组成了筷子做斜线穿插打破了呆板的布局形式，背景采用笔墨形式增加了中国味道。在美国进餐文化招贴设计中，作者抓住了快餐这一美国特色进餐方式，给汉堡插上了翅膀，将其比喻成丘比特，薯条成了丘比特射出的箭，表达了美国快餐文化对全世界饮食习惯的冲击。版式采用了斜向构图，具有动势。

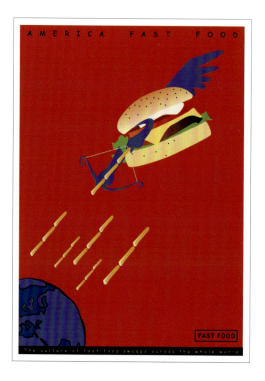

In the poster of Chinese diet culture design, the designer makes an ingenious connection between the Eight Cuisines and the Eight Diagrams, both of which are demonstrated on one plate. The Eight Diagrams change constantly and this concept used to show the richness of Chinese cuisines and the profoundness of Chinese diet culture. In addition, chopsticks composed of words appear on the poster as slanting lines to break the sterile layout, while the ink in the background gives off a Chinese flavor. In the poster of American diet culture design, the designer gives hamburger wings and compares it to Cupid, while chips become Cupid's arrows, all of which together show the impact that American fast food imposes on world diet habit. This poster takes a slanting format, embedding a kinematic feeling.

Section 3

学生作品及陈述与教授点评(中国)
Work of Student, Narrative and Professor's Evaluation (China)

程　驰 | Chi Cheng

设计陈述：

中国饮食文化主题设计陈述

画面的主体部分是一个高举大海碗的革命战士形象，他精神抖擞，意气风发，口中大喊"开饭喽！"，突显了蓬勃的朝气，也暗喻着祖国人民高昂的激情和使不完的干劲。"人是铁饭是钢，一顿不吃饿得慌"，通俗的话语饱含着劳动人民的幽默。背景辅以劳动人民的群像丰满了画面，高大的红色旗帜和炽烈的太阳象征着我们伟大的祖国。图形通过饮食元素的运用，以小见大，鲜明地表现了中国特色。

美国饮食文化主题设计陈述

众所周知，美国的快餐业十分发达，而最被国人所熟知的莫过于行业巨擘肯德基了，所以图片的主体构成部分，我便选用了具有代表性的肯德基老爷爷的logo来完成，慈祥的笑容让人过目难忘。背景以写意的美国星条旗和林立的高楼大厦来衬托，突出了美国经济发达的特点。图片的边上辅以花体英文突出重点，使整幅作品更加完整。红黑双色的运用使得画面主次分明，对比强烈。

Design Narrative:

Chinese Diet Culture Design Narrative

The main body of the poster is the image of a revolutionary soldier holding a large bowl high, full of energy and enthusiasm. "Dinner is ready!" he shouts with great vitality, symbolizing the untamed passion

and endless power of Chinese people. "It is hard to labor with an empty belly" —this popular Chinese saying is teemed with the humor of Chinese laboring people. As for the background, the group imagery of laboring people adds a sense of richness to the poster, whereas the high red flat and stunning sun symbolizes our great nation. By employment of eating elements, this poster aims at affording a wide view through a small aspect with distinctive Chinese characteristics represented fully.

American Diet Culture Design Narrative
It is universally acknowledged that American fast food industry is highly developed, and to us Chinese the most familiar one must be KFC, a giant in American fast food industry. That is why I choose the most representative KFC Grandpa logo as the main body of this poster. While the kind smile of KFC Grandpa is quite unforgettable, the free styled Stars and Stripes and skyscrapers serve as the background to emphasize a most developed American economy. English words written with distinctive flourish are added to the picture to make it a complete unity. The employment of red and black colors makes a strong contrast and the main body of the poster stands out consequently.

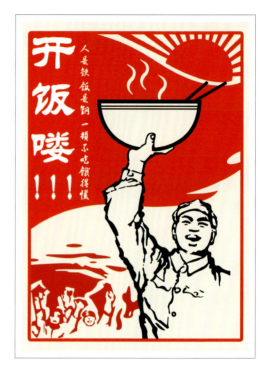

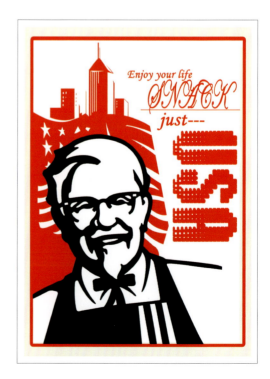

教授点评 / Professor's Evaluation

学生作品及陈述与教授点评(中国)
Work of Student, Narrative and Professor's Evaluation (China)

文革十年,留给我们太多抹不去的记忆。但是,对于80后的学生却是既陌生又熟悉。陌生的是没有亲身经历过那段轰轰烈烈的"文化大革命";熟悉的是他们无论是在生活中还是在书本上看到了太多那一时期的图文资料。即使是对其内涵一知半解,却也让那时的形色深深地留在了他们的视觉记忆之中。作品突显了那个时期的红色印记,整幅画面主题明确,形式表现独特、合理,视觉诉求一目了然。而作者对于美国饮食文化的表现也呼应了中国饮食招贴的视觉效果,并体现出了美国现代饮食文化的典型特点。

The ten years of Cultural Revolution leaves us too many unforgettable memories. However, to the generation born in the 1980s, this period of history is strange yet familiar. It is strange, because they themselves never experienced that frenzied time. It is familiar, because they have seen too many pictures and read too much literature concerning that period. Though they only have a vague idea of its conation, this period of history leaves them a deep visual impression. With a clear theme and a unique yet reasonable expression, this design emphasizes the red sign of that age and gives a direct and strong visual concussion. On the other hand, the poster of American diet culture corresponds with the Chinese one in terms of visual effects and shows typical features of American modern diet culture.

Section 3

学生作品及陈述与教授点评(中国)
Work of Student, Narrative and Professor's Evaluation (China)

杜 鹏 | Peng Du

设计陈述：

中国饮食文化主题设计陈述

要想了解一个国家的饮食文化需先了解这个国家的历史、地理及风土人情。一个国家民族饮食文化的形成与发展有两大主要因素：一是乡土性的地缘因素（Region），二是多元性的人为因素（Diversity）。由于中国有着五千多年的悠久历史与文化，乡土性的地缘因素要比多元性的人为因素更具影响力。我在中国饮食文化招贴中，采用了极富传统民族特点的图案纹样与象征富贵吉祥的牡丹花朵，并在视觉焦点的位置安排了色鲜味美的中式菜肴，同时用一个大大的"食"字点出主题，从而吻合"王者以民为天，而民以食为天"的创意思想。

印象美国主题设计陈述

美国文化强调个人价值，崇尚开拓和竞争，讲求理性和实用，其核心是个人中心主义，美国文化中代表性的文化点就是圣诞节，无论是规模还是形式，都深刻表现出了美国文化的特点，美国讲究信仰自由，大部分人信仰基督教，这与我们的生活有所不同。在美国的法律或现实生活中，大家可以发现美国人民对于法律的无比尊重。

Design Narrative:
Chinese diet culture design Narrative

To understand a country's diet culture, one must first learn something about the

设计陈述
Design Narrative

杜 鹏
Peng Du

history, geography, custom and traditions of this country. There are two dominant elements in the formation and development of a nation's diet culture, one is concerned with region and the other relates to diversity. As for China, the elements of region has more impact than diversity because of its rich history and culture of five thousand years. In Chinese diet culture poster, I chose patterns with distinctive Chinese traditional characteristics and peonies symbolizing wealth and fortune as elements. In addition, images of delicate Chinese cuisine were placed in vision focus, together with a big Chinese character "shi" (eating) to illustrate the design creativity that "while people is what matters to an emperor, food is what matters to people".

American Impression Design Narrative

In American culture, individual value is emphasized, adventure and competition is advocated, and reason and realism is valued high. The core of this culture is individualism, while the representative cultural sign is Christmas, which embodies American cultural characteristics in terms of scale and form. Americans value religion freedom and most citizens are Christians. This is different from Chinese life. The utmost respect that American people seem to give to law can be perceived both in American law and American daily life.

教授点评
Professor's Evaluation

学生作品及陈述与教授点评(中国)
Work of Student, Narrative and Professor's Evaluation (China)

以极富传统民族特点的图案纹样结合象征富贵吉祥的牡丹花朵烘托出色鲜味美的中式菜肴，恰当地体现出了历史悠久、博大精深的中国饮食文化。同时，以传统风格的版式编排结合对中国饮食文化理解的文案诠释，也充分地呼应了"食"的主题汉字，版式编排虽显稚嫩，却也吻合了"王者以民为天，而民以食为天"的创意宗旨。在美国印象的招贴设计中，作者以美国国旗以及领先于世界的电影艺术为设计元素进行了突显动态的编排形式，也表述出了其对美国文化中强调个人价值、崇尚开拓和竞争、讲求理性和实用的个人理解与印象。

Patterns full of Chinese traditional characteristics and peonies symbolizing wealth and fortune are combined together to give emphasis to the delicate flavor of Chinese cuisine, indicating the long history and profoundness of Chinese diet culture. Meanwhile, typesetting of a traditional style, together with narrative in words, is ingeniously correspondent with the Chinese character "shi" (eating). Though not very mature, this typesetting conforms with the creativity of the design that is "while people are what matters to an emperor, food is what matters to people". In the poster of American Impression, the designer adopts a kinematical composition with American national flag and the most advanced American film art as elements to tell his personal understanding and impression of America where individual values, adventure, competition, reason and realism are emphasized in this culture.

Section 3

学生作品及陈述与教授点评(中国)
Work of Student, Narrative and Professor's Evaluation (China)

郭梦婕 | Mengjie Guo

设计陈述：

美国饮食文化主题设计陈述

美国是一个历史短暂的文化大熔炉，没有自己特有的传统文化。在这个选择快节奏的生活方式的国度，美国人发明了快餐，衍生出了美国的"快餐文化"。作品以美国的标志性建筑自由女神像为背景，同时融入了美元等特有元素来展现美国。在快餐方面运用汉堡、薯条、冰激凌这些典型的食品，在每一个食品上都添加了表。用表来象征时间，一种无时不在的时间观念，体现出时间和效率在美国人心目中的重要性。

印象美国主题设计陈述

我选取美国独有的音乐文化——乡村音乐来表达我的美国印象。简单的线条勾勒出草原、栅栏还有吉他，一把吉他将内心的喜悦或忧伤抒发在了辽阔的草原上，不受任何事物的限制。美国乡村音乐是名副其实的美国"特产"，也是美国人民献给世界人民的一份美好礼物。标题由吉他中飘出的跳动的音符构成，为宁静的画面增添了动感。

Design Narrative:

American Diet Culture Design Narrative

America is a cultural melting pot with a short history and no distinctive traditional culture of its own. It is in this country which chooses a fast-paced lifestyle where

Americans invented fast food, with a fast food culture derived consequently. The designer chooses the landmark architecture of America, the Statue of Liberty as background. Additionally, some particular elements such as the US dollar are adopted to represent this nation. When it comes to fast food, hamburger, fries and ice cream all get their position. A clock is added to each item of fast food to show a concept of time which exists everywhere in this society and to emphasize the importance of time and efficiency in American's life.

American Impression Design Narrative

I chose country music, a musical culture peculiar to America, to show my impression of this nation. I use simple lines to depict pasture, fence and guitar. The feeling, be it happy or sad, is expressed through the guitar, and nothing could influence its freedom. American country music is a genuine America specialty, as well as a beautiful gift that Americas dedicates to the whole world. The title is composed of dancing notes coming from the guitar, rendering a sense of action.

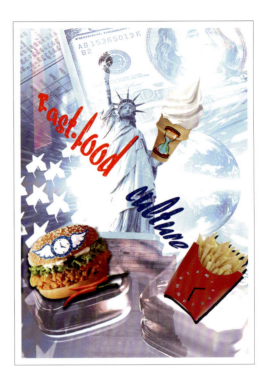

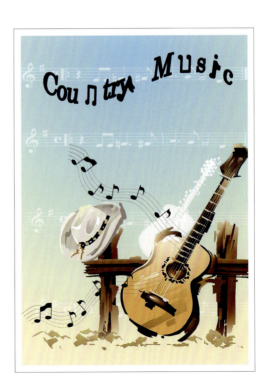

教授点评
Professor's Evaluation

学生作品及陈述与教授点评(中国)
Work of Student, Narrative and Professor's Evaluation (China)

在美国进餐招贴中，作者以时间为创意主线，淋漓尽致地展现出了美国人快节奏的时间观念。元素运用上既有象征美国的国旗、自由女神，又融入了快餐食品，不仅恰当地呼应了主线，又揭示出饮食与人生态度之间地内在联系，赋予了作品一定的哲理性。版式编排自由流畅，但视觉层次略显凌乱。

当耳畔萦绕着优美、清新的乐曲《乡村之路》时，我们仿佛看到了西弗吉尼亚山区的美丽风光，这就是美国乡村音乐的魅力所在。在印象美国招贴中，草原、栅栏、吉他等元素合理地组合到了一起，向我们呈现了乡村音乐的美妙印象。通过文字和音符的动态编排变化，将悠扬的乐感融入了招贴设计之中，构图灵活、表现到位，充分展现了作者的美国印象。

In the poster of American diet culture, the designer adopts time as the dominant line of the creativity, portraying American's fast-paced time concept in a vivid and thorough way. As for the elements, the American symbols of its national flag and the Statue of Liberty are combined with fast food to make a correspondence with the dominant line on the one hand, and on the other hand, to reveal the inner relations between diet and life attitude, which endows a sense of philosophy to the design work. The composition and typesetting are smooth and fluent, but the visual effect is little bit out of order.

With the beautiful and crisp melody of Country Road ringing in ears, the glamorous view of West Virginia mountains is extending in front of our eyes, and this is where the charm of American country music lies. In the poster of American Impression, elements such as pasture, fence, guitar are put together in a reasonable way, the beautiful impression of American country music is therefore presented to the audience. Words and musical notes are integrated dynamically, giving the poster a sense of musical enjoyment. In addition, the picture is arranged in a flexible and expressive way, which fully presents an American Impression in the designer's eyes.

Section 3

学生作品及陈述与教授点评(中国)
Work of Student, Narrative and Professor's Evaluation (China)

李 磊 | Lei Li

设计陈述：

中、美饮食文化主题设计陈述

中国有句古话叫做"民以食为天"。每个国家都有自己独特的饮食文化。我希望通过在饮食文化上的差异来相互比较，我认为这里有足够的文化差异来形成鲜明的对比，最后的视觉效果应该会很好地把它呈现出来。

在美国饮食文化的设计中，我选择从快餐这方面着手。美国是一个生活节奏很快的国家，所以在饮食方面快餐比较有代表性。美国式饮食不讲究精细，追求快捷方便，也不奢华，比较大众化。一日三餐都比较随便。这幅作品主题是一些快餐食品，不过是以油印的方式印在纸上，在感觉上给人一种快的感觉，旁边的字用亮色，表现得比较干净，整体风格清新，体现出"快"字。

中国饮食文化的设计中，我选择的是从饮食的"文化内涵"上着手。在中国，饮食已经不单单是吃饭那么简单了，它更像一个社交的媒介，一种氛围。所以我选用了一个极具代表性的吃饭场景，而并非具体刻画食物上的特殊性，色彩上古朴、庄重，目的就是增强两种文化的对比。

印象中国、印象美国主题设计陈述

这两幅招贴展示了中国和美国给人们带来的不同感受。我把玉和瓦当作为中国印象设计的切入点，在中国，"玉"已经远远超出了一种宝石的意义，由于玉质地坚硬、温润和无瑕纯净，符合了古人对君子的要求，所以一直有"君子比德于玉"之说。中国人对玉

设计陈述
Design Narrative

李 磊
Lei Li

的喜爱贯穿了整个中华文明，玉的精神也深深地渗透到中华民族的骨子里。而瓦当的图案大多数以祥兽为主，也寄托着人们的一种美好愿望。我把两种能代表中国文化底蕴的东西结合在一起，在颜色上选择了代表地位的黄色，以黑色衬托，给人一种大气庄重的感觉。在玉的造型上我选择了一个"兽面衔环"的造型来突出中国特色。

在美国印象的设计中，我从音乐方面体现我对这个国家的认识。这幅作品的主体是一个典型说唱歌手的形象。说唱艺术讲究的就是自由，无拘无束，个性的打扮加上即兴的表演非常符合美国这个国家的形象，而且说唱起源于美国、发展于美国，是美国比较具有代表性的当代艺术。这幅作品我运用的手法是将主体，也就是说唱歌手的形象抽象化，并多个叠加用来突出主体，周围用比较自由的字体加以说明，使其整体性保持一致，颜色上的运用也比较鲜艳，视觉上具有冲击力。

Design Narrative:

Chinese and American Diet Culture Design Narrative

There is an old Chinese saying: "Food is what matters to people." Every nation has its own distinctive diet culture, and what I am going to do is to make a comparison between different diet cultures. I believe that there must be a strong contrast due to a large difference between various cultures, and the final visual effects will reveal this contrast vividly.

In the design for American diet culture, I start with fast food. America is a nation with a fast paced lifestyle; therefore, fast food is very representative when it comes to the diet aspect. American diet cares less about delicateness, but more about speed and convenience. For Americans, food is no luxury but a popular commodity and three meals a day are quite informal. This design takes some fast food as its theme, and its uniqueness lies in the employment of the mimeograph method which gives the audience a sense of speed. The words are printed in bright colors to create a clean image and a clear and fresh style on the whole. The ultimate intention is to emphasize the sense of speed.

In the design for Chinese diet culture, I start with the cultural connotation of diet. In China, eating is not a simple action but more like a social medium, or even an atmosphere. So I choose a typical dinner scene. Attention is given to depict the dignified atmosphere but not the special characteristics of a particular kind of food. The intention is very clear, which is to strengthen the contrast between the two cultures.

Chinese and American Impression Design Narrative

These two posters show different impressions that China and America give to the world.

As for Chinese Impression, I take jade and tile as the breakthrough point. In China, jade is not considered as a mere jewel. With its solid, meticulous, clean and pure texture, jade complies with the requirements for a nobleman in ancient China perfectly, with a result of the saying that a nobleman always compares his virtue to jade. A love for jade has penetrated the whole Chinese civilization, while the spirit of jade is deeply infiltrated into the blood of the Chinese nation. On the other hand, the patterns carved in tiles are mainly lucky animals which also express people's good wishes. In the poster, these two objects with deep Chinese cultural connotations are combined together, with the color of yellow to show status and the color of black to set off a sense of dignity and generosity. As for the shape of the jade, the pattern of a lion with a ring between its teeth is chosen to emphasize distinctive Chinese characteristics.

In the design for America Impression, I prefer to express my understanding of this nation from the music aspect. The main body of this design is an image of a typical hip-hop singer. What is central to hip-haop is freedom without restrain, non-mainstream dressing up and improvised performance, which is conformed to America's national image. What's more, hip-hop originated in America and has developed prosper-

设计陈述
Design Narrative

李 磊
Lei Li

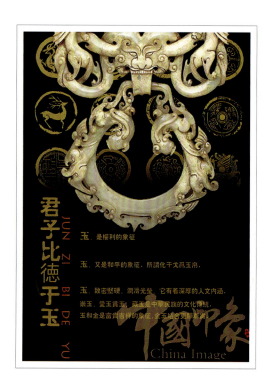

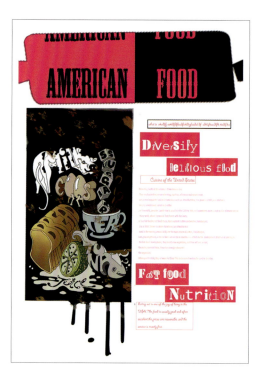

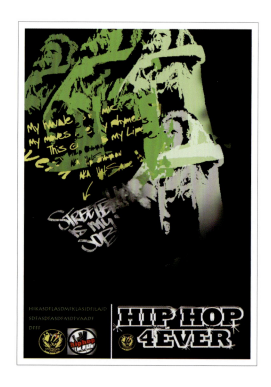

ously in America, thus surely deserves to be a representative of American modern art. In this poster, the image of a hip-hop singer as the main body is overprinted in an abstract way and the words surrounding are printed in a loose font to make it an integrated and unified whole. Besides, I specially choose brighter colors to create a strong visual effect.

教授点评
Professor's Evaluation

学生作品及陈述与教授点评(中国)
Work of Student, Narrative and Professor's Evaluation (China)

美国发展迅速的"快餐文化"与中国悠久历史的"宴席文化"本身就形成了鲜明的对比。作者准确抓住中美饮食文化的不同点，利用美国现代插画形式和中国传统线描手法突显、强化了这种差异。截然不同的版式编排风格、具有地域文化韵味的色调不仅强调了主题，更赋予了作品深刻的思想性。

在美国印象的招贴中，主题形象鲜明、有张力，作品构图形式大气，视觉冲击力强，直接传达出现代美国的文化气息和生活节奏，具有很强的感染力。"玉"的创意蕴涵了东方"德"文化的博大精深。作者在其中国文化招贴中选择玉和瓦当作为设计元素，造型上选择了"兽面衔环"，独特的元素符号，严谨的构图，标志性色彩的运用，使得作品较有气势，较好地展现了中国文化与印象。

A strong contrast can be made between the rapidly-developed fast food culture of America and the richly-historied banquet culture of China. In the posters, difference between Chinese diet culture and American diet culture is grasped accurately, and the employment of American modern illustration and Chinese traditional line drawing emphasizes this difference further. Moreover, the use of layouts with complete different styles and color full of regional culture flavor does not only strengthen the theme, but renders the design a profound ideological content.

In the poster of American Impression, American modern culture and life style is presented with impressive visual effect through a vivid theme image and a graceful composition. On the other hand, the creativity of jade embeds the profoundness of Chinese virtue culture. The deliberate choice of jade, tile and pattern of a lion with a ring between its teeth shows great originality. These particular elements, together with a precise composition and typical colors, lead to a design with a sense of dignity and grace which presents Chinese culture and Chinese impression perfectly.

Section 3

学生作品及陈述与教授点评(中国)
Work of Student, Narrative and Professor's Evaluation (China)

李 霞 | Xia Li

设计陈述：

中国饮食文化主题设计陈述

在接受并思考了课题要求后，经过大量的网上搜索并结合自己的经验，我发现中国饮食跟美国饮食很大的一个差异就是食物原料，中国式饮食讲究自然，以青菜和素食为主；而美国是一个以肉食为主的国家，所以我决定从这一点着手来完成这次设计。

中国文化底蕴深厚，所以这个招贴的主色调追求一种稳重的感觉，作品的主要元素是最具代表性的中国式饮食用具——筷子和瓷盘。筷子的颜色应用了中国文化的代表色——红色。瓷是中国的特色发明，青花也是中国的一种特色瓷器。筷子与盘子的摆放形式组成了现代感的金牌与绶带的样子，眯起眼睛来看，主体元素又构成了一个"！"。这也隐喻了对中国饮食特色的惊叹之感，感叹中国式饮食是如此的淳朴自然，文化是如此的博大精深！整个画面运用典型的中国元素和典型的中国饮食用具，传达出的是浓郁深邃而又清新自然的中国饮食文化特色。

美国饮食文化主题设计陈述

印象中，美国人体型高挑，个性直率。他们的餐具以刀、叉、勺为主，刀、叉、勺恰恰也具有高挑修长的特征，乃至他们的餐桌，餐椅——细长的桌腿椅身，代表了他们这个民族优雅的绅士作风。作品用美国饮食餐具——刀、叉、勺的特性：造型简洁，修长，

设计陈述
Design Narrative

李 霞
Xia Li

刚硬，来表现美国人民的优雅，绅士风格。生肉牛排做饮食餐桌，强烈地表现了美国民族喜肉食的饮食偏向。整个画面色调单一，线条流畅，元素简洁，表现出了美国人快速、直白的行为习惯，传达出追求直接，率真的民族特性和快捷的饮食姿态。

Design Narrative:

Chinese Diet Culture Design Narrative

After a careful consideration of the project requirements and with a combination of information searched from internet and my personal experience, I got the idea that one of the biggest differences between Chinese diet and American diet lies in food material. While Chinese people prefer a natural diet with vegetables as their major food, Americans definitely like meat more. That's why I decide to design my work from this perspective.

Chinese culture is profoundly focused on details. So the predominant color of this poster intends to give a sense of steady and modesty. As for the elements, I choose the most representative tableware in China—chopsticks and china. The color of chopsticks is red, the representative color of Chinese culture. While china is a special invention of China, the blue-and-white porcelain is a special kind of china. The chopsticks and the china are placed in such a way that they look like a golden medal and belt. However, seen from a little distance, it composes a" !", which implies the world's marveling at Chinese diet characteristics. How can the Chinese diet be so simple and natural, yet the culture embedded is so profound and impressive! The employment of typical Chinese elements and typical Chinese tableware delivers a deep yet fresh sense of Chinese diet culture.

American Diet Culture Design Narrative

We have the impression that American people are tall and direct. And when it comes to cutlery, they prefer knife, fork and spoon with the same characteristics of being long and slender. Even the long legs of their dinner table and chairs symbolize the elegance and grace of the nation. Therefore, the simple slender solid characteristic of American cutlery is chosen to show a graceful and gentle feature of American people. On the other hand, raw beef steak is used as dinner table, which clearly reveals Americans' preference for meat. With a single color, flowing lines and simple elements, this picture indicates Americans' behavior and habit of being fast and direct. Consequently, a direct and frank national characteristic and a fast diet attitude is expressed.

教授点评
Professor's Evaluation

学生作品及陈述与教授点评(中国)
Work of Student, Narrative and Professor's Evaluation (China)

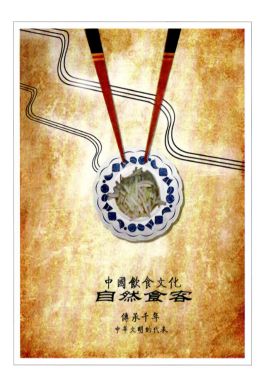

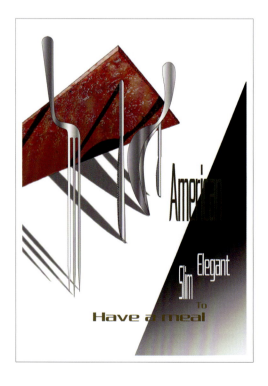

不同的地域形成了不同的文化，不同的文化孕育了不同的餐饮习惯。该系列招贴从中美的餐具差别入手来表现中美各自的饮食文化特色，隐喻了中国饮食的内敛、雅致以及美国饮食的直接与率真。其中在中国进餐文化招贴中，把筷子、瓷盘等典型的中国餐具作为设计元素，赋予了中国饮食令世人惊叹、享誉世界的含义，构思巧妙，虽然在构图上略显呆板，但是展现出了清新自然的中国饮食文化特色。在美国进餐文化招贴中，作者同样从餐具入手，运用刀、叉、勺等美国餐桌常见的餐具作为设计元素，而夸张性地以牛排做餐桌更表现了美国人以肉食为主的饮食习惯。倾斜的构图方式使整个画面具有动势，并且通过投影增加了招贴的纵深感，用最简洁的视觉语言表现了美国的进餐文化。

Different regions have different cultures, while different cultures breed different diet habits. This series of posters deals with diet cultures of China and America from the angle of tableware differences. A restrained and delicate Chinese diet culture and a direct American diet culture are ingeniously presented in these posters. In Chinese diet culture poster, chopsticks and china are cleverly used as design elements to indicate the fact that Chinese cuisine is world famous. Although the arrangement of composition is a little bit stiff, this poster does reveal the fresh and natural characteristics of Chinese diet culture. In American diet culture poster, the designer also starts with tableware where the common American cutlery is chosen as design element and the exaggerated use of beef steak as the table demonstrates Americans' eating habits in a direct way. A slanting composition embeds a kinematical beauty while the projection renders a feeling of depth. Overall, the American diet culture is illustrated through the simplest visual language.

Section 3

学生作品及陈述与教授点评(中国)
Work of Student, Narrative and Professor's Evaluation (China)

梁凤秀 | Fengxiu Liang

设计陈述：

印象中国主题设计陈述

作品的主题元素主要采用中国的神秘文化之一"周易"来创作，它的内容极其丰富，对中国几千年来的政治、经济、文化等各个领域都产生了极其深刻的影响，远古的伏羲氏之"始作八卦"，乃起于观察，普遍观察天、地、人、物以后，归纳所得，制作为八卦的思想符号。中古时代，姬昌被纣囚禁于羑里，遂体察天道人伦阴阳消息之理，重八卦为六十四卦，并作卦爻辞，即"文王拘而演《周易》"，所以该作品提取"周易"作为主题进行设计。这幅招贴的整个背景是一张陈旧古老的纸张，画面的所有内容都是在这张纸上编排，在画面的左边部分用红色打底衬托主题"印象中国"，这四个字在颜色上借鉴周易中的太极图的阴与阳做了一个黑白对比的效果，主题下方的竖排文字是对周易太极之说的一个概述，图的右半部分是整个招贴的主要部分，用文字编排成一个八卦图的样式，下方用篆体标明副标题"易学"，古人习惯书写完后在文尾打上印章，所以在右下方用中国印章做了一个点缀。

印象美国主题设计陈述

这幅招贴是从美国的影视出发，提取美国早期著名的喜剧表演大师卓别林作为主题元素，并不是说美国的所有文化都是外来的，美国的电影业就是在本土发展并壮大起来的。从早期的无声电影到有声电影，甚至到现在的好莱坞发展成为影视重地，都显示出了美国电

影在世界电影史上的地位和影响。提到美国的无声电影就不得不提到卓别林，卓别林出生在英国，后移民到美国并在美国取得了成功。

这幅招贴的整个画面是用美国国旗做了一个舞台的幕布设计，卓别林以人们最熟悉的流浪汉的打扮站在这个舞台上，所有的文字都在这个舞台上编排，画面最上方的文字主要介绍了美国电影的发展史，犹如一出舞台剧的开幕词，往下的中间是主标题"印象美国"和副标题"影视"、"卓别林"，两边分别介绍了卓别林的成名角色和所获得的奥斯卡奖项，分别采用左对齐和右对齐的方式编排，这是招贴的主要部分。右下角框起来的文字则介绍了一些卓别林的趣事，如同舞台插曲。整个招贴的文字编排规律，就像一个有秩序的表演流程一样呈现给观众，体现了一种秩序的美。

Design Narrative:

Chinese Impression Design Narrative

This design is inspired by the Changes of Zhou, one of Chinese mysterious cultures. With a profound and rich connotation, the Changes of Zhou has exerted extensive influences on various aspects of China such as politics, economics and culture. The Changes of Zhou was created when the Fuxishi summarized his observation about the sky, earth and people and finally invented the eight diagrams. During the middle ancient times, Ji Chang was held in captivity by King Zhou in Youli. He made a further observation on the world, people and Yin and Yang, remade the eight diagrams into sixty-four and gave an explanation for each diagram. Thus comes the story that Wenwang, a king of Zhou dynasty, wrote The Book of Changes in captivity. And this poster adopts the changes of Zhou as its design theme. With an antiquated piece of paper as background, the poster has all its contents arranged within this framework. On the left part of the picture, red is used to set off an atmosphere for the Chinese characters "Zhong Guo Yin Xiang" (Chinese Impression). As for the four Chinese characters themselves, they are printed in black and white to make a contrast, which reveals the idea of Yin and Yang in Diagram of the Supreme Ultimate in the changes of Zhou. Words printed in a vertical setting of types is about the summary of tai chi in the changes of Zhou, while on the right side, words are arranged in the pattern of the Eight Diagrams to form the main body of this poster. Under the Eight-Diagrams pattern is the subtitle printed in the seal character. Furthermore, ancient Chinese people used to add a seal in the end of the writing, so I place a Chinese seal at the lower right part of the poster as an ornament.

American Impression Design Narrative

This design is based on American film culture, and Chaplin, a famous comedy actor in early America, is chosen as the thematic element. While America has always been famous for its borrowing culture, American film culture is an absolute native one. From the silent film to motion picture, and the recent Hollywood being world film center, America has earned its fame and status in world film history. And when talking about silent film of America, you can never forget Chaplin, a great actor born in England yet immigrated to America and made huge success there later.

In the poster, the American flag is used as the stage curtain, and Chaplin stands on the stage in his world familiar tramp appearance. All the words are arranged on this stage. Words at the top are a brief introduction of American film history, just like the opening speech for a stage play. In the middle are the title American Impression and subtitle Film and Chaplin with famous roles Chaplin played and Oscar awards he won on both sides, which composes the main body of the poster. Words are arranged in the way of left-aligned and right-alighted respectively for this part. Inside the lower right textbox are some anecdotes about Chaplin, just like an interlude. The overall arrangement of words intends to follow a systematic order that feels like an orderly performance, which entails a sense of order beauty.

教授点评
Professor's Evaluation

学生作品及陈述与教授点评(中国)
Work of Student, Narrative and Professor's Evaluation (China)

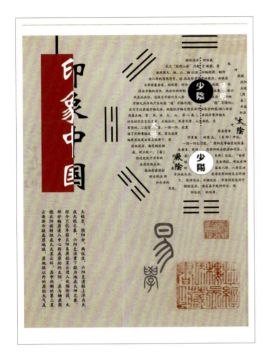

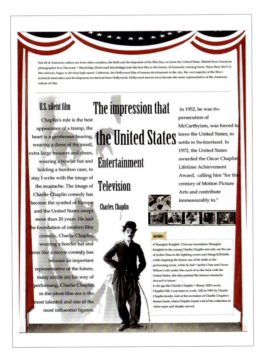

周易是中国古代文化的智慧结晶，是中华文明的瑰宝，蕴涵着阴阳互应、刚柔相济，提倡自强不息、厚德载物的哲理和内涵。这幅招贴选择周易作为中国印象的主题，借助八卦图形传达了中国文化的历史印象，同时加入了篆书、印章等设计元素，并在文字处理上呼应了太极图阴阳对比。整幅招贴引入了很多中国传统文化符号，展现给观众一个富有历史文化特色的中国印象。在美国印象招贴中，作者以美国电影作为切入点，选取了著名电影大师卓别林作为创意主线，采用对称式构图方式，将美国印象浓缩成了一场舞台剧，美国的国旗被用做舞台的幕布，通过图文的穿插和字体的编排，表达了其对美国的印象。构思合理，表现较为到位，突显了主题的可识别性和认知性。

As a crystallization of ancient Chinese culture, the Changes of Zhou is the treasure of Chinese civilization. It embodies the philosophy of Yin and Yang, it is a combination of hardness and softness, it reveals the principle of striving to become stronger and great virtues carrying great responsibilities. The Changes of Zhou is chosen as the theme of Chinese Impression, while the Eight-Diagram pattern is selected to express the impression of Chinese ancient culture. Meanwhile, a seal character and Chinese seal are also included, and words are processed in a way to echo with the contrast between Yin and Yang in Chinese tai chi concept. In summary, a lot of traditional Chinese cultural symbols are brought into this poster to present a Chinese Impression full of historical cultural features. In the poster of American Impression, the designer starts with American film and chooses the famous film master Chaplin as creativity mainline. In this symmetrically composed poster, American Impression is condensed into a stage play whereas the American flag is used as stage curtain. With interwoven pictures and words and a contrast in the typeface, this design expresses personal impression of America and emphasizes the identifiable and cognitive theme in a comparatively impressive way.

Section 3

学生作品及陈述与教授点评(中国)
Work of Student, Narrative and Professor's Evaluation (China)

刘书振 | Shuzhen Liu

设计陈述：

中国饮食文化主题设计陈述

这幅作品的设计理念来源于中国人吃饭喜欢大伙一起吃，吃得香。所以我以筷子为题材，用筷子围成一个圆的形状，在中间以一个桌子的样子来体现这种想法，所以我给这幅作品起的题目为"好味来自百家"。另外，中国两个字的出现主要是强调只有在中国，才会出现"好味来自百家"。左下角出现的四个人物也正是我想体现的中国人的团结统一，和对"好味来自百家"的一种支持。文字的叙述也体现了这幅作品的主题，使其更加形象生动。背景采用中国红和黄为主，这两种颜色是中国古代权威的象征。红色上面为中国古老的文字，体现了中国饮食文化的历史悠久。黄色上面的图案是以中国古代山水为主题的画面。这两幅背景的使用使整个画面看起来有一种古老庄严的感觉，以体现中国饮食文化在世界中的地位。

美国饮食文化主题设计陈述

这幅作品的设计理念就是以薯条、汉堡、可乐和面包等为背景，前面是一些快餐的图片，把它们拼在一起，然后用两手从中间撕破，寓意着美国快餐业已经在不知不觉中成为他们生活中不可或缺的东西。在美国，快餐已经成为一种习惯，一种依赖。路标主要是体现虽然美国人也意识到这一点，但是他们已经无法改变，虽然很想改变，但是却很难做到。此幅作品的题目为 Fast food，下面的人物作沉思状，好像也是在思考这个问题，增加了这幅作品的趣味性。背景采用涂鸦的形式，体现出随意性。让整个画面给人一种轻松愉快的感觉。

设计陈述
Design Narrative

刘书振
Shuzhen Liu

印象中国主题设计说明

中国印象作品是受中国园林的启发。设计的特点就是寓意着透过门看到的内、外世界的一切，有山、有水、有花草和有树等。这些视觉元素都是在 Illustrator 里面用画笔勾画出来的，中间的小亭子也起到了一种装饰作用。这幅作品的题目为"印象中国"，副标题为"春色落谁家"。当中的文字都是围着这两大主题而写的，更能体现出这幅作品的主题。在作品的两边以梅花作为装饰，更能让人感受到一种初春的气氛，使整个画面显得更加和谐。

印象美国设计说明

此幅作品是对美国迪斯尼的一种诠释，在美国社会中，迪斯尼的东西在儿童心中占了很大一部分，所以我以迪斯尼为创作题材进行了创作。首先我把迪斯尼的几个主要成员用 Illustrator 勾出来，然后把那只狗放在现在，打出一句话，"I want to go to Disneyland"来表达一种心情，连狗都对迪斯尼有一种向往。然后背景采用美国 20 世纪 70 到 80 年代大海报的那种颜色——米黄色，来诠释现在与近代的结合。上面的任务也是以 80 年代时期的人物造型来解释的。字体的设计就采用字体编排的设计，采用比米黄色稍微深一点的颜色来设计，让整个画面显的统一。

Design Narrative:

Chinese Diet Culture Design Narrative

This design originates in the idea that Chinese prefer to have a large group of people at dinner together. So I choose chopsticks as elements. Chopsticks form a circle the center of which is an image of a table. The title of this poster is Delicious Food Comes from Various Families, and the two Chinese characters "Zhong Guo" (China) emphasizes that this kind of situation is peculiar to China. The four figures in the lower left symbolize the unity and harmony of Chinese people, and also serve as a support of the concept that delicious food comes from various families. The narration in words also emphasizes the theme and makes it more vivid. For background, red and yellow is adopted, which symbolize authority in ancient China. Ancient Chinese characters are printed in the red background to indicate a long history of Chinese diet culture, while ancient Chinese landscape painting is drawn in the yellow background, all of which brings an ancient and solemn flavor and reveals the status of Chinese diet culture in the world.

American Diet Culture Design Narrative

In this design, fast food such as fries, hamburgers, coke and bread, etc. serves as the background with more fast food printed in the front. However, this integrated picture is torn apart from the middle, indicating that fast food has gradually become something indispensable in America's daily life, something people are used to, something they depend on. As for the landmark, it reveals that it is a fact that Americans are aware of but cannot change, even though they do want to change it. The title of this poster is called Fast Food. The person in meditation seems to be thinking over this problem too, which increases a sense of enjoyment of the poster. Graffiti is adopted as background to set off an easy atmosphere. The whole picture intends to bring a sense of pleasure and ease.

Chinese Impression Design Narrative

This design is inspired from China landscape. Its uniqueness lies in the moral that observing the inner and outside world through this door. Here is the landscape composed by hills, waters and plants, all of these visual elements are sketched in Illustrator. The pavilion in the middle serves as a kind of ornament. The title of this design is called Impression of China, with a subtitle Where is Spring going. Words are written based on these two subjects to strengthen the design theme. Plum blossoms are drawn on both sides as ornament, which brings an atmosphere of early spring and meanwhile, makes the picture a harmonious unity.

American Impression Design Narrative

This poster is an illustration of American Disney culture. Disney plays an important part in American children's life, and that's why I choose it as the design theme. Several major Disney characters are drawn by the application of Illustrator and are placed in a dramatic way to set off an easy and cheerful atmosphere, while the sentence "I want to go to Disneyland" just expresses the same feeling. As for the background, maize-yellow, the universal color for posters of the 1970s and 1980s in America, is used to show a combination of today and the modern times. A color that is a little bit darker than maize-yellow is used for the words, which brings a sense of unity to the whole picture.

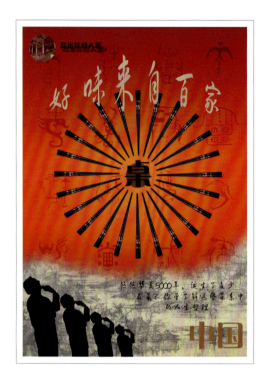
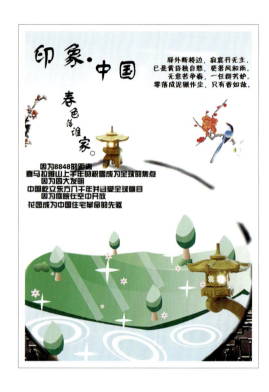
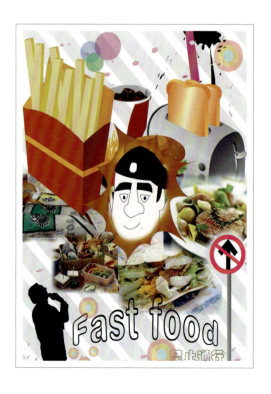
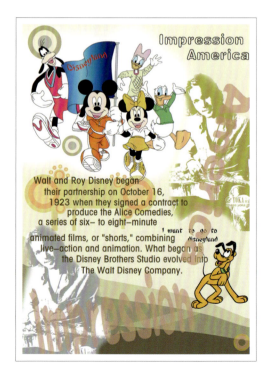

教授点评
Professor's Evaluation

学生作品及陈述与教授点评(中国)
Work of Student, Narrative and Professor's Evaluation (China)

华民族是一个文化广博但又注重融合的民族。在中国进餐文化的招贴中，作者表现了"好味来自百家"的主题，中心放射式构图使画面引人注目，重复性的手法表现出了中国人热情好客的特点，红、黄色彩的搭配以及山水画的借用都增加了中国韵味，在整体上体现了中国饮食文化的内涵。在美国进餐招贴中，作者选择快餐作为主题，表现出了快餐在美国人生活中已经成为一种习惯、一种依赖，置身其中而无法摆脱的境况。

春色满园关不住，一枝红杏出墙来。作者在中国印象招贴中用春天的园林景色来映射中国印象，其中运用了园林美景中的花草、树木等元素，版式编排灵活，表现出了"春色落谁家"的意韵。很多人都是伴随迪斯尼的动画片长大的，在美国印象这幅招贴中，采用了美国迪斯尼动画形象作为美国印象的创作主题，合情合理，只是表现手法略显幼稚，版面略显凌乱、主题内容不够突出。

The Chinese nation is a nation with extensive cultures but emphasizes harmony between different cultures at the same time. In the poster of Chinese diet culture, the designer focuses on the theme of Delicious Food Comes from Various Families. The ray-like composition in the middle makes the picture more attractive, whereas the usage of repetition reveals Chinese people's hospitality. Moreover, a combination of red color and yellow color, together with the employment of Chinese landscape painting, covers the picture with a Chinese flavor and reveals the connotation of Chinese diet culture. In the poster of American diet culture, fast food is chosen as the subject to show the fact that fast food has become a habit and dependence in Americans' life. It also reflects the situation that American people are aware of but cannot get rid of.

You can never keep spring exclusive in your own garden, when a spray of red apricot blossom has already reached over the wall. In the poster of Chinese Impression, a garden view in spring is depicted to reflect Chinese Impression with flowers and trees as elements arranged in a flexible way to imply the connotation of the poem where has spring come. In the poster of American Impression, it is quite reasonable to choose Disney as the subject, since many people did grow up with Disney cartoons in America. However, the expression technique is a little bit childish and the composition is out of order, and consequently, the theme is not emphasized adequately.

Section 3

学生作品及陈述与教授点评(中国)
Work of Student, Narrative and Professor's Evaluation (China)

邱 菁 | Jing Qiu

设计陈述：

中国饮食文化招贴的设计说明

谈到中国饮食文化，许多人会对中国食谱以及中国菜的色、香、味、形、器赞不绝口。中国饮食在世界上是享有盛誉的，中国饮食可以说是"食"遍天下。中国传统文化注重从饮食角度看待社会与人生。老百姓日常生活中的第一件事就是吃喝，有"开门七件事，柴米油盐酱醋茶"之说。逢年过节，亲友聚会，喜庆吊唁，送往迎来，不管是喜是悲，无论穷富贵贱，都离不开吃。传统食物饺子和包子，总是使人体会到浓浓的中国情。

美国饮食文化主题设计说明

在美国的饮食文化中，因为美国人白手起家，靠劳动致富，所以，美国人吃饭以吃饱为准。在美国人的边缘意识中，他们把食物和爱紧紧联系在一起。在美国人眼里食物就是"安全的性"。虽然他们在潜意识里对性有负面情感，但是美国人接受进食产生的快感。其次，美国有一种食物爱好者的亚文化。食物爱好者热爱食物，而且从精心准备食物的过程中获得快乐。美国人很享受进食带给他们的快乐，所以，我的美国饮食文化招贴，就是为了表现以上三点，来突出美国人进餐的氛围和心情，更重要的是突出美国人的文化情感。

设计陈述
Design Narrative

邱　菁
Jing Qiu

Design Narrative:

Chinese Diet Culture Design Narrative

When talking about Chinese diet culture, many people will marvel at Chinese diet menu as well as Chinese cuisine in terms of color, flavor, taste, shape and even tableware. Chinese cuisine is famous all over the world, while Chinese people hold an attitude that delicious food can be found everywhere. In traditional Chinese culture, people tended to think about society and life from a diet perspective. For Chinese common people, eating and drinking is the first thing to consider in daily life, which has its best interpretation in the saying that there are seven most important things in life, firewood, rice, oil, salt, sauce, vinegar and tea. When it comes to festivals, family gatherings, weddings and funerals, eating is always an indispensable element, no matter it is a happy gathering or a sad parting. As for the particular food, jiaozi (Chinese dumplings) and baozi (steamed stuffed buns) always deliver a distinctive Chinese flavor.

American Diet Culture Design Narrative

Americans build up their nation from nothing and earn the wealth by hard work; therefore they emphasize a sense of fullness in diet culture. Food and love is closely related in Americans' marginal awareness, where food is actually considered as a kind of "safe sex". Although holding a negative feeling towards sex subconsciously, American people enjoy the pleasure of eating. Moreover, there even exists a subculture among food lovers who derive pleasure from the elaborated preparation process of food. And for Americans, the joy that eating brings can be immense. The above is what I want to express in this poster, and what is emphasized here is an atmosphere, a feeling, and most of all, a cultural emotion of America.

教授点评
Professor's Evaluation

学生作品及陈述与教授点评(中国)
Work of Student, Narrative and Professor's Evaluation (China)

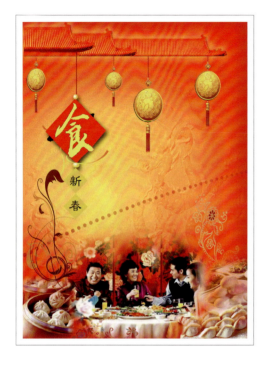

中国有一句民谣叫"大寒小寒，吃饺子过年"。春节是中国最重要、最隆重、最富有特色的传统节日，饺子则是节日里的主打食品。作者运用了瓦檐、灯笼、春联、纹饰以及欢乐的聚餐场景，营造了一个真实、有层次感和文化感的视觉空间，充分展现了中国新春年夜饭的快乐氛围，进而折射出了中国饮食文化的特色。

作者在美国饮食文化招贴中用特殊的构架方法，将不同的人、物、环境集于一个地点，利用幽默的手法，依然以渲染进餐氛围和心情为主，通过很多窗口不同人物形象看似随意的表现，间接地反映了美国的饮食文化，并通过各种元素的运用，对招贴的意义与内涵进行了深层次的拓展，诱发了受众对画面中有限空间的无限想象。

There is a ballad called "Great Cold, Slight Cold, Don't Forget Eating Jiaozi for the Spring Festival." Spring Festival is the most important, most ceremonious and most authentic festival in Chinese traditional culture, while jiaozi is the dominant food for celebration. In this poster, tiles, lanterns, spring festival couplets, ornamentation and a merry dinner scene are put together to create a real visual space with a sense of cultural depth. In this visual space, a cheerful atmosphere of family reunion dinner on Chinese New Year's eve is created which fully reflects the distinctive characteristics of Chinese diet culture.

In the poster of American diet culture design, the designer adopts a special composition which places different people, objects and environments under one situation. The intention again is to set off an atmosphere and express a special feeling. American diet culture is reflected in an indirect way by different images in different windows. The connotation of this poster is extended through an application of various elements, which induces an infinite imagination out of a limited space.

Section 3

学生作品及陈述与教授点评(中国)
Work of Student, Narrative and Professor's Evaluation (China)

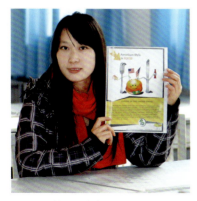

荣 洋 | Yang Rong

设计陈述：
中、美饮食文化主题设计陈述

在作设计之前，我参考了很多关于两国文化的文章，并作了初步的总结，在中国，对于进餐是相当讲究的，通过"吃"的内容和形式可以体现一个人的地位、修养甚至受尊重的程度。而在美国，快节奏的生活让人们无暇过多地讲究这些礼仪，"速战速决"的理念让快餐文化在美国风行。

在这个设计中，我想通过棋子的繁多和棋盘的承载作用来体现中国的地大物博，南北方进餐饮食风格差距较大，菜系繁多，口味各不相同。我将各类菜系和各种口味的饮食文化转化为棋子置于棋盘当中，体现出中国的餐桌文化。

出于文化上的差异，美国进餐则体现的是快餐文化，将汉堡包作为主要元素，并搭配刀叉，刀叉被拟人化，并手中持有美国国旗插在汉堡上面，表示这是美国的方式。图中的食物虽然在西方国家中都是常见的，但是通过刀叉手中的美国国旗可以体现美国的进餐文化。

Design Narrative:
Chinese and American Diet Culture Design Narrative

Before getting down with the design, I read a lot of articles on cultures of the two nations and made a preliminary summary. Chinese people are pretty particular with eating, the contents and forms of

设计陈述
Design Narrative

荣 洋
Yang Rong

which imply a person's social status, self-cultivation, and even the way he is respected. In the fast-paced America, however, an elaborated etiquette is something people have no time to attend to and the pursuit for speed makes fast food culture most popular all over America.

In this design, multiplicity of the chess pieces and loading function of the chess board indicates China's profoundness. With different cuisines and flavors, Chinese diet style varies greatly from south to north. What I am doing is to reveal Chinese dinner culture by comparing different diet cultures to those chess pieces.

Due to cultural differences, American diet poster expresses a fast food culture, with hamburger as the main element and a personified knife and fork on it. Although food in the picture is very common in every Western country, the national flags in the hands of the knife and fork reveal it is American diet culture.

学生作品及陈述与教授点评(中国)

Work of Student, Narrative and Professor's Evaluation (China)

幅员辽阔的中国,因为特定地域的地理环境、气候物产、矿藏资源和特定地域的历史文化积淀等原因形成了南北文化的差异,进而也不可避免地形成了南北饮食文化的不同。作者敏锐地捕捉到这一创意点,并趣味性的将其与中国特有文化之一——象棋联系在一起,不仅直率地表达了中国饮食的"融"与"对",更延伸至中国"酒桌谈判"的文化现象,拓展和深化了主题。

在美国饮食招贴中,作者对美国典型食物与餐具做了卡通式涂鸦,并用拟人化的设计手法和幽默的表现形式表达出了对美国饮食文化的理解。整个画面生动、充满童趣,有效展现了美国人饮食追求轻松、欢快气氛的主题。

China is a country with a vast territory. Regional differences in geography, climate, mineral materials and history inevitably lead to cultural difference between north and south China. The designer grasps this creativity with a sharp eye. Chinese diet culture is ingeniously related to one of the particular Chinese cultures—Chinese chess, which expresses the harmony and contrast between different styles of Chinese diet directly. The extension to Chinese "negotiation at dinner table" culture strengthens the design theme further.

In the poster of American diet, the designer makes graffiti of American fast food and cutlery, and expresses his personal understanding of American diet culture by the employment of personification and humor. The whole picture is filled with children's interests, emphasizing the theme of an easy atmosphere in American diet culture.

Section 3

学生作品及陈述与教授点评(中国)
Work of Student, Narrative and Professor's Evaluation (China)

任　娜 | Na Ren

设计陈述：

中国饮食文化主题设计说明

在中国把饮食看作是一种文化，咀嚼中隐含的是感受文化，享受文化的意境。中国人喜欢欢聚一堂一起吃饭的热闹氛围。中国有句俗话叫"民以食为天"，因此我用元素替代的手法，把"食"字的一撇用筷子代替，同时筷子的图形采用了正负形的形式，突显出中国"龙"的权威象征。因为中国人讲究团圆，所以采用圆桌的造型，把八个"食"字放于桌面，中间放一个碗，碗的底部印有八卦图案，八卦的八个时辰恰好与八个"食"字交相呼应，突显出中国浓郁的文化氛围和中国进餐讲究饮食与文化的双重结合。

美国饮食文化主题设计说明

美国进餐不同于中国，不讲究那么多文化和色香味俱全的结合，他们更注重的是营养。美国式饮食不讲究精细，追求快捷方便，也不奢华，比较大众化，一日三餐都比较随便。美国的饮食发展是向速食方向发展，因此在美国进餐招贴中我采用的是借代的手法，把美国自由女神像手中的火炬替换为麦当劳的袋子，里边飞出来的是美国的各种快餐饮食，如：可口可乐和汉堡，再加以箭头的配饰，突显美国进餐注重快捷方便的特点。

印象中国设计说明

我采用青花瓷为中国印象的主题，突显中国的清新淡雅以及浓浓的中国古韵。我以缥缈山水为背景，衬托出青花瓷的雅而不凡，代表中国手工技艺的高超，同时它的古朴

设计陈述
Design Narrative

任　娜
Na Ren

又凝聚着中国人的高风亮节与修身养性的处事之道。

印象美国设计说明

美国的《独立宣言》给我带来美国印象的设计灵感。自1776年以来，"人人生而平等"作为美国立国的基本原则、人们的信念和理想，就一直为人所传颂。因此，我的设计以美国国旗为背景，体现美国的不拘小节以及开放，同时英文字母表述的是自由、开放、和平等，字母中间印有美国国旗的"嘴"，来展现美国人寻求自由的勇气与强烈的愿望。

Design Narrative:

Chinese Diet Culture Design Narrative

Eating is viewed as a culture in China, where eating experience is also a cultural experience and cultural enjoyment. Chinese enjoy the atmosphere of gathering for dinner. There is a common saying in China called "what matters to people is food", which gives me the inspiration for this poster. I adopt the method of element replacement, where the stroke to the left in Chinese character "shi" (eating) is replaced by the image of a chopstick. Meanwhile, chopsticks are arranged in positive and negative forms to emphasize the authority of Chinese Dragon. Additionally, a pattern of a round table is chosen to symbolize reunion. Eight Chinese characters of "shi" are placed on the table with a bowl in the middle. At the bottom of the bowl there is a pattern of Eight Diagrams, the eight time signs of which are correspondent with the eight Chinese characters of "shi". The intention of this poster is to show a thick Chinese cultural atmosphere and a combination of diet and culture.

American Diet Culture Design Narrative

American diet is different from Chinese diet in that Americans do not emphasize the sense of culture or the combination of color, flavor and taste. What they emphasize is food nutrition and convenience, but not delicacy or luxury. American diet tends to be common and fast with three meals taken in an ease and informal way. In this poster I adopt the method of replacement where the torch in the hand of the Statue of Liberty is replaced by a McDonald bag from which fly out American fast food such as Coca Cola and hamburgers, together with arrows to show the speed and convenience of American diet.

Chinese Impression Design Narrative

In this poster the blue-and-white porcelain is selected as the theme to show a fresh and grace Chinese Impression and an ancient Chinese flavor. Mountains and waters serve as the background to set off the blue-and-white porcelain which represents excellent crafts and a self-cultivation philosophy of Chinese people.

American Impression Design Narrative

I get my inspiration for this poster from the Declaration of Independence. Ever since the foundation of the United States in 1776, as the foundation principle for the nation as well as a social ideal, "all men are created equal" has always been advocated. Therefore, American flag is used as background to reveal America's not bothering about trifles and openness. In addition, freedom, openness and equality is expressed with English words with an image of mouth made of American flag in the middle to symbolize America's brave and strong desire for freedom.

设计陈述　　　　　　　　　　　　　　　　　　　　　　任　娜
Design Narrative　　　　　　　　　　　　　　　　　　Na Ren

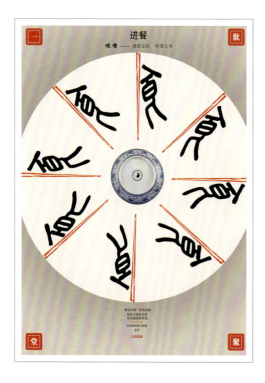

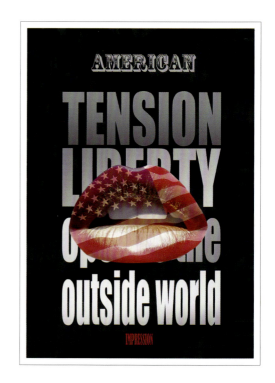

跨文化艺术设计教育尝试

学生作品及陈述与教授点评(中国)
Work of Student, Narrative and Professor's Evaluation (China)

"圆"蕴涵了东方文化的博大精深和各种亚文化间的相互融会贯通，同时也体现在进餐文化中。与食物相比，中国人更追求大家欢聚一堂的温情氛围。作者能够紧扣这一思想主题，将"食"寓于"圆"中。构图严谨但不呆板。在美国饮食招贴中，同样采取元素替代的方法，将快餐元素和图标以散点的方式进行分布，整体构图疏密结合，对比合理，富有节奏感和韵律感。

在中美印象的招贴设计中，作者借用水墨、青花体现中国内敛含蓄的美，借用红唇、国旗体现出美国张扬热情的美，无论是图案、色彩的选择还是文字编排，都具有强烈的地域文化特征。

The shape of a circle implies the profoundness of Oriental culture and a harmony between various subcultures, including Chinese diet culture. Compared with food, a sweet and tender atmosphere of family reunion is something the Chinese crave more. Based on this theme, the designer makes a clever combination of the action of eating and the shape of a circle. The composition is compact but not stiff. As for the American diet poster, the same element replacement method is employed which arranges elements of fast food and logos in a dispersed way. Contrast is made between the compact and the dispersed, which renders a sense of musical rhythm to the poster as a unified whole.

In posters of Chinese Impression and American Impression, ink together with blue-and-white porcelain represents the beauty of modest of China, while red lips and the national flag embody the beauty of passion of America. Distinctive regional characteristics are reflected both in the choice of patterns and colors and in the arrangement of the words.

Section 3

学生作品及陈述与教授点评(中国)
Work of Student, Narrative and Professor's Evaluation (China)

邵 瑜 | Yu Shao

设计陈述：

中国饮食文化主题设计陈述

中华饮食文化博大精深、源远流长。中华饮食文化就其深层含义可以概括成：精、美、情、礼。招贴中有一个鱼形中国结，它是由各种中国的特色小吃拼合而成，因为"鱼形"中国结象征着年年富足，吉庆有余。"结"在中国文化中代表着亲密、团圆。中国结寓意深刻，内涵丰富，是人们表达心语、传递情谊、祈求幸福的吉祥物。招贴整体采用红色，体现出喜庆，再加上鞭炮更让人体验到欢乐祥和的氛围。

美国饮食文化主题设计陈述

汉堡、可乐和薯条是美国进餐中具有代表性的快餐食物，此招贴是从美国的快餐体现出美国的进餐文化的。此招贴上半部分的英文单词"FOOD"是用薯条拼成的，图中的一双手捧着汉堡，体现出了其受欢迎的程度。而手捧着的汉堡正在喝着可乐，也体现出汉堡和可乐的配餐模式。双手后面大小不一的环形就像是慢慢地扩散的水波，象征着美国快餐文化在不断地发展，更多的人正在逐渐地了解美国的进餐文化。

中国印象主题设计陈述

此设计是用有着中国特色的圆形竹窗作背景，前面用毛笔画的中国传统的吊脚楼楼角，而后面一滴墨滴溅到纸上迅速扩染开来。右面是毛笔书法，最前面是中国的国粹戏曲。

设计陈述
Design Narrative

邵 瑜
Yu Shao

运用了国画、书法、戏曲这样有着悠久历史传统的中国元素，体现了中国文化的深厚底蕴和多样化，在整体上运用灰色也体现出了它的神秘色彩。

美国印象主题设计陈述

提到 NBA 大家都会想到美国篮球。此招贴背景用的是一个荒废的工厂的一角，可以让人联想到人们在这里自由自在地享受着篮球运动的快乐。图中的篮球明星和 NBA 标志也能让人意识到美国篮球，让大家想到篮球明星们在赛场上顽强的拼搏精神。招贴下半部分是用美国的星条旗组成的一个太阳，象征着美国篮球运动的蒸蒸日上。

Design Narrative:

Chinese Diet Culture Design Narrative

The diet culture of China is quite profound, owning a very long history. Seeing from its inner meaning, we can summarize the diet culture of China as follows: being refined, elegant, emotional, and courteous. In the picture there is a fish-like Chinese knot made up of many kinds of typical Chinese snacks. As is known, fish-like Chinese knot symbolizes annual prosperity and richness, and "Jie"(knot) means reunion and intimacy in Chinese culture. Chinese knot owns profound meaning and connotation, and it is a mascot that expresses feelings, transfers friendship and prays for blessings for people. The poster is red on the whole, showing a happy and auspicious atmosphere that has been enriched by the firecrackers as well.

American Diet Culture Design Narrative

Hamburger, Coca Cola, and chips are typical fast food of America, so the poster reveals to us the American diet culture by taking such food. The word "FOOD" in the first part of the poster is made up of chips. A pair of hands holding a hamburger shows the popularity of hamburgers, which is drinking Coca Cola, implying hamburger and Coca Cola are combo food. Rings of different sizes behind the hands look like water waves spreading slowly, which means the fast-food culture of America is developing constantly, more and more people are having access to American diet culture.

Chinese Impression Design Narrative

The background of this poster is the round bamboo window with distinctive Chinese characteristics. The front part of the picture is a turret of a traditional Chinese house built on stilts, drawn by Chinese writing brush; and the rearward part is a spatter of ink that is spreading fast on a piece of paper. On the right side it is Chinese brush writing, and in the very front it is Beijing opera. This poster embodies such historical Chinese elements as painting, calligraphy, and opera, showing us the profoundness and diversity of Chinese culture. Furthermore, the soft grey tone of the picture helps add a shroud of mystery.

American Impression Design Narrative

When mentioning NBA, American basketball comes into our mind. The background of this poster is part of a deserted factory, reminding us that we can enjoy the happiness of playing basketball freely here. The basketball star and NBA logo in the picture also remind us of the energetic spirit of those NBA stars. The second part of the poster symbolizing the prosperity of American basketball looks like the sun, which is made up of "the Stars and Stripes".

设计陈述
Design Narrative

邵 瑜
Yu Shao

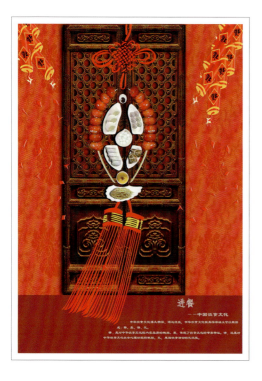

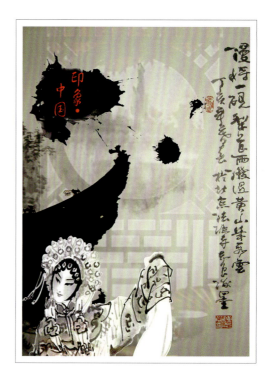

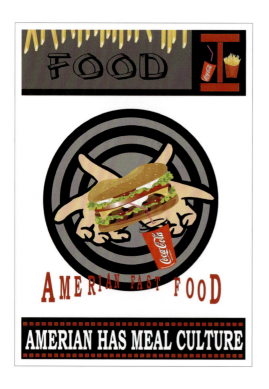

教授点评
Professor's Evaluation

学生作品及陈述与教授点评(中国)
Work of Student, Narrative and Professor's Evaluation (China)

在中国的进餐文化招贴中，作者采用了中国"年年有鱼"的吉祥寓意，整个画面以红色为主色调，营造出了喜庆吉祥的氛围，表达出了中国的饮食特色和风貌。在美国的进餐文化招贴中，以双手托出汉堡的形式形成画面的焦点，烘托出了美国餐饮的典型食品，并将汉堡拟人化地品尝可乐，增加了趣味。另外，通过水波扩散表达了美国饮食向全球的传播之意。在两幅饮食文化的招贴中，作者对相应的元素进行挑选、提取，在表现饮食内容的基础上更注重对饮食文化内在的探讨，注重对饮食文化理念的传播，使招贴具有更深的思想内涵。

在中国印象的招贴设计之中，作者采用中国国粹京剧和书法作为表现对象，背景辅以中国古式窗户，整幅招贴层次丰富，既有京剧艺术的魅力，又有书法艺术的自由洒脱，将中国印象表现得鲜明突出。美国职业篮球享誉世界，尤其是梦之队更是被许多人视为偶像球队。作者以美国NBA篮球联赛作为创意主题来表达其对美国的印象，招贴下部由星条旗构成了一个太阳，构思较为巧妙，传达出了美国篮球蒸蒸日上之意，版式编排错落有序，为我们展示了一个篮球之都的美国印象。

In the poster of Chinese diet culture, the designer makes good use of the symbolic meaning of "Nian Nian You Yu" (annual prosperity and surplus). And the dominant hue is red, which creates a happy and auspicious atmosphere and shows us the distinctive diet characteristics and features of China. In the poster of American diet culture, the highlight is the hamburger held by hands, it is a typical food of America. Furthermore, the image of the hamburger drinking Coca Cola gives a relish to the poster, and the spreading water waves seem to tell us that American diet culture is spreading all over the world constantly. In these two posters of diet culture, the designer has selected and refined those relevant elements. While introducing the contents of the diet cultures, he leads us to conduct an investigation into the inner meanings of them; and most importantly, he pays great attention to publicize the diet culture thoughts, making the posters much more meaningful.

In the poster of Chinese Impression, the designer adopts traditional Chinese opera, calligraphy, and windows, so that the whole picture looks well-arranged, owning the glamour of Chinese opera and the grace of traditional Chinese handwriting. In this way, the impression of China has been displayed vividly and thoroughly. The professional basketball of America is world-famous; in particular, the Dream Team has become an idol in certain sense. NBA is chosen as the design theme of American Impression in the poster, and the sun made up of the American flag is quite creative as well, symbolizing the prosperity of American basketball. As a whole, the layout of the poster is perfectly arranged, showing us the impression of America as a basketball kingdom.

Section 3

学生作品及陈述与教授点评(中国)
Work of Student, Narrative and Professor's Evaluation (China)

史倩倩 | Qianqian Shi

设计陈述：

中国饮食文化主题设计陈述

在中国饮食文化的主题招贴中，我主要从代表中国文化特色的餐具、食物、乐器入手，让三者相结合。青花瓷盘和面条巧妙构成了一个琵琶的形状，呈现出一种古典中国风的韵味，让视觉、味觉和听觉相结合。中国的特色食物——面条被当作琵琶的琴弦，用筷子和热气共同组合成为一个中国特色的琵琶，体现了中国人的进餐是一种享受的过程。

美国饮食文化主题设计陈述

我是从美国食物的角度来表现美国饮食文化的。最能代表美国饮食的就是它的快餐，美国的儿童吃的是汉堡，蜘蛛侠是美国电影里的一个人物，让他去抢汉堡，强调了汉堡是美国人的最爱，代表了美国的快餐文化。美国人很珍惜时间，所以经常吃快餐。快餐没有什么营养，而且有激素，所以导致好多美国儿童得了肥胖症。从而这幅招贴也能起到一种警示作用，要让儿童多吃新鲜蔬菜和水果等健康食品。

印象中国主题设计陈述

这幅中国印象是中华五千年文明历史发展过程的印象。一本打开的古代线装书中装载了从古代到现代的整个过程不断变化的印象。前页上的古代建筑与后页的中国现代高楼大厦形成了鲜明的对比，也体现了中国文化发生的巨大变化，力图把中国丰富的历史文化

设计陈述	史倩倩
Design Narrative	Qianqian Shi

遗产底蕴表现出来。

印象美国主题设计陈述

这幅招贴采用报纸排版的形式来说明美国文化。因为美国的历史比较短暂,没有丰富的文化遗产,所以,我把能代表美国的山姆大叔,标志性雕塑自由女神像,电影明星加菲猫、卓别林和圣诞老人等都排到报纸里,刻意拼贴出一幅招贴,以此来体现美国文化的多样性。我还在报纸上放了一杯咖啡,来代表美国人喜欢喝着咖啡悠闲地看报纸的生活方式,整体采用一种陈旧的色调,把美国的历史和现代结合起来,营造出一种怀旧的气氛。

Design Narrative:

Chinese Diet Culture Design Narrative

In the poster of Chinese diet culture, I start with the typical Chinese dishes, foods, and musical instruments, integrating them into a whole. A Chinese lute is made up of a blue-and-white porcelain dish and some noodles, showing us a kind of classical Chinese charm, combining our visual sense, taste sense and auditory sense together. Noodles, a special Chinese food, are made into strings; together with chopsticks and steam, a Chinese lute is made up, showing us the joy of appreciating Chinese diet.

American Diet Culture Design Narrative

American food is chosen to display American diet culture, and the most typical food is fast food. American children often eat hamburgers, and Spiderman in the film has been asked to take hamburgers, that is to say, hamburger is the favorite food of Americas, it represents the fast-food culture of America. As is known, Americans value time highly, so that they often prefer fast food. But fast food lacks nutrition and contains a lot of hormones, which brings obesity to many American children. In this sense, this poster would also send a warning signal to the children, encouraging them to eat more fresh vegetables and fruits.

Chinese Impression Design Narrative

This poster of Chinese Impression is an impression of the developing process of Chinese civilization during the past five thousand years. An unfolded thread-bound book embodies the history of China from ancient times to present. The ancient architecture on the first page and the modern skyscrapers on the other show us a sharp contrast and reveal the huge change of Chinese culture.

American Impression Design Narrative

Newspaper layout is used in this poster to illustrate American culture. As the history of America is relatively short without rich cultural heritage, so that Uncle Sam, the Statue of Liberty, the popular culture figures Garfield, Chaplin, and Santa are all put into the "paper" to make it into a poster, showing the diversity of American culture. In addition, a cup of coffee is put upon the "paper" so as to display the leisure life of drinking coffee and reading newspapers. The dominant hue of the poster, a little bit dated, combines the past with the present and creates a nostalgic atmosphere.

设计陈述
Design Narrative

史倩倩
Qianqian Shi

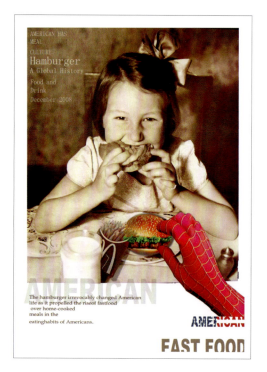

教授点评
Professor's Evaluation

学生作品及陈述与教授点评(中国)
Work of Student, Narrative and Professor's Evaluation (China)

在中国饮食文化招贴中，作者别出心裁地将中国的面食与优美的青花碟组成了一个乐器琵琶，将中国饮食的色、香、味以天籁之音的形式准确地传递出来。版式采用倾斜构图具有张力，较好地呈现出了中国饮食文化特色。在美国饮食文化招贴中，作者表现了美国人对于汉堡等快餐食品的热衷，并表现美国电影人物蜘蛛侠抢汉堡且引申汉堡是"垃圾食品"的内涵，在表现创意上比较直接，视觉效果基本协调自然。

水墨残荷，书法篆刻，中国历史文化悠久，充满了艺术魅力。在中国印象招贴中，将中国文化浓缩成了一本书，从古代水墨画到现代高楼大厦都出现在书中，并用书法和篆刻加以点缀，整个画面充满了中国情调，从时空的视角表现出了其对中国的印象。在美国印象招贴中，作者采用了类似的方式，将美国文化浓缩到了一张报纸之中，从山姆大叔到卓别林，从自由女神到圣诞老人，极具创意，很好地传达出了一种美国式的幽默，将作者对美国的印象直白地展现在我们面前，带给观众的是凝重的历史感和淡淡的怀旧情怀。

In the poster of Chinese diet culture, the designer makes up a Chinese lute by using some noodles and a delicate blue-white porcelain dish, delivering the color, fragrance, and taste of Chinese food through a kind of melodious sound tactically. The slant format enables the poster to be much more edgy, showing the characteristics of Chinese diet culture perfectly. In the poster of American diet culture, the designer pays much attention to American people's preference to fast food. By taking Spiderman's action of plundering hamburgers as an example, he insinuates that hamburger is junk food. The manifestation of the poster is quite direct, and the visual effect is quite natural and harmonious.

Ink and wash, calligraphy and seal cutting, all of these present us the charming, time-honored Chinese culture and arts. In the poster of Chinese Impression, Chinese culture is condensed into a book, in which we can not only find ancient ink-and-wash painting, but also modern skyscrapers. Together with Chinese calligraphy and seal cutting, the whole picture is full of Chinese flavors, and the impression of China is revealed from the angle of time-table. In the poster of American Impression, the designer has adopted the similar way and condensed American culture into a newspaper by taking such figures as Uncle Sam, Chaplin, and the Statue of Liberty, Santa. It is quite creative, and shows us the American sense of humor perfectly, presents the impression of America thoroughly, and gives the audience a strong sense of history and a slight nostalgic feeling.

Section 3

学生作品及陈述与教授点评(中国)
Work of Student, Narrative and Professor's Evaluation (China)

孙铭徽 | Minghui Sun

设计陈述：

中国饮食文化主题设计陈述

"之乎者也"是文言文中最常用的语气词，不仅能代表中华文化的神韵，更能表现以儒家文化为主体的华夏文化温文尔雅的底蕴。作品把"之乎者也"中的"者"字更改为"煮"字，同时和作品中毛笔描绘的砂锅相结合，取其"煲汤"过程中的耐心和享受，使之成为中华饮食的代表。同文言文的温文尔雅相结合，体现儒家的和顺、修身和养性的特点，与欧美的现代文化相比较，更加体现了中国文化的特色。

美国饮食文化主题设计陈述

设计中运用大量美国快餐的代表元素（汉堡、薯条和冰激凌等），充分表现出美国饮食的特点。快餐元素和美国西部小镇景色的有机结合，凸显美国地域特点。美国西部文化是美国文化的代表之一，而自由女神像更是美国著名的地标，这些图像矢量化之后，既不失去美国文化的本来意义，又增加了一些时代感。

Design Narrative:

Chinese Diet Culture Design Narrative

"Zhi Hu Zhe Ye" (literary Chinese, pedantic terms) are those quite commonly used words in the classical

Chinese language, they represent the essence of Chinese culture on one hand, and on the other hand reveal to us the refined and cultivated foundation of the culture centering on Confucianism. In the poster, the word "Zhe" (者) is changed into "Zhu" (煮(cook, boil)). Together with the earthen pot drawn by writing brush, the poster has shown us the patience and enjoyment in the process of "making soup", which has become an important part in Chinese diet culture. The diet culture has combined with the refinement and elegance of Confucianism, reflecting such characteristics of Confucianism as harmony, inner and mind cultivation, showing the features of Chinese culture in comparison with modern Western Culture.

American Diet Culture Design Narrative

A lot of representative elements of American fast food (hamburger, frying chips, ice cream, etc.) are used in the poster to display the characteristics of the American diet. The elements of fast food are combined with the landscape of Western United States, presenting geographical characteristics of America. The culture of Western United States plays an important role in the country's entire culture, and the Statue of Liberty is a famous landmark of the country as well. A vectorization of these elements in the poster does not only convey the original meaning of American culture but also adds a sense of the times to it.

教授点评
Professor's Evaluation

学生作品及陈述与教授点评(中国)
Work of Student, Narrative and Professor's Evaluation (China)

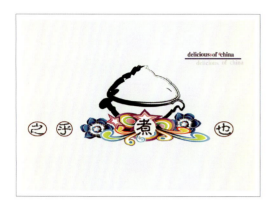

在中国的饮食文化招贴中,作者利用隐喻的手法,用儒家的修身养性比喻中国饮食的精心烹制,立意点有独到之处,很含蓄地表现出了中国的饮食文化特色。特别是标题中将"之乎者也"变成"之乎煮也",让人不禁会心一笑。

在美国的饮食文化招贴中,作者运用了汉堡、薯条、冰激凌等美国快餐的象征元素,并结合了美国自由女神和美国西部小镇的剪影,营造出了一种美国式的饮食文化氛围。画面整体造型巧妙,构图活泼,视觉效果简洁,主题表述清楚。

In the poster of Chinese diet culture, the designer has made use of a metaphor, comparing the inner cultivation of Confucianism to the meticulous diet in Chinese diet culture. It is quite creative, and reveals the characteristics of Chinese diet culture implicitly. In particular, he changes the title "Zhi Hu Zhe Ye" (之乎者也) into "Zhi Hu Zhu Ye" (之乎煮也), which sounds quite humorous.

In the poster of American diet culture, the designer makes good use of such representative elements as hamburger, frying chips, ice cream; and by combining them with the silhouette picture of the Statue of Liberty and the landscape of the countries of Western United States, he creates a distinctive cultural atmosphere of the American diet. The format of the poster looks ingenious and vivid; with clean and neat visual effects, the theme is demonstrated clearly.

Section 3

学生作品及陈述与教授点评(中国)
Work of Student, Narrative and Professor's Evaluation (China)

张 娟 | Juan Zhang

设计陈述：

中国饮食文化主题设计陈述

为了体现"中国味"，作品的背景我采用了具有烟墨效果的"水墨画"。北宋沈括《图画歌》云："江南董源传巨然，淡墨轻岚为一体"。众所周知中国烹饪的标志就是中国的"八大菜系"，"八大菜系"经过长期演变而自成体系，具有鲜明的地方风味特色。在设计中我采用以实物的形式插入画面中，主要是为了体现中国食物的"色"。为了衔接这些毫无关联的食物，我采用了千手观音的形象。在千手观音的带领下，整幅画面具有了动态的美。画面中的字体采用的是中国的古典字体，同时也成为作品的特色之一。作品设计采用了多种中国元素把中国的"八大菜系"有序地连接起来，凸显了"中国饮食文化"的主题。作品中我力图体现虚和实，这样不仅突出了主题，而且让画面整体看来更为丰富。

美国饮食文化主题设计陈述

此设计是针对美国特有的食物和美国进餐习惯设计的。美国食物分快餐、西餐等，此设计中既有快餐中的汉堡和薯条，又有西餐中的红酒和牛排。在食物插图周围有图形作修饰，使得插入的食物图片不会显得单薄，让整个画面更饱满。整个画面的颜色偏向于暖色调，暖色调的使用会让人们在欣赏时觉得食物更可口。在整个画面中如果只有图片是不完美的，所以，我用字体来修饰插入的食物图片，在画

设计陈述
Design Narrative

张 娟
Juan Zhang

面中插入对食物的介绍，一来让画面更充实，二来可以让欣赏者对所对应的食物有一些了解。字体围绕着食物的外形进行排版，使得字体在画面中不生硬，也会给观众留下更深刻的视觉印象。

Design Narrative:

Chinese Diet Culture Design Narrative

In order to embody the Chinese characteristics, ink-and-wash painting has been employed in the poster. In his Song of Painting, Shen Kuo wrote like this, "Dong Yuan from the south owned great reputation, and the hues of his ink-and-wash painting are in perfect combination." As is known, the symbol of Chinese diet is the so-called Eight Cuisines, for they have established their own systems with regional characteristics. Realistic photos of foods are put into the poster to display the visual beauty of Chinese food. In addition, the image of the Thousand-hand Buddhist Goddess of Mercy has been hired to join together those separate foods, in this way; the whole picture looks dynamic as well. The characters (words) used in the picture are traditional Chinese characters, being distinctive point of the design. In this poster, many kinds of Chinese elements are used to join together the eight big cuisines, emphasizing the theme of Chinese diet culture. Besides, realistic objects and visional ones are combined together so as to show the theme and to make the poster fulfilled.

American Diet Culture Design Narrative

This poster is based on typical American food and diet habits. American food can be divided into fast food, western food and so on. For this reason, there are not only hamburger and frying chips, but also red wine and beef steak in this poster. The illustrations of foods are surrounded and decorated by delineations, so that they wouldn't be dull or monotonous, making the whole poster fulfilled. Besides, the poster is in warm color as a whole, which makes the foods seem much more delicious. A poster that is characterized only by pictures is not a perfect one, therefore, some words are added in the food illustrations, making the frame much more fulfilled on one hand, and providing some information for the audience on the other hand. Those words are skillfully laid out around the food illustrations, without dullness; meanwhile, which would help to strengthen the visual impressions of the audience.

教授点评
Professor's Evaluation

学生作品及陈述与教授点评(中国)
Work of Student, Narrative and Professor's Evaluation (China)

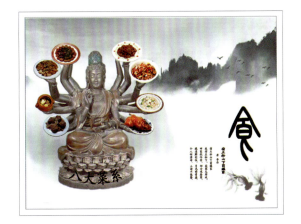

中国的烹饪技艺历史悠久，经历代名厨传承至今，形成了各具特色的鲁、川、苏、粤、闽、浙、湘、徽八大菜系。作者巧妙地将这八大菜系与千手观音的形象相结合，既展现出中国饮食的丰富，又隐喻了中国饮食"安乐"的文化精髓。水墨式的背景和书法艺术形式等细节刻画，不仅强化了主题文化氛围，而且表现出了中国饮食与中国文化息息相关的特点。

在美国饮食文化招贴中，作者将美国的西餐和快餐的典型食品都排列于画面之上，既有汉堡和薯条，又有红酒和牛排，同时将图形与字体配合排列，画面信息清晰、流畅，视觉效果舒展。

Chinese diet has a very long history, passed down from generation to generation; it has developed into eight big cuisines: Shandong cuisine, Sichuan cuisine, Jiangsu cuisine, Guangdong cuisine, Fujian cuisine, Zhejiang cuisine, Hunan cuisine and Anhui cuisine. In the poster, the designer has combined the eight big cuisines with the image of the Thousand-hand Buddhist Goddess of Mercy, having shown us the numerous varieties of Chinese food and implied the essence of peace and happiness in Chinese diet culture. The ink-and-wash background and handwritings have promoted the cultural atmosphere on one hand, and have on the other hand revealed to us the undeniable relationship between Chinese diet and culture.

In the poster of American diet culture, there are not only such fast foods as hamburger and frying chips, but also red wine and beefsteak. Characters subordinating to the pictures are laid out skillfully so that the poster looks smooth and explicit with comfortable visual effects.

Section 3

学生作品及陈述与教授点评(中国)
Work of Student, Narrative and Professor's Evaluation (China)

孙文静 | Wenjing Sun

设计陈述：

中、美饮食文化主题设计陈述

美国饮食文化招贴的视觉元素主要是以围绕麦当劳的快餐形象主题进行设计的，表现形式多元化，从侧面映射出了美国多元化发展的特点。表现中国饮食文化的招贴则体现了中国悠久的传统文化。自古以来，中国地大物博，天南海北的菜肴各具特色。我采用南方的粥作为画面的主体，加以传统的盘子、筷子充盈画面，主次得当。美国进餐的背景用手绘的形式使画面灵活生动，创意点之一在于汉堡的投影为麦当劳标识"M"，用一句"我喜欢麦当劳肯德基，它们来自美国"的英文组成，其中尤为突出 USA。其次，在右上角的标识设计上我用真实的薯条和番茄酱摆拼出麦当劳标识，更加直观，形象和生动。

印象中国、印象美国主题设计陈述

美国印象的主题设计主要以文字为主。对于美国，我印象最深的就是它强大的经济实力，还有就是很多人熟知的著名建筑物。我的设计创意是把麦当劳叔叔替换到美元上，然后组成美国的英文缩写作为画面的第一视觉中心。而我对于中国文化的了解远远超出了美国文化。画面的主色调以中国红为主色，喜庆祥和，其次在印象美国的招贴中我利用自由女神像和白宫的外形，通过巧妙的设计把关于这两个建筑物的英文与其自身的形象相结合，有近有远，相互呼应。背景是把国旗和美国地图相结合，用一只飞翔的鹰表现

设计陈述
Design Narrative

孙文静
Wenjing Sun

美国是一个富有魅力的国家。在中国印象的主题设计中，我运用古代城墙、城门、石狮和中国结等传统元素的结合，通过错落有致的排列，以"开门红"的文字与图片穿插放置，充分体现了中国文化的内涵。

Design Narrative:

Chinese and American Diet Culture Design Narrative

The visual elements in the poster of American diet culture originate from the fast-food image of McDonald. The diverse forms of expression in the poster has indirectly reflected the diversifying development of American culture. The poster of Chinese diet culture has reflected the traditional Chinese culture with a long history. Down the ages, China owns a vast territory with rich resources, and the foods from all over the country differ from one another. The southern porridge is the main subject of the poster, together with the traditional plate and chopsticks, making the whole picture concordant. The background of American diet poster is drawn freehand, so that the whole picture looks much more lively and vivid. The highlight of this poster is the shadow of the hamburger, for it looks like McDonald's logo "M", which is made up of one sentence, "I like McDonald and KFC, they are from U.S.A.." Furthermore, in the upper right corner of the picture, the logo is composed by frying chips and tomato sauce, and it looks like the logo "M" of McDonald, being intuitive, lively and vivid.

Chinese and American Impression Design Narrative

The design theme of American Impression focuses on characters (written words). When mentioning America, its powerful economic strength comes into our mind first, together with those famous buildings. In this poster, I put Mr. McDonald onto the American dollar, composing the name of the country-U.S.A.-by making use of these "dollars". This is the first visual point of the poster. As for Chinese culture, I am quite familiar with it, and the dominant hue of the poster is red, being auspicious and harmonious. Then in the poster of American Impression, the Statue of Liberty and the White House are employed, and their English names and images are well-combined so that they look quite concordant. The background is made up of the national flag and map of America, and a flying hawk implies that America is a captivating country. In the poster of Chinese Impression, such traditional elements as ancient wall, gate, stone lion, and Chinese knot are combined together and well-arranged. Woven with the words and pictures of "Kai Men Hong" (开门红), the poster has revealed the connotation of Chinese culture thoroughly.

设计陈述
Design Narrative

孙文静
Wenjing Sun

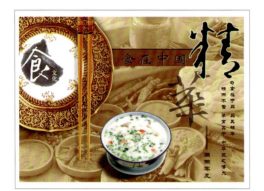
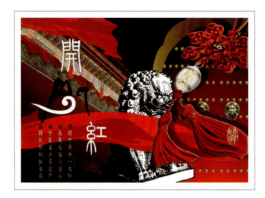
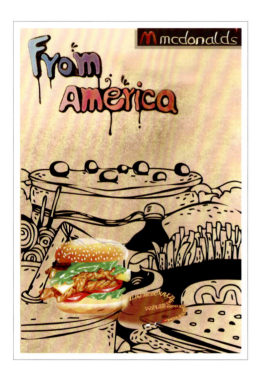
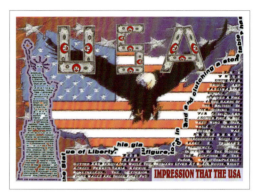

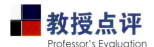
教授点评
Professor's Evaluation

学生作品及陈述与教授点评(中国)
Work of Student, Narrative and Professor's Evaluation (China)

在中国主题招贴上所运用的粥、盘子、筷子和城墙、城门、石狮、中国结等视觉元素，不仅展现了中国的特色文化，更体现出了中国文明的丰富与多元。版式的编排上注重空间的解构、穿插叠加，使得画面比较丰富，但是由于对虚实、大小、节奏的处理不足,使得画面略显凌乱和呆板。相反，在美国主题招贴设计中，作者采取了线条与图片结合的表现方式，形式新颖合理，设计中注重细节的处理，使得画面更加生动形象，主题表达更加突出，传达了作者对美国经济文化的突出印象。

In the posters of Chinese diet culture and Chinese Impression, such visual elements as porridge, plate, chopsticks, ancient wall, gate, stone lion, and Chinese knot have not only shown the characteristics of Chinese culture but also the diversification of it. As for the format, the spatial structure looks multi-layered and substantial, but a little bit messy and stiff, because the manipulation of the contrast between realistic and visional elements is not that perfect, and the handling of the dimension and rhythm of those elements also needs improving. By contrast, in the posters of American diet culture and American Impression, the designer has combined lines of characters with pictures, making the posters be creative. In the process of designing, a lot of attention has been paid to the details, so that the picture looks much more lively and vivid, showing us the designer's indelible impression of the economy and culture of America.

Section 3

学生作品及陈述与教授点评(中国)
Work of Student, Narrative and Professor's Evaluation (China)

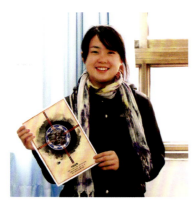

王春梅 | Chunmei Wang

设计陈述：

中国饮食文化主题设计陈述

中国是文明古国，饮食文化源远流长。在中国，任何一个筵席都是大家团团围坐，共享一席。筵席所用的圆桌，从形式上就营造了一种团结、礼貌、共趣的气氛。美味佳肴放在一桌人的中心，它既是一桌人欣赏、品尝的对象，又是一桌人感情交流的媒介物。人们相互敬酒，相互让菜、劝菜，在美好的事物面前，体现了人们之间相互尊重、礼让的美德。虽然从卫生的角度看，这种饮食方式有明显的不足之处，但它符合中华民族"大团圆"的普遍心态，反映了中国古典哲学中"和"这个范畴对后代思想的影响，便于集体的情感交流。此次设计采用中国特有的餐具筷子和青花瓷盘，以及用饺子这种特有的食物来表现出中国的"和"的内涵。

美国饮食文化主题设计陈述

快餐是典型的美国饮食文化，十分普及，被称为"快餐国度"。美国饮食的发展方向是向速食发展，他们的蔬菜大都生吃，营养不会损失，更主要的是省时间，而作为一种省时间的食物，麦当劳是他们的首选，所以背景色选用了麦当劳的颜色，而主体物则用了美国快餐的代表"汉堡"，加上刀叉，突出美国的快餐饮食文化。

印象中国主题设计陈述

水墨丹青一直被视作中国文化的代言品，它流动的特性与丰富的墨色层次，唤醒了我们追求自然的归属感，形成印象中国系

设计陈述
Design Narrative

王春梅
Chunmei Wang

列之"水墨印象"。水墨山水相互呼应,丹青的悠然和印玺的神圣等古典元素的完美结合,使整个设计氛围形神之间若隐若现、自然朴素……

这个设计没有斑斓的色彩,仅以黑、白、灰为基调,更采用丹青手笔大片留白,隐喻了中庸之道,使视觉冲击上更觉蕴含无穷力量……

印象美国主题设计陈述

谈到美国,很多人会一下子想到自由女神像,所以把自由女神像放到招贴的显著位置,让人一看,就能嗅出美国的味道。背景采用浓重的颜色衬托出美国历史的发展,而背景的下部则采用了美国的总统山。每当人们游览此地时,抬头仰望以蓝天白云为背景的浅灰色花岗石头像,他们脸朝不同的方向,彼此和谐地呼应着,四周被气势雄伟的层峦叠翠所环绕,使人顿生景仰之情。如今,拉什莫尔国家纪念碑频繁地出现在描绘美国生活和风光的影视作品及图片中,成为美国的重要象征之一。

Design Narrative:

Chinese Diet Culture Design Narrative

China is a country with an ancient civilization, so that the diet culture also owns a long history. In China, people sit in a circle in a banquet, enjoying the dinner together. The round table gives people a mood of union, courtesy, and sharing. Delicious foods are put onto the round table, being the objects of enjoying as well as the media of emotional contact for the people sitting around. They propose toasts and encourage each other to eat, demonstrating the virtue of mutual respect and comity. Though, in terms of health, this kind of diet is not advisable, it is in accordance with the acknowledged idea of Reunion in Chinese culture. It reflects the classical Chinese philosophic idea of "harmony", and it is a platform for emotional contact. In this poster, the typical Chinese dishes-chopsticks and a blue-and-white porcelain—are employed, and jiaozi is also used to illustrate the connotation of "harmony" in Chinese culture.

American Diet Culture Design Narrative

Fast food has formed a typical American culture, and it is so popular that the country has been called "the fast-food country". The development of American diet is fast-food oriented; Americans eat raw vegetables most of the time, for the nutrition of the food does not lose when eaten this way, and most importantly, fast food can help them save time. For this reason, McDonald has become their preference; so that in this poster the color of the background is that of McDonald's, and the main subject is the typical hamburger with a pair of knife and fork, showing the fast-food characteristics of American diet culture.

Chinese Impression Design Narrative

Ink-and-wash painting has always been regarded as the spokesman of Chinese culture; it looks liquid with ink color, arousing in our mind a sense of belongingness to nature. Ink-and-wash impression is one part of the overall Chinese Impression. Ink and wash combine with painting and seals, all of these classic elements enable the poster to be visional and natural.

The poster is not colorful, and the dominant hues are black, white and grey, insinuating the idea of moderation and producing dynamic visual impacts.

American Impression Design Narrative

When mentioning America, the Statue of Liberty often comes into our mind. In the poster, the Statue of Liberty has been put in a remarkable position so as to show people the features of America at first sight. The background has a bright color, demonstrating the development of American history; and the lower part of the background is Mount Rushmore. When visiting this place, tourists would hold in view the light grey granite head-sculptures set in a background of blue sky and white clouds. Surrounded by a range of hills and mountains, the sculptures face to different directions, arousing a sense of respect and admiration in the audience's heart. Today, Mount Rushmore National Memorial can be found in many pictures, films and television programs that describing American scenery and life, it has become a most important symbol of the country.

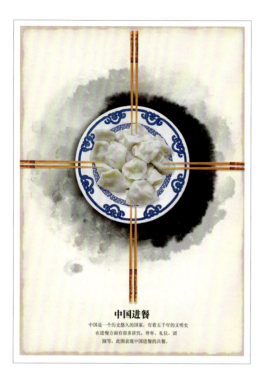
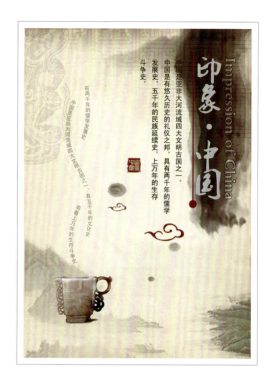
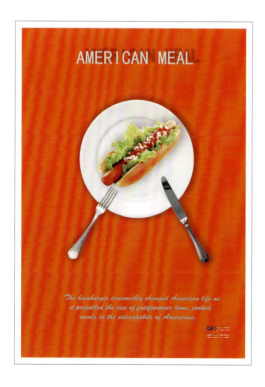
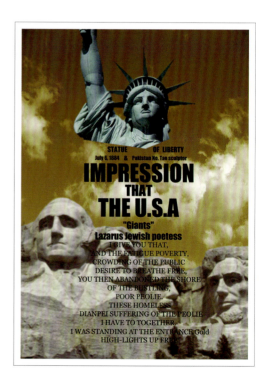

教授点评
Professor's Evaluation

学生作品及陈述与教授点评(中国)
Work of Student, Narrative and Professor's Evaluation (China)

作者系列招贴的设计形式比较统一，并通过对大量的中美元素进行典型提取与精炼，利用各种元素的穿插、层叠构图，传达出不同地域的文化特征，画面丰富充实。

在印象中国招贴中，作者采用了山水画和笔墨形式构成了画面的底色，以中国的儒家文化作为表现主题，引入了壁画、古代的杯子、纹饰等设计元素，并通过点、线、面的编排形式，表现出了中华文明古国的印象。在印象美国招贴中，作者以美国自由女神像和拉什莫尔国家纪念碑这两个美国的象征物凸显了美国文化。版式编排采用中轴式排列的形式，表现了庄严、肃穆、宏伟的美国印象。

The styles of these posters are homologous. By taking and refining a lot of typical elements from Chinese and American culture, the designer has produced some perfect pictures with different structures overlapped and different elements interspersing with each other, revealing to us the cultural features of different regions.

In the poster of Chinese Impression, landscape paintings together with ink-and-wash paintings have made up the background, and Confucianism is the theme. In addition, frescos, ancient cups, and decoration lines are used, showing us the impression of a country with an ancient civilization. In the poster of American Impression, the Statue of Liberty and Mount Rushmore National Memorial are employed to reveal American culture. As for the shaft-arrangement of the format, it is in central symmetry, demonstrating a majestic, grave and state image of America.

Section 3

学生作品及陈述与教授点评(中国)
Work of Student, Narrative and Professor's Evaluation (China)

王晓庆 | Xiaoqing Wang

设计陈述：

中国饮食文化主题设计陈述

在做这个主题作品时，我将中国的太极拳和中国的拉面结合在一起，表现的是中国人吃饭更多的是一种享受，是一种意境，是五千年文化所积淀下来的值得人们去品味的文化底蕴。将打太极拳和拉面的人物作主体，表现的不仅仅是进餐，而是内涵。

美国饮食文化主题设计陈述

关于美国的饮食文化，我选取了具有美国特点的可口可乐和西方人在饮食当中经常食用的汉堡包，将文字编排成可口可乐的喷洒效果，使整体排版风格活跃。背景色采用美国国旗红色、蓝色、白色，更能表现美国的特点。

中国印象主题设计陈述

对于印象中国的主题设计，我采用了具有中国传统文化特点的红墙绿瓦。在做这幅作品时，我不时的想起小时候玩耍的情景，那种亲切感不断地充斥着我的思维，用代表中国的传统红色为主体色调，明确了主题，将为主题做的印象标志放置在中间，以中英两种字体表现，说明了中国现在在国际上有很高的地位；同时我还将中国人家喻户晓的元素列在其中，例如雷锋、红绿灯、香港等，从人文、社会、环境等方面说明对中国的印象。

设计陈述
Design Narrative

王晓庆
Xiaoqing Wang

美国印象主题设计陈述

对于印象美国这幅作品，我更多地考虑到的是美元，所以我选取美国纽约证券交易所做整幅作品的主体部分。这是很多人的梦想之地，是世界经济的中心；这里能使人一夜成为百万富翁，也可以让人一夜成为穷光蛋。在作品的中心部分是为这个主题做的印象标志，以中英两种文字体现，紧密地围绕主题；在整幅作品的顶部我选取了美国金门大桥、著名影星麦当娜等形象，借以表现美国的多元文化。

Design Narrative:

Chinese Diet Culture Design Narrative

In this poster, tai chi and hand-pulled noodles are joined together, showing us that the diet of China is not only some kind enjoyment, but also an artistic and poetic conception, and it is cultural deposits worth appreciating. The person who is playing tai chi and making hand-pulled noodles takes up a large part of the picture, revealing to us not only the diet, but also the connotation of Chinese culture.

American Diet Culture Design Narrative

When it comes to American diet culture, Coca Cola with typical American features and hamburger that is quite popular in Western diet stand out. In the poster, the written words are laid out in the shape of water spray, and the layout style is active and lively. The colors of the background are that of the national flag of America---red, blue and white, demonstrating the characteristics of America effectively.

Chinese Impression Design Narrative

In the poster of Chinese Impression, the traditional Chinese red walls and green tiles are employed. When designing the poster, the memory of my childhood emerges, and the cordial feeling occupies my mind. The dominant hue is traditional red which specifies the theme; the impression mark of the theme is put in the center and illustrated by both Chinese and English words, implying that the international status of China has risen notably. Meanwhile, such household elements as Lei Feng, traffic lights, Hong Kong, are put into the picture as well, showing us the impression of China in terms of humanity, society, environment, etc.

American Impression Design Narrative

When designing the poster of American Impression, I take American dollar into consideration and has made New York Stock Exchange the main body of the picture. NYSE is the center of the world economy and a dream place of many people; here one may become a millionaire overnight from poor, and vice versa. In the center of the picture lies the impression mark, it is made up of Chinese and English, centering on the theme. In the top there are such images as Gold Gate Bridge, the famous film star Madonna, and so on, showing the diversification of American culture.

设计陈述
Design Narrative

王晓庆
Xiaoqing Wang

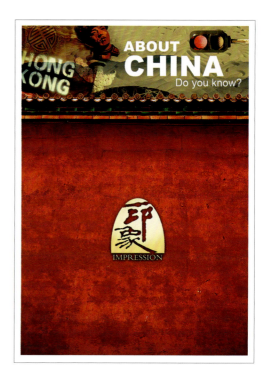

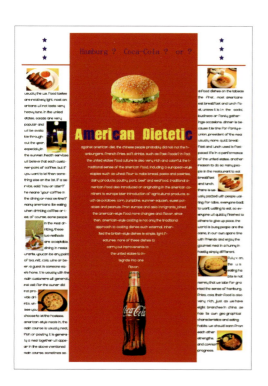

教授点评
Professor's Evaluation

学生作品及陈述与教授点评(中国)
Work of Student, Narrative and Professor's Evaluation (China)

在中国饮食文化招贴中，可以看出作者很留意对日常生活观察，细心地发现了做拉面的动作与打太极拳的动作有相似之处，并以此为创意，将中国太极的意境融入到了中国饮食文化之中，通过硕大的"和"字与精致小字的纵向编排形成对比，同时人物的实和笔墨的虚形成虚实对比，层次效果丰富，表达出了中国饮食的文化品位和博大精深。在美国饮食文化招贴中，作者选取了美国的可口可乐和汉堡两种最典型的快餐食品作为设计元素，版面编排虽采用了中轴式排列的形式，但是通过精心编排达到了文字由可口可乐喷射出的效果，从而打破了呆板的格局，用直接的视觉语言表现出了美国进餐文化的特点。

在高楼林立的今天，红墙绿瓦似乎已经成为历史的缩影，但是却依然停留在每个人的记忆深处。在印象中国招贴中，红墙绿瓦成了创意的主题，通过大面积的红墙和小面积的"印象"二字形成了鲜明对比，给人以舒畅的红色印象，在红墙绿瓦之上又附以中国古今的一些人和事物，亦增添了招贴的中国味道，整个设计简洁大方。在印象美国招贴中，与印象中国招贴采取相同的设计手法，传达出了美国是世界经济中心的印象，在交易所建筑上方，选取了金门大桥、影星麦当娜等形象表现出了美国文化的多元性。

In the poster of Chinese diet culture, we can find that the designer pays a lot of attention to the very details of daily life. He has found that the movements of playing tai chi had some similarities with the movements of making hand-pulled noodles, so that he has blended tai chi into Chinese diet when designing the poster. The big Chinese character "he"(harmony) is in contrast with the delicate small words, and the focused person is in contrast with the vague-visional drawing style, so that the picture looks hierarchical, showing us the richness and profoundness of Chinese diet culture. In the poster of American diet culture, Coca Cola and hamburger are chosen as elements; the picture lays out in central symmetry of shaft-arrangement, but the water spray of Coca Cola has broken the dull structure, demonstrating the characteristics of American diet culture through a straightforward visual language.

Surrounded by skyscrapers, red walls and green tiles have become an epitome of history today, but still kept in our memory. In the poster of Chinese Impression, the design theme and highlight is the use of red wall and green tiles, and the huge red wall is in contrast with the two small characters "yin xiang"(impression), sending to us a comfortable image. Upon the red wall and green tiles there are some figures and some other things from ancient times to the present, which have added some Chinese features to the poster and made the whole poster look much more humble and majestic. In the poster of American Impression, the design method is similar with that of the poster of Chinese Impression. This poster shows us that America is the economic center of the world; besides New York Stock Exchange, there are Gold Gate Bridge, the film star Madonna, and so on, these elements have demonstrated the diversification of American culture.

Section 3

学生作品及陈述与教授点评(中国)
Work of Student, Narrative and Professor's Evaluation (China)

王昱懿 | Yuyi Wang

设计陈述：

中、美饮食文化主题设计说明

我选择美国的快餐文化来进行美国饮食文化主题的招贴设计，并把美国的饮食文化用风向标的形式展现出来。西方的饮食讲究快捷便利，但也十分讲究营养搭配。

其实，我们都知道美国的历史很短暂，历史文化的积淀不深，大部分继承了欧洲的文化，并经过自身的演变发展而来的。但是，由于美国人生活节奏较快，快餐文化应运而生。在中国最常见美国快餐是肯德基和麦当劳，这些快餐便利了大众，同时也抢占了中国大部分的快餐市场。

在喧嚣的美国都市，高楼林立，因此，我以高低错落的美国都市剪影作为画面背景，井然有序的交通和人群作为前景。画面正中赫然出现了一个道路指示牌，并把它演变成一个承载了美国多种饮食的风向标，鲜明独特又具有时尚气息。风向标上多种饮食汇集：牛扒，薯条等分别运用营养、快捷等符号替代，简洁明快。

在中国饮食文化招贴设计中，我运用中国的历史元素，例如：青花瓷、筷子和碗等错落有致的摆放，将其打乱而再次排列组合，已达到招贴的时尚感。大部分的毛笔字作为背景，表现了传统的中国文化，既有内涵又有韵味。

印象中国、印象美国主题设计说明

我的设计重点主要是着眼于由美国带动的第三次工业革命，第三次工业革命是电子信息技术的革命，但仍然传承了第一、二次工业革命的成果。画面主色以黑、蓝、红为主。巨大的工业怪人占据画面的一大部分，其带着

设计陈述
Design Narrative

王昱懿
Yuyi Wang

帽子，拄着拐杖，身披长衣的资本主义政客形象恰当地展示了美国的社会制度，背景是层层叠叠的工厂烟囱不时冒出滚滚浓烟，在处理这些图形时，我运用了打印特效增强画面的厚重感，不乏韵味。

美国天空的颜色则选用了偏桃红的蓝色，营造出了一种巨大的工业城市给人带来的沉重感和压抑感，令人窒息。文字与画面的穿插增强了画面的观赏性。首行文字的运用规范得体，强调的是一种压迫感，与画面整体表达相协调。下面的文字选择了能柔和画面紧张感的轻松明快的字体，时尚感十足。

在印象中国文化招贴设计中，我采用了最具有代表性的笔墨纸砚，背景以宣纸的质感为主要基调，毛笔的墨痕洋洋洒洒，独树一帜，给人以强烈的视觉冲击力和民族韵味，并将书画工具与文字相结合，温婉大气。在制作过程中，我体验到了很多中国文化的传统精髓，在设计的同时也学到了很多知识，并得以通过我的作品来表达中国五千年的文化传统和展现浓重的历史气息。

Design Narrative:

Chinese and American Diet Culture Design Narrative

This poster of American diet culture is based on American fast food, illustrating the diet culture by making use of a wind vane. The Western diet is particular over convenience and quickness, meanwhile, pays much attention to nutrition.

As is known, the history of America is relatively short, and the foundation of its historical and cultural heritage is not profound. Inherited from Europe and cultivated by themselves, American culture has taken its own shape. The fast-paced life style of Americans has brought fast-food culture into being. In China, we can also find a lot of McDonald and KFC restaurants, which have been facilitating our life, but at the same time have taken up most of the fast-food market of China.

The noisy cities of America are crowded with skyscrapers. For this reason, the background of this poster is the cityscape, and the foreground is a scene of orderly traffic and crowd. A signpost stands in the front and looks like a wind vane carrying various kinds of American foods, being unique as well as fashionable. Upon the wind vane, we can find such foods as beef-steak, frying chips, which are convenient and rich in nutrition.

In the poster of Chinese diet culture, such historical Chinese elements as blue-white porcelain, chopsticks, and bowl are employed and laid out disorderly but coherently, making the poster fashionable. The background is Chinese characters written with brush, showing us the connotation and accents of traditional Chinese culture.

Chinese and American Impression Design Narrative

As for the poster of American Impression, I focus on the Third Industrial Revolution(Information Technology Revolution) driven by America. The Third Industrial Revolution is also information technology revolution, but it has inherited the accomplishments of the first and the second industrial revolution as well. The dominant hues of the picture are black, blue and red. A big odd figure of industry occupies a large part of the picture, wearing a hat and leaning on a stick, and this image of a capitalism politician demonstrates the social institution of America. And the background of the poster is made up of a range of chimneys puffing heavy smoke. In addition, printing effects are employed in the design so as to promote the sense of steadiness of the poster.

The sky above America is blue, with a little bit pink, so that the huge industrial city seems to exert upon us a feeling of depression and oppression. The crisscross of characters and pictures has helped to improve the visual effects of the poster. The top line of characters is standard, emphasizing the feeling of oppression, and they are concordant with the overall tone of the poster. The characters below look much more smooth and lively, relieving the stress of the picture, keeping abreast with the times.

In the poster of Chinese diet culture, the four treasures of the study, i.e. the writing brush, the ink, the ink-stone, and the paper, are employed. The texture of China paper fulfills the background; and the writing of brush runs like dragons and snakes, showing us dynamic visual effects and the

unique national features. As a whole, the combination of characters and painting tools has made the poster gentle but magnificent. In the process of designing, I witnessed the essence of traditional Chinese culture, and got to learn a lot from it. All in all, this poster has revealed to us the five-thousand-year history and cultural tradition.

学生作品及陈述与教授点评(中国)
Work of Student, Narrative and Professor's Evaluation (China)

在印象美国招贴中，作者将资本主义政客化身为工业怪人，并且附以工厂的浓浓黑烟，表现出了工业带给人们的一种沉重感和压抑感。在印象中国招贴中，选择了书法艺术这一中华艺术宝库的瑰宝作为创作主题，通过笔、墨、纸、砚的编排组合展现了中国书法艺术的魅力和厚重的历史感，营造出了一种浓浓的书香情怀和文化风韵，恰当地表达了印象中国的文化特点。

In the poster of American Impression, the designer has changed a capitalism politician into an odd person of industry and added heavy smoke to the background as well, implying that industry has brought to us a sense of depression and oppression. In the poster of Chinese Impression, the design element is the traditional Chinese handwriting, whose charm and historic sense are revealed to us through the combination of the four treasures of the study. The academic atmosphere and cultural flavor of this poster demonstrate the impression of China perfectly.

Section 3

学生作品及陈述与教授点评(中国)
Work of Student, Narrative and Professor's Evaluation (China)

姚可心 | Kexin Yao

设计陈述：

中、美饮食文化主题设计陈述

从餐具来看，筷子与刀叉影响了东西方不同的生活理念，形成了饮食习惯的差异。刀叉必然带来分食制，而筷子匹配于家庭成员围坐桌边共同进餐。西方人习惯于分食进餐，由此衍生出西方人讲究独立，有子女成年后独自闯世界的传统习惯。而筷子带来的合餐制，突出了老老少少坐一起的家庭气氛，从而让东方人拥有了比较牢固的家庭观念。

我的设计便以此为中心，将中国的聚餐制与美国的分餐制进行对比。版式中选用了5个青花瓷盘作为主要元素，四周摆放着四双筷子，体现家人围坐的概念。为了避免单调乏味，我对盘子中的花纹进行了特效处理，做成中国传统水墨风格的梅兰竹菊图案，中间的盘子选用中国结的造型图案。每个图案都与青花瓷餐具本身的质感、颜色相匹配，实现了每个个体在整体统一中各具特色。筷子的摆放在整张作品中呈放射状，给观者以扩散的视觉感受，盘子的组合体现了"聚"的主题，盘子与筷子的整体组合又像一个中国结，实现了布局的完美呼应。背景采用中国红作为主色调，尽显民族特色。为了使画面更富有层次感，背景填充了径向渐变，使中心的主体更为突出。在美国饮食文化主题的设计中，我采用了四套西式餐具分开摆放，体现分餐制。刀叉的表现方式与筷子相同，使用简单线条勾勒，填充白色，简洁明快，一目了然，二者形成对比与映衬。背景选用

设计陈述
Design Narrative

姚可心
Kexin Yao

美国国旗主色调蓝色，充分体现了美国特色的进餐习俗。

印象中国、印象美国主题设计陈述

经过认真思考和调研，了解了由美国起源和发展的嘻哈街舞 Hip-hop。于是，我决定在美国印象的设计中选用以 Hip-hop 为主题的报纸全版设计。设计中选用图文并茂的形式，以文字为主，图形为辅，主要以黑白色进行对比，彰显美国黑人青年的时尚与跃动，添加辅色及简单元素创造轻松、活跃和动感的气氛，使观者虽然没有听到音乐却已经感受到舞动的节奏，起到了视觉的传播效果。为了避免呆板，文字排版中部分设计打破常规，进行颜色、形状及排版的变化尝试。

印象中国选用了京剧为主题，京剧是中国的传统戏曲之一，其历史源远流长，发展延续至今，其内涵之丰富，影响之宽泛，已经成为中国最具代表性的艺术形式之一。它集曲词、音乐、美术、表演的美为大全，充分调动了各种艺术手段的感染力，相互烘托，达到和谐统一的意境，形成了中国独有的、节奏鲜明的表演艺术。京剧凝聚着中国传统文化的美学思想精髓，在世界戏曲舞台上闪耀着独特的艺术光辉。中国被誉为制扇王国。中国扇文化有着深厚的文化底蕴，是民族文化的一个集成部分，它与竹文化、佛教和道教等文化有着密切关系。文字借用扇形编排，尽显中华民族丰厚的文化底蕴和独特的东方魅力。

Design Narrative:
Chinese and American Diet Culture Design Narrative

In terms of dishes, the chopsticks and the knife and fork reflect different life styles between the East and the West, for they have brought into different diet habits. The knife and fork has aroused the individual serving system, while the chopsticks mean coordination and harmony between all family members. The westerners get used to eating separately, which has led to the independent characteristics of them, when being of age; adults would get into the world independently. The chopsticks, on the other hand, has brought into the idea of eating together, emphasizing the family atmosphere. For this reason, the concept of family is much steadier in the East.

Based on the contrast mentioned above, a comparison between Chinese diet culture and American diet culture has been illustrated here. In the poster of Chinese diet culture, five blue-white porcelain dishes make up of the main elements of the picture, while the four pairs of chopsticks laid out around the dishes, telling us that family members are sitting together. The patterns of the dishes are traditional Chinese ink-and-wash paintings—Plum, Orchid, Bamboo and Chrysanthemum; and the dish in the very center also has the pattern of a Chinese knot. Every pattern matches well with the texture and color of those dishes, which means each one is concordant with the others in the whole picture. The chopsticks are laid out in a radial pattern, sending to the audience a diffuse visual effect. The assembly of the dishes implies the theme of" union"; while the combination of dishes and chopsticks looks like a Chinese knot, corresponding to the overall layout of the poster. Chinese red is the dominant hue of the background, demonstrating the national characteristics thoroughly. In addition, Radial Gradient has been employed in the background so as to make the frame look hierarchical, emphasizing the theme. In the poster of American diet culture, four sets of knife and fork are laid out separately, implying the Western individual serving system. The manifestation mode of the knives and forks is similar with that of the chopsticks; besides, the simple linear construction and white color are very simple and concise, in contrast with each other. The background hue is blue, the color of American flag. All in all, this poster has revealed to us the American diet culture perfectly.

Chinese and American Impression Design Narrative

After careful investigation and research, I have got to know well about Hip-hop originating from and well-developed in American, so that in the poster of American Impression I make Hip-hop the theme. Words and pictures are combined in the poster; putting words first and pictures second; and white and black color are in contrast, showing the fashion and motivation of the black youth. In addition, subsidiary colors are employed so as to create a lively, easy and dynamic atmosphere, in this way, the audience can feel the dancing rhythm though there is no music. To avoid dullness and monotony, the words are laid out creatively with their colors, patterns and typesettings combined and mixed.

In the poster of Chinese Impression, Beijing opera is the theme. As is known, Beijing opera owns a long history, with profound connotation and great influence; it has become a most important representative of Chinese culture. It has gathered together the beauty of lyrics, melody, music, art, and performance, and has assimilated the magnetism of these artistic forms and made them coordinate with each other, creating a state of harmony and a unique Chinese performing art with distinctive rhythms. Beijing opera has condensed the aesthetic essence of traditional Chinese culture, playing a critical role in the world dramas. China has been called the Kingdom of Fan, and its fan culture has a steady foundation and is an important part of the overall national culture. The fan culture also has a close relation with bamboo culture, Buddhism culture and Taoism culture. So in the poster the words are laid out in the shape of a fan, showing us the profound national culture of China as well as its unique charm.

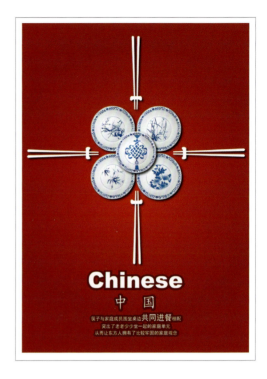

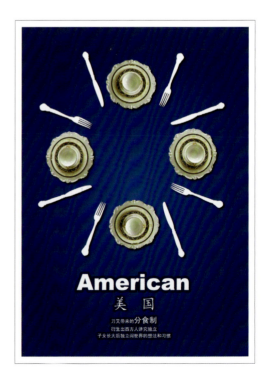

教授点评
Professor's Evaluation

学生作品及陈述与教授点评(中国)
Work of Student, Narrative and Professor's Evaluation (China)

在中美饮食文化的招贴中，以餐具作为基本设计元素，寻求中美餐具中的共性与个性，以图形的不同排列组合方式来诠释"聚"与"分"的观念。而对盘子花纹的细节处理，使画面变得更为形象、精致，整体效果简洁却不简单。

舞蹈、戏剧、音乐都是文化的典型代表，以其独特的艺术语言形式展现着各国乃至各民族的文化特色。在印象中国、印象美国招贴设计中，作者借用中国京剧与美国嘻哈街舞的艺术语言，来彰显东方和谐的艺术风采与美国的现代及个性。文字与图片相得益彰，画面整体和谐，设计表现形式感强，整体韵律把握较好。

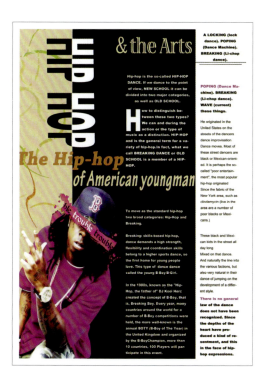

In the poster of Chinese and American diet culture, dishes are the dominant elements of design. The designer has shown us the similarities and differences between the two kinds of dishes, interpreting the idea of "uniting" and "separating" by different sorts of permutation and combination. In addition, the patterns of the dishes are also processed in detail, making the picture much more exquisite and vivid. The whole poster looks humble but intricate.

Dance, drama, and music are typical representatives of culture, displaying the cultural features of different countries or ethnic groups through unique artistic languages. In the posters of Chinese Impression and American Impression, Beijing opera and Hip-hop are employed to show us the harmonious artistic features of China and the modernity and individuality of America. The words and pictures coordinate with each other perfectly, the overall pattern looks concordant, the design style is active and lively, and the rhythm of the whole poster is well-handled.

Section 4
肆 设计交流
Design Communication

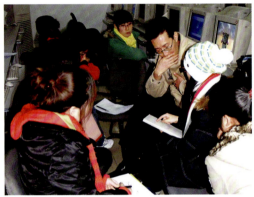

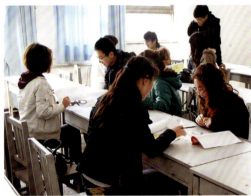
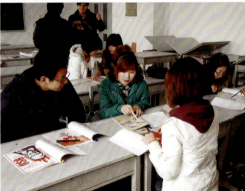

设计交流	课程教学剪影(中国)
Design Communication	The Classroom Snapshots (China)

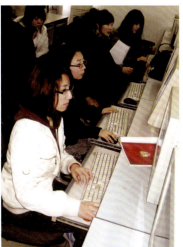

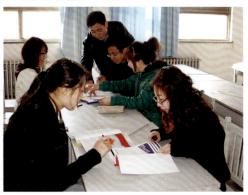

Experimental Education of Intercultural Visual Communication Design | 87

Experimental Education of Intercultural Visual Communication Design

Part
three

A Record of Art Design Education in America

第三部分·美国艺术设计教育实录

跨·文·化·艺·术·设·计·教·育·尝·试

Section 1
壹 教育教学模式（美国）
Education Mode & Teaching Style (America)

美国的艺术设计教育教学没有一个固定的模式，各院校都有其各自的特点，无论从课堂结构、课程内容以及课程教学手段上都具有相同之处，又有个性区别。由于早期欧洲艺术设计教育的影响，再加上现代科学技术的不断发展使美国艺术设计教育体系呈现了一个极具活力又充满生机的局面，但大多都是以设计的应用性和市场竞争为导向，以科学技术发展为依托，采取一种不断调整、不断充实的运动式的教育模式，以适应发展和社会的需求。这种运动式的教育体系不仅仅避免了教育内容的陈腐化和教条化，同时由于随时注入新技术、新内容从而促使艺术设计教育本身保持了一贯的生命力。

美国各高校办学有着一定的自由度，有绝对的学术自由，并由全国民间的教育团体还有地方的教育团体根据软件和硬件给予认证。就艺术教育而言，美国的国家艺术教育学会（National Art Education Association，简称 NAEA）就是一个权威的认证机构。一般来讲，美国艺术教育层面丰富，不同层面的教学目的明确，这样为培养多层次的设计人才提供了方便和机会，无论从设计师证书，大专、大学本科，还是研究生（其中 MA 为艺术硕士，MFA 为美术硕士，也是工作室艺术的最终学位），多层面的教育机构为提供培养多层面的艺术设计专业人才提供了广泛的空间和机会。仅从大学本科学士学位的艺术设计的教育来讲，又分为 BS、BA 和 BFA，这三种学士学位的知识结构要求对于专业有各自不同的侧重点，BS 强调的是技术；BA 作为一种泛学历；那么 BFA 是一种专业学位，根据不同的方向，更加强调或侧重于设计技巧。无论哪种学位，课程结构分为三个层次：公共课、专业基础课、专业课，另外，专业实习和毕业设计也是整个课程结构的重要组成部分。学生所修课程采取学分制，除了必须修满公共课和专业基础课的学分以外，每个学校又有其各自要求的专业必修课，同时每个学生又有一定学分的选修课，可根据各自需求，选修本专业和跨专业的课程，学生修满必修学分即可毕业。

美国政府在 1994 年颁布了《艺术教育国家标准》，美国学生从小在学校接受该标准所规定的相关课程，再加上教育气氛宽松，鼓励个性化发展，所以，一般都具有独立的创造性思维和丰富的想象力，又具有较强的动手能力。大学艺术设计教育拓展了这种教学环境。艺术设计教育的相关课程大多都采取工作室性质的教学模式，工作室里配备了教学和相关专业设备，并注重营造一种真正的专业设计氛围。尽管每一个教授的教学方法和教学手段有所不同，但都基本遵循着鼓励学生独立思考、独立研究的能力，培养引导学生进行创造性思维，充分尊重学生的个人见解，其中：课堂讲座、示范、课堂讨论、课堂讲评和面对面辅导，以及参观博物馆和外部专业工作室等都是必要的教学环节，学生参与讨论和课堂互动环节是评分的重要组成部分。

值得一提的是，有的学校定期或不定期地聘请校外的访问学者和访问艺术家短期驻校研究和创作，这种制度不仅给学校注入了新鲜的学术空气，使学术气氛更加新鲜活跃，学校和社会紧密接轨，同时也开阔了师生的眼界和创作思维，及时有效地了解了学术前沿和发展趋势。

教育教学模式(美国)
Education Mode & Teaching Style (America)

美国艺术设计教育实录
A Record of Art Design Education in America

The American art design education mode and teaching style are not fixed but highly flexible; different institutions have different features in terms of education structures, curriculum contents as well as teaching methods where there are both similarities and differences. Affected by the early European art design education, combined with the increasingly development of modern science and technology, the American art design education system has taken a vigorous and dynamic look. Based on advanced science and technology development, it is mostly oriented to the design application and the market competitivity. To meet the pace and the needs of the real world, the American art design adopts a vital education mode that is constantly adjusted and enriched. This kind of education mode hasn't only avoided the old education content or the dogmatic teaching methods, but also maintained the consistent vitality of the art design education by continuously injecting new technology and fresh content.

American people enjoy certain degree of freedom in founding new institutions and absolute freedom in academic achievement pursuing. Various non-governmental educational organizations and local educational bodies have been established for certifying these institutions by using certain software and hardware. National Art Education Association (NAEA) in America is such a certifying authority in the field of art education. Generally speaking, there are various education levels in American art education which have distinctive teaching objectives. Therefore, professionals at different levels can be cultivated. And a wide range of students, whether one with a designer certificate or with an associate degree, a bachelor degree, or a graduate (MA is Master of Art, MFA is Master of Fine Art, a terminal degree in studio art) degree, can study in such institutions featured with multi-level education. In art and design education, for example, there are three kinds of bachelor's degrees, namely BS, BA and BFA. They are different however: BS emphasizes on design technology; BA serves as a general degree while BFA functions as a professional degree and highlights specific design skills in specific professional divisions. Whatever the degree, curriculum is always composed of three levels of courses: general education courses, foundational professional courses and professional courses. In addition, the professional internship and senior seminar are also important parts of the whole curriculum. An academic credit system is usually used for all courses. Students are required not only to gain credits in general education and foundational professional courses but also in some professional required courses varying in different schools as well as in several elected courses selected according to their own needs. Only those who have managed to gain all the required credits mentioned above can get a diploma.

The American government issued the document "The National Standard for Art Education" in 1994. Lessons required in this document, combined with the relaxing teaching atmosphere, encourage American students to develop their individualities into full play. As a result, they are possessed with creative and imaginative thinking as well as operation abilities. This kind of teaching atmosphere has even better and more thoroughly embodied in art design universities. Related courses in art design education are mostly given in studios. A genuine design atmosphere can be created with classrooms well equipped and professors available. Although professors have different teaching methods, they are in common as to their teaching goal, that is, to encourage students' creative thinking and independent research on the basis of respecting their individual opinions. Lectures, representations, seminars, evaluations and face-to-face counseling as well as visits to museum and external studio are indispensible for students. Besides, discussions and interactive performances in classes are also important parts according to which their marks will be given.

What is worth mentioning is that some schools have been, on the regular basis or not, inviting other visiting scholars or artists to do short-term academic studies in their schools, which hasn't only created a refreshing academic atmosphere and made a close tie to the society, but also broadened the horizon of the whole faculty and developed there creative thinking ways, consequently facilitating them to learn the academic frontiers and the development trend in advance.

Section 2

贰 课题说明(美国)
Project Guideline (America)

课题 / 主题文化招贴设计
Projects / Cultural Poster Design

张跃起 教授 / 南犹他大学艺术设计系
Professor Yueqi Zhang / Department of Art and Design, Southern Utah University

课题大纲

有效的招贴应该及时地捕捉它的预期特定目标。由于开幅尺寸较大，一幅招贴能够吸引并保持观众短暂的注意力。在短短的时间里，它可以唤起或激发观众的感受，使观众出现喘息、微笑、反省、怀疑、赞成、抗议、畏缩或者其他方式的反应。招贴的功能是贩卖、促销、鼓励或劝导，甚至可以成为一种变革的推动力。

本课题要求选择你个人对中美两国文化差异的特别印象，以与公众对话的形式，设计一组具有丰富内涵的系列招贴作品，最终设计方案为系列招贴（2~4张）。设计构成要基于你选择的设计主题和目标受众，其中设计主题可以是广义的（例如传统节日、生活方式等）或者是狭义的（例如习俗、饮食等）。根据个人意愿选择除了政治问题之外的任意主题，然后确定目标受众和设计方向——是使用幽默、讽刺，还是震撼或理性的诉求？这是最终确定最适合本课题的设计元素的关键。此外，字体、色彩、摄影风格和插图风格等都是有助于招贴设计统一和谐的手段。

目 标

1. 增加对如何处理在大幅空间中组织多种设计元素和创建超越语言层次的视觉层次的理解。
2. 着重训练对已知信息的分析、提纯和对未知信息的搜集、提炼。
3. 提高以有效的视觉方式把有效的信息传达给目标受众的能力。

要 求

招贴中必须包含标题、正文以及其他相关文字信息，并采用摄影、抽象拼图、电脑插画或凸版印刷等表现形式。建议你亲自拍摄和制作适当的图像或插画去表现主题。作品完稿尺寸不超过18" x 24"(立式)，直接装裱在22" x 28" 黑色展板上，并在展板的右下角标注一个 2"x 1" 的设计标签（包括你的姓名、日期和课题/课程名称）。四色匹配或四色套印 (CMYK) 输出可任选一种。

设计流程

在开始正式设计前，首先要对设计主题进行认真仔细的调查研究和分析，在充分了解主题范围的前提下，用具体的知情方式去表现主题。调查研究的内容也应该包括对以往类似设计作品(视觉和书面资料)的检索。下载偶尔发现的视觉元素，保存网址以便参考，并且将全部研究资料整洁有序地编排在作为存档资料的设计手册中。

设计流程的其他方面还包括头脑风暴的书面记录，草图和计算机生成的略图。书面记录关键词联想和头脑风暴是取得独特设计方案的绝佳方法。一旦完成了全面彻底的调查研究，及时记下在研究中所出现的任何关键词，并写出与这些词以任何方式相关联的其他词语，这种练习不但有助于创造性探索的深入，同时还可以提升创造性思维的能力。除此之外，草图也应该显示出创意升华的全过程。

时间表
第一周
设计流程开始: 调研，选择恰当的主题，头脑风暴，按照可能的概念方向勾画粗略草图。选择两个方案完成大致的版式设计，连同设计草图和调研资料一起带到课堂以供点评。
第二周
基于你在批评意见中得到的反馈，集中到一个概念方案上并修改或重做它，以完成一幅全尺寸大致彩色版面设计给同学们品评。
第三周
基于对全真版式的反馈信息，调整整套设计以供课堂点评。
第四周
完善终稿，撰写设计陈述和编排设计手册，准备展示。
展示和点评

最终展示
最终设计展示为全彩色印刷招贴。
完稿尺寸
18" ×24" 直接裱在 22" × 28" 的黑色展板上。
设计手册
硬壳封面，目录，词语联想，研究资料，缩略图，草图，最终方案粗略稿等。
设计陈述
提交 1000 到 1500 个词的硬壳封面设计陈述。

课题说明(美国)
Project Guideline (America)

美国艺术设计教育实录
A Record of Art Design Education in America

Project Brief
The effective poster should achieve its aim immediately. By the very nature of its size, a poster can seize the attention of the viewer and then retain it for a brief moment. During that short time a poster can provoke and/or motivate a viewer – it can make the viewer gasp, laugh, reflect, question, assent, protest, recoil, or otherwise react. At its most effective, a poster can sell, promote, encourage, or persuade. It can be employed as a dynamic force for change.

Design a substantial series work that aims to create public dialog regarding a specific impression of your choosing about comparison of America and Chinese culture. Your final solutions should be a series of poster (two–four pieces). The rationale for choosing the construct should be validated by your choice of topic and target audience. The topic can be as general (traditional holidays, life styles) or as specific (conventions, food) as you wish, but political issues. You must determine your target audience and your tenor immediately. Will you use Humor? Satire? Shock? An appeal to intellect? Only then can you determine what elements will be best fitted to the project. Typography, color, photographic style and illustrative style are all properties that can contribute to the unity of your posters.

Objective
1. To gain an understanding of how to work with a large scale space with a variety of elements and to work in creating a visual hierarchy out of a verbal hierarchy.
2. To intensify practices of analyzing and distilling the already known information and collecting and extracting the essence of the unknown information.
3. To communicate the desired message to the desired target audience in as effective a fashion as possible.

Requirements
Your posters must include a title, body copy and other relevant information. Media should include photography, collage, computer illustration, typography etc. You are encouraged to take appropriate pictures or illustrations by yourself to match your topic. The final size should be no large than 18"x 24" (vertical) and flush mounted on 22"x 28"black board. A 2"x 1" name tag (including your name, date and project/course name) on the corner of right bottom of the black board. You may use up to 4 match colors or 4-color process (CMYK).

Process
Your topic must be thoroughly researched and analyzed before you begin any serious design work. You must fully understand the scope of the topic before you can hope to address it in an informed fashion. Research should also include examples (in visual and written form) of past design work done for the same cause. Download visuals as you run across them, and save URLs in a file for future reference.

This research should be compiled neatly in your process book for your own reference. Other areas of process include written brainstorming, thumbnail sketches, and computer developed roughs. Word association brainstorming with a pen and paper is an excellent way to discover unique solutions. Once you have done a sufficient amount of research, write down any key words from your research, and begin writing other words that are in any way associated. Such an exercise may help facilitate your creative explorations. Thumbnails should show evidence of extensive exploration.

Schedule
Week one
Begin the design process: research, choose the right, brainstorm, and develop thumbnail sketches on possible concept directions. Choose two to make into rough layouts for critique. Bring your thumbnail sketches and your research finding to class.
Week Two
Based on the feedback you received in critique, focus on one concept and revise or rework it into a full-size rough color layout for class critique.
Week Three
Based on the feedback your full size layout received, create a finished poster series comprehensive for in class critique.
Week Four
Refine your comps, organize you design narrative and process book, prepare your presentation.
Final presentation and critique

FINAL PRESENTATION
For your final presentation, you will need to print out your posters in full color.
DIMENTIONS
Print 18"x 24"
Black board 22"x 28"flush mounted.
P ROCESS BOOK
Hard cover page, table of contents, written brief, research, thumbnails, sketches, final roughs etc..
DESIGN NARRATIVE
A 1,000 to 1,500 words design narrative with a hard cover must be submitted.

Section 3

叁 学生作品及陈述与教授点评(美国)
Work of Student, Narrative and Professor's Evaluation (America)

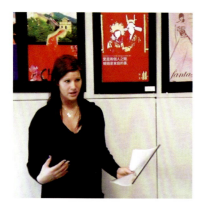

阿里尔·拉姆 | Ariel Lamb

设计陈述：婚礼

每种文化都有它自己的道德、价值和传统。这个课题要求我们阐述中国和美国的文化差异。当我研究了日常生活的不同侧面后，我决定选择"婚礼"作为设计主题，因为我发现很有趣的是不同社会的婚礼在实际操办过程中存在着很大的差别。

在典型的美国婚礼准备过程中，许多新婚夫妇忙于准备鲜花、婚宴菜谱、接待大厅、教堂和婚礼的配色方案。新婚夫妇的亲属有时会参与这些准备工作，但是最终，这一天的安排规划都由新婚夫妇自己来决定。女人从小女孩时就梦想着与心中的白马王子喜结良缘的那一刻。几乎每个新娘都有一条长长的、华丽的白色婚纱和一个象征已婚的漂亮戒指。作为一种传统，婚礼仪式的所有物品都是白色的，代表着新婚夫妇的纯洁和忠贞。

当我设计招贴时，我想展现出新娘美丽的姿态和自信，把礼服设计得长长的、飘动的，突出了女性的个性和精神面貌。新娘后面的玫瑰造型增加了画面的层次感，同时体现了新娘在婚礼中如同鲜花一样的美丽。我选择了一种手写字体来简短地描述典型的美国婚礼。我相信这幅招贴体现了幽雅、简练的风格并描绘了婚礼最重要的元素。

中国的婚礼和美国婚礼极不相同。在传统中国婚礼中，新娘在新婚来临之前的离别时刻，深受朋友和家人的眷顾。大量用红纸包装的彩礼会送到新娘家中，婚礼的主要颜色是大红色。婚礼的鲜花、用具、礼物、礼品纸和许多其他小道具都是大红色的。在婚礼前，新婚夫妇要给新娘家属敬一杯茶，以表示尊敬和感激。如果新娘家同意这门婚事就会把嫁妆送到

设计陈述	阿里尔·拉姆
Design Narrative	Ariel Lamb

新郎家，然后迎亲队伍就会向婚礼举办地行进。就像你所看到的，家庭在中国文化中占有极其重要的地位，就算婚礼当天也不例外。

在设计中国婚礼招贴时，我使用了纯红色，这样可以突出美国婚礼的白色和中国婚礼的红色之间的差异。我创作了一张穿戴传统礼服和头饰的典型中国新婚夫妇的肖像并进行了概括处理，使它更具有装饰性。我相信招贴上的中文口号概括了婚姻主题，我觉得必要的英文翻译可以教育美国民众。右下角的三个有力度书法涵盖了"婚姻"、"家庭"和"传统"的婚姻主题。

在针对这个课题的探索和设计后，我更加意识到作为美国人，我们对于中国文化的认识过于陈旧和抱有成见。我同时也被中国的婚礼习俗所感动。这不仅非常浪漫并且经过了精心设计，同时还涉及家庭生活历程的每一步，所有这些中有许多美国人不再重视的东西。这个课题启发、教育了我，我相信我们整个社会每天都可以从文化认知中获得很多东西。

Design Narrative:
Wedding Ceremony

Every culture has its own morals, values, and traditions. For this assignment, we were asked to illustrate the cultural differences between Chinese and American culture. As I researched many different areas of everyday life, I settled on standard wedding ceremony because I found it very interesting that such an important event in both societies could be so vastly different in practice.

In preparation for the typical American wedding, many couples are busy planning the flowers, dinner menus, reception halls, churches, and color schemes for the wedding line. These decisions will involve the family of the couple on occasion, but ultimately, the day is designed entirely by the newlyweds to be. Women dream from the time they are small girls about the day they 'tie the knot' with their Prince Charming. Almost every bride has a long, gorgeous, white wedding dress, and a beautiful ring to symbolize their status as a married woman. It is traditional that everything at the ceremony be white, to symbolize purity and loyalty in the newlywed couple.

When I designed my poster, I wanted to illustrate the poise and confidence of a gorgeous bride-to-be. The dress is long and flowing, but accentuates the personality and spunk of the woman. The silhouettes of the roses behind the bride give the poster dimension, and compliment the bride much like flowers at the actual ceremony would. I chose a script style font to write a brief description of a typical American wedding. I believe the poster is elegant and concise; illustrating the 'most important' elements of the ceremonial day.

The day of a wedding in China is extremely different from what our society is used to. In a traditional Chinese wedding, the bride may be taken by friends and family as a fair-well time before her big day. Large gifts are brought to the bride's family wrapped in red paper. The primary color in wedding ceremony is scarlet red. The flowers, outfits, gifts, gift paper, and many other props for the ceremony are red in color. Before the wedding, the newlyweds to be will serve tea to the family of the bride as a token of respect and appreciation. If the family approves, the couple will bring a few gifts back to the groom's family, and a procession will start towards the place of ceremony. As you can see, family is extremely important to the Chinese culture, and the wedding day is no different.

When designing the Chinese wedding poster I wanted to use solid, saturated reds to symbolize the relationship between the American use of white and the Chinese use of red for weddings. I created an image of a typical Chinese newlywed couple in traditional gowns and head wear, and converted them to a more graphic style to simplify the image. I believe the two written sentences sum up the largest theme of the wedding day, and I feel the English translation above is necessary to educate the American public. The calligraphic symbols in the lower right corner of the poster each stand for "Marriage", "Family", and "Tradition"; which I felt were three powerful words to describe the event.

After researching and designing for this project, I have become more aware of the stereotypes we as Americans make everyday regarding the Chinese culture. I also felt a very moving emotion reading about the Chinese wedding tradition. It is all very romantic, and elaborate, while still involving the family every step of the way, which is something that many Americans no longer feel is important. This project has been enlightening and educational for me, and I believe our society as a whole can gain from cultural awareness every day.

教授点评
Professor's Evaluation

学生作品及陈述与教授点评(美国)
Work of Student, Narrative and Professor's Evaluation (America)

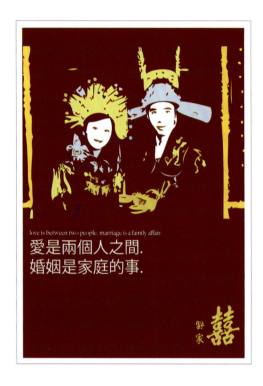

从某种意义上讲，婚礼是一项繁杂的、具有丰富文化内涵的系统工程。不同文化背景下的婚礼，往往浓缩了其所属文化的传统观念和习俗。当 Ariel 向我提出她的选题后，我首先欣赏她对课题的理解，对事物敏锐的观察和对主题准确的切入，随后是担忧她对如此庞杂信息的组织能力。尽管有短暂的犹豫，但是我还是肯定了她的选题，决定让她去应对她自己提出的挑战，因为兴趣是成功的重要前提之一。从研究、分析、创意和设计实施，我密切关注着每一个环节，不做任何硬性干预，包括中文字义和翻译，只是引导她透过事物的表面，深入体会、领悟其内涵，提出问题并获取更多相关的延伸信息和资料，从中汲取和视觉化可用的抽象设计元素。从她作品中所展示的浓郁的文化氛围和畅快淋漓的视觉语言可以证明，她做到了。

In some sense, marriage is a complex and systematic program full of cultural connotations. Marriage in different backgrounds usually embodies condensed traditional ideas and customs in specific cultures. When Ariel told me her topic, I first appreciated her deep understanding of the topic, her acute observation and accurate discussing points, but I then doubted about her organization abilities of the involved massive information. Even though with a moment's hesitation, I approved of her proposal, hoping that she could face the challenge posed by herself, considering interest is an vital premise of success. I closely observed each stage from research, analysis, creative thinking and design realization, and didn't make any interference whether in Chinese character meanings or in translation, but only guided her to thoroughly understand and appreciate the implications of affairs through observing their surfaces, ask questions and acquire more related information and materials, and introduce abstract design elements that are useful for concept visualization. However, she did succeed, judging from the thick cultural atmosphere and the vivid and pleasant visual languages she had shown in her works.

Section 3

学生作品及陈述与教授点评(美国)
Work of Student, Narrative and Professor's Evaluation (America)

奥布里·达林 | Aubrey Dalling

设计陈述：日历纪年 / 牛年

马丁·埃米斯曾经说过"有时我感觉生命正在流逝，不是慢慢的……生命正在流逝，然而我是直接面对所有变化挑战的人。"

时间以及它的来来去去总是吸引着人们。明天总在那边，但始终不会到来；昨天总在那边，但始终不会离开。有时日子好像比实际上更长或更短。

我是依靠跨越时间之路上如同障碍物的生日、节假日等来作为本课题创意的。因为没有一年实际走过、跑过、流逝等迹象，所以时间的速度取决于观众的决定。

观者看待时间的方式是由他们生命中的某个特定时刻决定的。生命中有没有什么事能使时间变慢的？压力、学校、工作、家庭？怎样会使时间加速呢？新的友谊，幸福？对每一年的看法会随着环境改变的。

一些东亚国家用12种动物生肖来纪年，其中中国的黄道十二宫用动物生肖体现了十二年一个循环。每种动物都有不同的个性和特征，生肖也因此被认为是影响每个人个性、成功和幸福的重要因素。

一个人可能拥有其所属生肖动物的个性，比如循规蹈矩的老鼠，值得信赖的牛，刚烈叛逆的老虎，和蔼可亲的兔子，宽宏大量的龙，明智伶俐的蛇，兴高采烈的马，优雅唯美的羊，精力充沛的猴，条理分明的鸡，聪明智慧的狗和沉着忍耐的猪。在中国的八卦中动物符号也按月份分配（也被称为内在动物）并按时辰分配（称为神秘动物）。所以一个人在龙年出生就属龙，但是也可以是内在的蛇或者神秘的牛。

因为是牛年，所以我想用黄道十二宫图表

设计陈述
Design Narrative

奥布里·达林
Aubrey Dalling

现牛年。设计中，我面临的最大问题是如何让整体设计避免凌乱。我尝试了很多方法，最终确定了用十二宫图围绕月亮的想法，并在其中安放了可作为中国符号的牛。

Design Narrative: The Calendar Year / The Year of the Ox

Martin Amis once said "Sometimes I feel that life is passing me by, not slowly either … It's passing, yet I'm the one doing all the moving."

Time and the way it comes and goes has always been fascinating to human beings. Tomorrow is always there, but never comes; yesterday is always there, but never leaves. Sometimes the days feel like they're going longer or shorter than they actually are.

My concept behind this piece was walking through the calendar year – birthdays, holidays, etc. always obstructing our paths. Since there is no indication of how fast or slow the actual year is walking, running, sneaking, etc., it's up to the viewer to decide its speed.

The way the viewer sees this piece is probably going to depend on what they're going through in life at that particular moment in time. Is there something in life that's making it slow down? Stress, college, work, family? How about speed up? New relationship, happiness? The view of the calendar year may change according to circumstance.

The Sheng Xiao is 12 animals which are representative of years in some East Asia countries; and the Chinese zodiac is the 12-year cycle of these animals. Each year of the 12-year cycle is named after one of the original 12 animals. Each animal has a different personality and different characteristics. The animal is believed to be the main factor in each person's life that gives them their traits, success and happiness in their lifetime.

Such personalities, like disciplined (rat), dependable (ox), rebellious (tiger), amiable (rabbit), magnanimous (dragon), wise (snake), cheerful (horse), artistic (ram), motivator (monkey), organized (rooster), intelligent (dog), and patient (pig) are not the only ones in a person's life. In Chinese astrology there are also animal signs assigned by month (also called inner animals) and hours of the day (called secret animals). So a person could be a dragon because of the year they were born, but they might also be a snake internally and an ox secretively.

As it is the year of the ox, I wanted to depict the year of the ox, but with the zodiac too. My biggest problem was depicting it without cluttering up the piece too much. I tried many different things with it and finally came up with the idea of making the zodiac the outside of a moon, wherein lies the Chinese symbol for ox.

教授点评
Professor's Evaluation

学生作品及陈述与教授点评(美国)
Work of Student, Narrative and Professor's Evaluation (America)

理念延伸和隐喻是这个课题的主要任务之一。Aubrey 巧妙地借助日历纪年的形式，表达了一种对生活的态度和人生的领悟，以及对生命的理解；富有哲理性地揭示了事件和生命的现实意义和内在联系。戏剧化的构图、恰当的视觉元素应用，有效地强化了中国式的严谨、轮回和美国式的活泼、幽默的主题，突显了时间概念在不同文化中的差异。文字的编排和格言的采用，更赋予作品深刻的思想性和深奥的内涵，令人回味。

Concept extension and metaphor is one of the main tasks of this project. Aubrey ingeniously adopted the form of calendar year to show the attitude, thinking and understanding of life, which reveals the realistic meaning of events and life, as well as their inter relations. A dramatic composition and proper application of visual factors strengthens the preciseness and recurrent in Chinese culture and liveliness and humor in American culture, which emphasizes different time concepts in different cultures. The arrangement of words and adoption of maxim render the poster a deep ideological content and connotation, providing the audience a powerful aftertaste.

Section 3

学生作品及陈述与教授点评(美国)
Work of Student, Narrative and Professor's Evaluation (America)

德文·道戴尔 | Devon DowDell

设计陈述：

我选择锦鲤展览会作为文化招贴设计的主题。我的业余爱好是收藏锦鲤，知道很多国家有锦鲤展览会。从2000年开始，我每年都去圣迭戈锦鲤展览会。我特别希望中国也有类似圣迭戈的展览会，所以我在Google上搜索，结果发现了香港锦鲤展览会，香港锦鲤展览会甚至比圣迭戈锦鲤展览会还早两年。看起来这是一个良好开端，我有了一个在美国和中国都流行的设计主题，只不过两国使用不同的视觉设计文化元素来推广锦鲤展览会。

 首先，我从我所知道的开始构思。我住在美国圣迭戈，南加利福尼亚文化充斥着我的整个生活，所以我的美国文化感受是有限的南加利福尼亚体验。尽管美国是文化多元化的国家，我在南加利福尼亚州的成长经历与同我年龄相仿的得克萨斯州男孩还是有着很大的差别，海洋、棕榈树、冲浪、汉堡包和好莱坞是我的全部美国文化感受。

 其次，我编制了一份图像清单，比如In-n-Out网站上的棕榈树，冲浪圆领汗衫和冲浪风格的图片，你可以在冲浪板或是动感的板上看到色彩。我利用这些素材构成了一种装饰特色和色彩风格，想以此达到象征南加州及其海岸线的效果。我用抽象的黑色剪影组成了锦鲤。我发现了一种很不错的字体叫"夏威夷杀手"。这种字体有海岸冲浪的感觉。我在锦鲤下面使用了它。象征性的水流动在锦鲤周围，我将锦鲤顶部躯体组成了一个流动的S形。这种手法带有新艺术运动的特征，并且给人以水的感觉。这张招贴混合了冲浪的感觉、南加州的生活方式、新艺术运动风格和锦鲤之美。

设计陈述
Design Narrative

德文·道戴尔
Devon DowDell

接下来，我开始做中国文化招贴。我对中国文化了解得很少，所以我再次利用Google来搜索。我寻找了能够象征中国丰富历史和文化的流行色。暗红与金黄的色彩组合给我留下了很深刻的印象，所以我采用这两种颜色作为主色调，以给人一种真正的中国感觉。我采用了很中国化的字体，并用黑色把文字加以强调，同时我还在设计中借鉴了中国古代的风水理论。

设计过程中，我同样想将中国古老的龙加入到锦鲤之中。我觉得锦鲤最好设计得抽象些。我想到在锦鲤的背上加一条龙的图案，或者是变化锦鲤身上的纹路为龙的图案，使龙和锦鲤结合在了一起。我使用了Photoshop的滤镜将我手绘的龙进行了特效处理，并且对处理后的视觉效果非常满意。这条鱼对于整个招贴而言很有亚洲和中国的格调。风水布局的融入激活了中国字体、中国文化的丰富色彩和令人惊奇的抽象龙锦鲤图案。这个招贴做得很精彩，是我做过的最喜爱的设计之一。

Design Narrative:

I chose to do my Cultural Poster Design on Koi show conventions. I love the hobby of Koi keeping, and knew there are Koi show conventions, in just about every major country. I have been to the San Diego Koi Show every year since the 2000 year show. I was hopping that there was a show similar to the San Diego show, but in China. I searched Google, and right away found the Hong Kong Koi Show. The Hong Kong Koi Show is two years older then the San Diego Koi Show. This seemed like a great place to start. I had a design subject that is popular in both the U.S. and in China. Though, both use different visual design culture elements to promote the Koi shows.

First, I started with what I know. I have lived in the American/Southern California culture my whole life. So my American culture experience is the micro Southern California experience. America is very culture diverse. My experience growing up an American in Southern California, is much different then the experience of lets say a boy my age that grew up in Texas. The Ocean, Palm Tree's, Surfing, Hamburgers and Hollywood are icons of my American experience.

Second, I compiled a list of images. Like palm tree's on the In-n-Out website. Images of surfing t-shirts and surfing style. Colors that you see on a surf board, or boogie board. I put this all together to get a décor and color style that symbolizes Southern California and the coast. I incorporated the Koi, very abstract in just black outline of the body and pattern. I found a great font called "Hawaiian Killer". The font has a coastal surfing décor to it. I used it above and below the Koi. This symbolizes water flowing around the Koi. I turned the top side of the Koi's body into a flowing "S" shape. This has characteristics of Art Nouveau movement, also gives the feel of water. The poster is a combination of this Surfer Décor, Southern California life style, Art Nouveau, and the beauty of Koi.

Next, I worked on the Chinese Culture poster. I don't know much about China, so I again turned to Google. I looked up popular colors that symbolize China's rich history and culture. I came across a dark red, and gold combo. So I adopted that as my color décor for the poster. It gives a real Chinese feel to the viewer, when the two colors are used in harmony with one another. I also used black as an accent for some of the text. The font was very Chinese, and used the ancient Chinese art of Feng Shui in its design.

Moving forward, I also wanted to incorporate the ancient Chinese Dragon into my Koi. I decided that it would be best to go very abstract with the Koi. I wanted the Koi to have an image on it's back that could be seen as a dragon, or could be seen as a normal pattern found on a Koi. I incorporated my hand drawing of a dragon, and the Koi. I ran it through a couple filters in photo shop, and I am very happy with how it looks. It has a very Asian feel to the fish, and a very Chinese feel to the whole poster. The combination of the Feng Shui inspired Chinese font, the rich colors from Chinese culture, and the amazing abstract Dragon Koi. Made this poster amazing, and one of my favorite designs I have ever done.

教授点评
PROFESSOR'S EVALUATION

学生作品及陈述与教授点评(美国)
Work of Student, Narrative and Professor's Evaluation (America)

以展览招贴的形式为载体，描述不同传统背景下的相同事件，不仅具有很大的表现空间，同时也面临着强化视觉冲击力的挑战。这是一个很聪明的选择。Devon并没有刻板地按照设计流程进行创作，而是像做冲浪运动一样，满怀激情、精力充沛地保持状态，迎接并战胜一个个问题的浪峰。设计过程本身就是一个完善过程。注重细节是设计成功的必备条件之一。Devon很好地做到了这一点。构图中设计元素之间的穿插、遮挡产生了一种厚重的空间感。锦鲤身上的纹路和龙的造型的合二为一，以及锦鲤的造型和棕榈树的造型的合二为一等细节刻画，不仅生动有趣，成为极强的文化特征符号，给人以充分的联想空间，同时也隐喻不同地域文化的审美情趣和传统价值观。

In this design, the same events under different traditions are described with posters as the carrier. This form entails great exhibition space and a challenge to strengthen visual impact at the same time. However, this is a clever choice. Devon did not follow the rigid design process, but welcome and resolve every problem with passion and energy, just like what we do in surfing. The design process is a process to make improvements, while attention to details is definitely one of the essential factors leading to success. Devon has done a good job in terms of details. The interweaving and blocking of design elements renders a sense of space, while the interesting details such as the combination of lines of the fancy carp and the pattern of dragon, together with a combination of fancy carp and the palm tree represents a cultural sign which provides a large imagination space at one hand, and indicates different aesthetic values and traditions in different regional cultures at the other hand.

Section 3

学生作品及陈述与教授点评(美国)
Work of Student, Narrative and Professor's Evaluation (America)

埃里克·诺伯格 | Erik Norberg

设计陈述：

我这组招贴是为中国的文化和瑞典的文化而设计的。我来自瑞典。在我开始设计这组招贴之前，我做了一些研究。尤其是研究了做这个课题之前我不太了解的中国文化。最终我选择了能代表这两种文化的两个节日。中国文化的招贴设计我选择了中国新年，瑞典文化的招贴设计我选择了瑞典仲夏节。

当我确定了这两个节日后，通过持续的网上调研，我找到了两个节日庆典背后的故事和大量图片并以此作为参考。我发现龙是中国新年最具代表性的特征，所以我把龙作为设计重点。我发现五朔节花柱是瑞典仲夏节最有代表性的特征，所以我把它作为瑞典文化招贴设计的重点。在我的调研结束后，我围绕我的想法做了头脑风暴（构思），我想看看我的设计中是不是还需要加入一些重要元素，并挑选出我真正想要的东西。

然后我画了一些草图，并且确定了我最终方案。我想做一个简洁的设计，这个设计只包含两个庆典的一些元素以保证招贴的简洁和避免杂乱。我还想让我的两幅招贴在风格上保持一致。我用天空、草地、招贴中间的物体使设计简洁明了。

开始电脑处理过程时，我首先进行的是中国新年的招贴。第一步是勾画了一条强势的龙，这是完成整个设计中花费时间最长的部分。画完龙后，我加了星星和天空，我还加了些黑色的丘陵并在其中一座山丘上增加了城墙。我想把这段城墙做成中国长城的感觉。然

设计陈述
Design Narrative

埃里克·诺伯格
Erik Norberg

后我在招贴上加了"Chinese New Year"的标题。我在网上找到了一种有中国风格的字体并用在了标题上。最后我加了一些关于中国新年庆典的介绍文字。

当我开始设计瑞典仲夏节招贴时，采用了第一幅招贴的相近设计手法。我从五朔节花柱开始设计。然后我添加草地和巨大的带有渐变的蓝天。我还在一座山后加了一个升起的太阳，这个太阳象征着一天24小时的光（白昼），表现了仲夏节举办的特定时间。我开始时选择了一种中世纪字体，但是由于有点不容易识别，所以我不得不改成一种相近的、不太乱的字体。最后我加了一些关于瑞典仲夏节庆典的介绍文字。

Design Narrative:

I designed my posters for the Chinese culture and for the Swedish culture which I'm from. Before I started to think about the design for the posters I did some research. Especially for the Chinese culture which I didn't know so much about before this project. After a while I choose two different events for the two cultures. For the Chinese culture I choose the Chinese New Year and for the Swedish culture I choose the Swedish Midsummer Eve.

When I had chosen the two events I kept on doing research on the internet. I found the stories behind the celebrations and also a lot of pictures to use as references. I found out that the dragon is one of the strongest attributes around the Chinese New year, so I choose to design my poster with the dragon in focus. For the Swedish Midsummer Eve I found out that the Maypole is one of the strongest attributes for the celebration so I choose it as my main focus for the Swedish poster. After my research was done I did some brainstorming around my ideas, just to see if there was anything important to add in the design, and sort out what I really wanted to include.

Then I made some rough thumbnails and tried to figure out what my final design would look like. I wanted to make a simple design and only include some elements from each celebration, to keep the poster clean and not too busy. I also tried to make the two different posters have the same style. I made the design simple with on sky, one ground and the object in the middle of the poster.

When I started to design the posters in the computer, I began with the Chinese New Year Poster. My first step was to create a mighty dragon from a sketch. This was the part of the creation that took the longest time to accomplish. When the dragon was finished I added a star filled sky in the background. I also added some dark hills and a wall on one of the hills. I tried to make this wall look like the Great Wall of China. Then I created a Headline on the poster with the text "Chinese New Year". I found a font on the internet who looked like a typical Chinese font, and applied it to the headline. Finally I added some body text with some short facts about the celebration of the Chinese New Year.

When I started to design the poster for the Swedish Midsummer Eve I had the same approach as the first poster. I started with the maypole first. Then I added grass for the ground and a gradient blue sky for the sky. I also added a rising sun behind a hill. The sun symbolize that there is light 24/7 the time of the year when the Midsummer Eve takes place. As font I first choose a medieval font, but it was a bit hard to read, so I have to change it to a similar font who wasn't so busy. Finally I added some body text with some short facts about the celebration of the Swedish Midsummer Eve.

教授点评
Professor's Evaluation

学生作品及陈述与教授点评(美国)
Work of Student, Narrative and Professor's Evaluation (America)

埃里克来自瑞典。当布置这个课题的时候，我曾经想到这对 Erik 来讲可能面临着重复性的工作。因为这个课题的主要任务包括训练学生对未知信息的搜集和对已知信息的提炼。如果根据原有课题要求去做，那么他只能完成并重复取前者而没有机会接触后者。所以我决定将他的作业按特案处理，鼓励他去做有关中国和他的祖国瑞典的文化主题。在他的完稿中，埃里克利用相似的版式编排风格，典型的图形符号和色调等视觉元素，准确传达了中国和瑞典特定节日文化特征和传统习俗的魅力，其中长城和龙、太阳和花柱上圆环在造型上的交相呼应，使画面更加协调有序。尤其是介绍性文字的加入，使目标受众有机会获取相关传统节日的详细信息。其设计手法简洁朴素，视觉和信息层次分明，很好地体现了招贴媒体的功能。

Erik comes from Sweden, and I once worried that this project might be a repetitive job for him since the task of the project is to train students' ability to collect the unknown information and process the known information. If follow this project, Eric will only finish the former task repeatedly but have no access to the latter. So I decided to assign him a particular theme about cultures of China and his motherland Sweden. In his design, Eric adopted similar lay out styles and typical visual elements such as graphic signs and hue to show the glamour of traditional festivals and custom in both China and Sweden. The patterns of the Great Wall, dragon and circles on the pillar correspond with each other to make the poster more coordinating and orderly. The introductive words give the target audience an access to relevant information of those festivals. With a simple and plain style, clear vision and information, this poster manifests the functions of poster medium in an effective way.

Experimental Education of Intercultural Visual Communication Design

Section 3
学生作品及陈述与教授点评(美国)
Work of Student, Narrative and Professor's Evaluation (America)

雅各布·戴迎 | Jacob Dyreng

设计陈述：

美国和中国似乎比过去的文化差别更大了，至少大多数人都这么认为。我们的文化处在与其他文化按一定比例的融合过程中，最重要的是可以看到我们的文化超乎想象的相互影响着。

选择比较两国的货币作为设计的主题，与此同时我想到了表达方法。我的招贴展示的流通货币好像印在砖上一样，另外用这些砖砌成墙来代表我们一直认为稳定的经济体系和基础。这是一种错觉，我们的美元并不像我们一直认为的那么可靠，我们的美元正在以令人担忧的比率贬值，更可怕的是美元的崩溃就在眼前了。有人甚至希望在美国、加拿大和墨西哥创造一种新的货币。

由于一些可知和不可知的原因，美元作为糟糕国家经济的一部分正在贬值。这面破败的墙代表美元价值的衰减。在一些地方砖头被抽走代表原本美元被幻想的感觉和美元实际的脆弱性，这与我们过去的看法不同。另外，抽走的砖还有从破败的墙壁里飘出来的烟，代表了我们无法确定导致衰败的全部因素。

Design Narrative:

The United States and China seem to have more cultural differences then the past. At least as most people would think. Our cultures are merging together along with all others at a consistent rate. Most importantly to recognize is that our cultures affect one another even with out intention.

I chose to compare the currencies of these two nations while making a statement that has been on my mind the same time. My posters show both currencies as if they were printed into a brick and then making a wall representing the solid structure and foundation of our economy that we have always believed is solid in value. There is an illusion in this. Our U.S. dollar is not the table solid legal tender that we always thought it was.

The value of our dollar is on the decline at an alarming rate and some very much fear that the failure of the dollar is on the horizon. Even to the point of planning and hoping to create a new currency for the U.S. Canada, and Mexico. As a part of the poor state of the economy for some known, and some unknown reasons our dollar is loosing value. The decaying wall represents the decay of the value of he dollar. In some places the bricks are pealing away and this represents the illusion of what we did think that the dollar was and in fact it is fragile not like we thought it was. Also there is smoke coming out of the decaying and pealing bricks and this represents the fact that we are not sure all factors that causing this decay.

教授点评
Professor's Evaluation

学生作品及陈述与教授点评(美国)
Work of Student, Narrative and Professor's Evaluation (America)

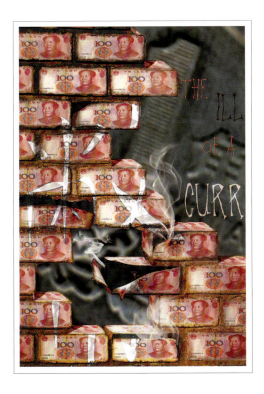

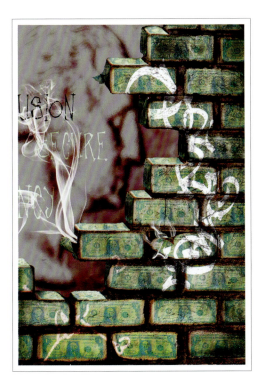

念是设计的灵魂。理念的形成是深入思考、系统分析的结晶。有效传达理念是设计成功的标志。面对突如其来的经济危机，有些人愤怒、抱怨，有些人却冷静、反思。Jacob准确地抓住了这一现象，采用象征的手法从文化剖析着手，进而引申到金融市场的货币战争，挑战了所谓传统的世界观、道德观和价值观，直接瞄准许多人不敢面对的事实，揭示了看似坚不可摧的经济堡垒外表神话般的错觉所掩盖的虚弱本质，隐喻了全球化大趋势下不同文化所面临的同种境遇。整个设计寓意深刻；尤其是视觉元素的选用，有关细节的刻画更是淋漓尽致，回味无穷。

Concept is the soul of design. While the formation of a concept is the crystallization of deep thinking and systematic analysis, an effective communication of concept is the sign for a successful design. Faced with the suddenly-aroused economic crisis, some people anger and complain, but others remain cool and begin to reflect. Jacob grasped this phenomenon accurately, starting with culture and then extending to the current war in financial market. With the method of symbolization, this poster presents a challenge for the so-called traditional world outlook, moral outlook and values. Targeting at a fact that many people are afraid to face, the design reveals the void nature under a mythical illusion of the seemingly indestructible economic fort, indicating the same situation that different cultures are confronted under the globalization framework. This design is profound in connotation, unique in the employment of visual elements, and thorough in the description of details, rendering the audience a long aftertaste.

Section 3

学生作品及陈述与教授点评(美国)
Work of Student, Narrative and Professor's Evaluation (America)

杰西卡·海斯 | Jessica Hays

设计陈述：

由于文化的渗透，过去这个世纪以来中美文化越来越相似了。我尝试着把设计方向集中在两种文化都存在或都涉及的相似事物上，我的目标是把运动作为这组招贴设计的统一主题。我的灵感来自于北京奥运会招贴中的运动卡通形象，这使我对面部表情和中国京剧脸谱产生了兴趣。

球类统一的特殊意义是我招贴要表现的元素。我想体现不同球类运动之间的互动，这是我把每个球的局部放在不同的画面中通过排列组成一个整球的原因。我想说的是：球类运动相互排到一起背后的意义就是每个人都有共同的东西，即使你在世界的另一边。

目标受众包括了所有年龄组，但是对6～12岁的孩子更合适。我想让每个人都关注它，并且不看文字也能明白其中的含义。我感觉在概念理解上是成功的。

使用棒球和乒乓球是个困难的决定过程。我使用棒球做美国文化招贴是因为棒球是美国发明的，是美国的过去。我使用乒乓球做中国文化招贴是因为我研究了中国的主要体育项目，我发现中国人很严谨并且擅长乒乓球运动。

我希望我能成功设计这组招贴来表现两种不同风格的文化，同时使其具有通用性。我想把一个球放在中间，在世界任何一边的人们都能拿到，使我们能共同享有并彼此关联。

设计陈述
Design Narrative

杰西卡 · 海斯
Jessica Hays

Design Narrative:

American and Chinese culture has become more and more similar in the past century due to cultural diffusion. I tried to focus on similar things that the people of each culture does and can relate to. My goal was to have sports as the unifying theme throughout the posters. My inspiration was the Beijing Olympic posters of cartoon characters playing sports. I was intrigued by the facial expressions and the Chinese opera look all of the characters had.

The significance of the ball is the uniting factor in my posters. I wanted each one to interact with each other. That is the reason for aligning each ball in the center where it lines up with the other ball. I would say the meaning behind the sport balls that align with each other is everyone has something in common even if you live on the other side of the world.

Target audience includes all ages, but it can identify more with children around the ages of six to twelve. I wanted everyone to be able to relate to it and be able to know what it was without text. I feel successful with that concept of understanding.

Reasons for using baseball an table tennis was a hard decision. I used baseball for the American poster because it was a sport invented in America. Baseball is known as America's past-time. The reasoning behind using table tennis for Chinese culture was because I had researched the different sports the Chinese had dominated, and I found the Chinese were very precise and were good at it.

I hope I succeeded with these two posters in showing the different styles of cultures along with making it universal. I hoped by having a ball in the center, other people could pick up that even though we're on the other side of the world we are able to have something in common and relate to one another.

教授点评
Professor's Evaluation

学生作品及陈述与教授点评(美国)
Work of Student, Narrative and Professor's Evaluation (America)

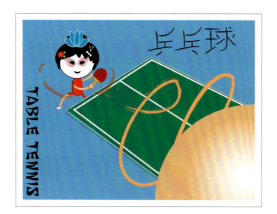

以体育项目为载体描述两种文化的外在区别和内在联系，进而引申为一个文化大同的概念。Jessica 在整个创作过程中紧紧围绕基本创意，努力探寻与主题相关的视觉元素以及表现形式。特别是她个人经过多次练习书写而成的汉字，更能凸显出一种对不同文化的深入理解和浓厚兴趣。"圆"的创意蕴涵了东方文化的博大精深和各种文化间相互融会贯通、逐渐"圆满"的人类文明进程。构图随意中有严谨，富有特色的卡通形象和线的运用，更使得作品活泼生动、富有韵律。

In this poster, sport is adopted as the carrier to show the external distinction and internal relation between two cultures, which is further extended into the concept of cultural harmony. In the design process, Jessica stuck to the fundamental creativity and tried to seek visual elements and expression forms relating to the theme. Among those elements, the Chinese characters that she wrote down herself after much practice particularly emphasizes a deep understanding and strong interests on a different culture. Moreover, the creativity of a circle is to symbolize the profoundness of oriental culture and a human civilization which gradually comes to its complete with an integration of different cultures. The composition is compact yet casual, while the employment of distinctive cartoon characters and lines makes the poster vivid, lively and full of rhythmic beauty.

Section 3

学生作品及陈述与教授点评(美国)
Work of Student, Narrative and Professor's Evaluation (America)

乔·罗林斯 | Joe Rawlings

设计陈述：

这个课题在很多方面对我来说是一种全新体验。我还从来没有设计过一整幅招贴，而且更重要的是我从来没被要求仅设计针对文化及其烙印的招贴。

这个课题在很多方面对我来说是一种全新体验。我还从来没有设计过一整幅招贴，而且更重要的是我从来没被要求仅设计针对文化及其烙印的招贴。

最后我脑中出现了一个灵感：美国是一个消费的国家而中国是一个工业化国家，这就是它们相关联的地方，我想表现美国人希望不工作就得到他们想要的东西。通过这个想法设计招贴，我们发现我们的手被绑在了背后。而关于中国的招贴设计，我的想法是人们通过努力工作获得他们想得到的，这使我想到用中国的秦始皇兵马俑列队对比充满大群工人的工厂。

主题确定后就该研究构图和视觉创意了。我找了很多集中表现版面内部空间的带有宽大页眉、页角的中国文章例子。对于美国的招贴设计，我想让信息更简洁，但是不完全清楚的去说明，更不刻意考虑主题。在我看来红、白、蓝三色最能代表美国文化；红、金、绿是中国文化的代表色。我希望招贴更有活力而不呆板，所以我通过对角线构图、多种色彩以及招贴中引人注目的线条感去创造视觉动感。

总的来说这是一次愉快的、不断增长能力的设计体验。通过这样的练习一个设计师得到了真正的成长和新的视角，这个视角对于设计者成功提供一种视觉体验来说是非常重要的。

Design Narrative:

This project was a totally new experience for me on multiple levels. I had never had any experience with designing a full size poster, but more importantly I had never had to designed anything based solely based on a culture and its stigmas.

To start I spent a lot of time brain-storming any and all of the ideas that I could come up with. I wanted for the posters to have a common thread that would help to tie then together for an overall cohesiveness. I did not however want for it to be a dead giveaway I wanted the audience to interpret on their own for a more intimate experience as a whole.

In the end I kept coming across the idea that America is a consumer nation and China is an industrial nation, and it is here that their relationship lies. In the American poster I wanted to covey that Americans expect to get what they want when they want without much work. It is through this that we find our hands tied behind our backs in the red. Whereas China in my mind comes off as a nation full of hard working civilians that work very hard to attain all that they have. It made me think of the Terra Cotta Army of China in the vast long lines of the Chinese army in comparison to of sweatshops full of an army of workers.

With a theme chosen it was time to research layout and visual ideas. I found many examples of Chinese pieces with large headers and footers with the main focus in on the interior. For the American poster I wanted the message to be simple but not completely spelled out and not to abrasive considering the subject matter. Red white and blue was an easy color choice for America and for me it seems red gold and green are prominent colors for the culture to use. I wanted the posters to be alive and to not appear stagnant so I applied visual motion through strong diagonals, sweeping color fields, as well as line to carry the eyes around the posters.

Over all it was an enjoyable experience and a growing experience. It is through exercises such as this one and a designer and really grow and take on new perspectives; perspectives that are essential for a designer to be successful in the pursuit of providing a meaningful visual experience.

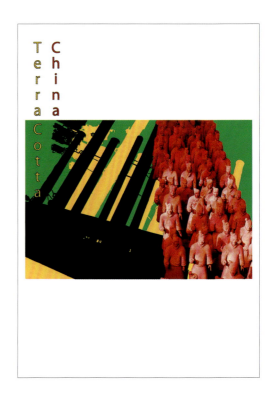

教授点评
Professor's Evaluation

学生作品及陈述与教授点评(美国)
Work of Student, Narrative and Professor's Evaluation (America)

乔在课题进行的前两个星期一直没有动静，只是反复地告诉我，会让我满意的。他是一个善于思考、做事精细、勤奋敬业的学生。但是这次他不同于在我其他课上的表现。我默默地观察、等待，任由他闭目沉思、信手涂鸦。我信任他，正像我信任所有的学生一样。对于他来讲，在这个阶段任何引导都可能成为干扰意识流的噪声。我选择了微笑的沉默。他需要这样一个痛苦思考的经历。两个星期后，他交给了我几个创意和一批草图。我默许了，尽管不是最好的。之后，他便开始了多个草图的视觉化图像处理。课题进行到最后一天是作品展示。他所展示的作品却是一个令人大吃一惊的全新创意。在他的作品中，一个看似松散、无序、随意、颠覆设计原理的未完成作品中所表现的是一种被捆绑了的、被超前消费所误导的数字化美国梦，和一种基础空白、横空出世的劳动密集型世界工厂的中国现状。看似松散的构图，恰恰体现了这个世界的无序；看似未完成的作品却准确地表现了文化发展和文明进程的不可预知性。整体设计采用了逆向思维的手法，以设计缺陷制造了强烈的视觉冲击，给受众留下了广阔的深入思考空间。

Joe did not take any action during the first two weeks of the project, but kept telling me that he would hand in a satisfactory design. He has always been a careful and diligent student who is good at thinking. But this time, he acted differently from what he did in my other courses. I just observed and waited, leaving him enough space to think and scribble. I trust him, just like I trust any other student. I knew that in this stage, any direction could become a noise which interrupted his stream of consciousness. So I chose to be silent, and smiled. He needed such a thinking process, maybe painful but necessary. After two weeks, he submitted several creativities and dozens of drafts. I accepted with silence, although they were not the best ones. After that he began to process visualized images of the drafts. Then finally came the day when students were supposed to present their designs. What Joe presented was a complete new creativity, a big surprise. Loose, casual, half-done, disordered, the poster seem to subvert design principles but actually show a digital American dream which is restrained and misled by over consuming, as well as the present situation of China being a labor-intensive world factory which has no foundation but surprises the whole world overnight. A seemingly loose composition represents a disordered world, while a seemingly half-done work expresses the unpredictability of culture development and civilization progress. With a reverse thinking, this design creates a powerful visual effect through design defects and leaves the audience an immense thinking space.

Section 3

学生作品及陈述与教授点评(美国)
Work of Student, Narrative and Professor's Evaluation (America)

丽莎·普拉特 | Lisa Pratt

设计陈述：

在本课题中，我想要表达的观点是世界正朝着文化全球化的方向发展。通常情况下，视觉元素的描述也反映了社会的发展趋势，所以我结合了这两种观点来进行我的招贴创作。

在中国招贴设计中，为了表现中国传统文化，我选用了剪纸风格的熊猫形象，接下来我选择了在中国随处可见，同时能够作为美国显著象征的麦当劳标志与其拼合。把这些元素融合到一起，我认为我找到了能够架起中国传统文化与全球文化结合的桥梁。我想要我的招贴做到简洁，以保证我想要表达信息的完整性。所以在设计中，我用没有纹理的平铺色来模仿中国传统剪纸艺术的自然平滑。为了保持视觉统一性，并再次强调文化的全球化，我把这种风格延承到美国招贴上。

在我的美国招贴中，我选用了拿着中国外卖食盒和筷子的米老鼠作为主体形象。米老鼠不论在美、中两国都是一个非常容易识别的符号。在色彩上，我使用代表美国的红、白、蓝三色。

有意思的是，中国食品在美国是美国化了的，就如同麦当劳在中国被中式化了一样。尽管菜单列表是一样的，但有时它们需要为了更好地融入当地文化而被改变。这样的现象在文化的其他方面比如服装、音乐、电影里面也可以看到。而我之所以选用食物作为设计元素，是因为我认为它们是最具代表性的文化特征。

设计陈述
Design Narrative

丽莎·普拉特
Lisa Pratt

通过这一课题，我认识到在平面设计中，我们所画的每一个线条、所加的每个文字都必须基于同一个主题，更重要的是要有相应的理念来支撑设计。

In this class I have learned that in graphic design we must have a purpose to every line we draw and every text we add and that having ideas to support our designs are very important.

Design Narrative:

For this project I wanted to convey the idea that the world is moving towards a global culture. Oftentimes design depicts social trends as well as visual unity and I kept both of these ideas in mind as I created my posters.

To represent traditional Chinese culture I chose to use a Chinese paper cut panda. I then wanted to incorporate a very recognizable symbol for America that is now seen all over China as well so I chose to use a McDonald's sign. By putting these things together I think I successfully bridged traditional Chinese culture with global culture. I wanted to keep my poster very simple so that my message would not get lost in my design. I tried to keep the colors flat with no textures as to mimic the flat nature of the traditional Chinese paper cut. I carried this style over to my American poster to keep the two unified and again to show a global culture.

For my American poster I chose to show Mickey Mouse holding a box of Chinese takeout. Mickey Mouse is a very identifiable character in the U.S. as well as in China and I used the colors red white and blue for the U.S. as well.

The interesting thing about Chinese food in America is that is similar but often times Americanized. This holds true for McDonalds' in China as well. Although many of the menu items are the same, they are sometimes changed to fit into the culture more easily. This can also be seen in other areas of culture such as clothing, music, and movies. The reason I chose to use food was because they have the most identifiable cultural symbols.

教授点评
Professor's Evaluation

学生作品及陈述与教授点评(美国)
Work of Student, Narrative and Professor's Evaluation (America)

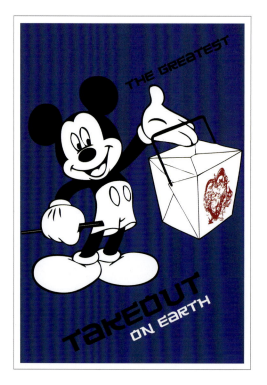

选用目标受众所熟知的视觉符号作为形象主题，本身就会使作品具有一种亲切感，类似的视觉符号同样会唤醒目标受众的视觉经验记忆，从而引起共鸣。Lisa在她的设计中选用了中美两国受众所熟悉的、憨态可掬的熊猫和诙谐滑稽的米老鼠形象作为两种文化的主题代表，同时用剪纸和卡通风格强调了不同文化的特征，并把两幅作品作为一个整体，交互穿插代表对方饮食文化的相应视觉元素，有效地表达了在国际大语境背景下文化交融和相互注入的生命力。设计定位准确，戏剧化的构图组织有效地传达了文化间相互欣赏、相互尊重、相互借鉴、相互推动的核心设计理念。Lisa在课题进行中，多次向我展示了她所搜集的不同信息，我为她能够准确把握主题，敏锐地摘取切入点，力求简洁明快的设计手段和视觉处理方法而感到欣慰。

Selecting visual signs which are familiar to target audience as the theme itself will render the design a sense of affability, for they will remind the audience's memory of visual experience and arouse sympathy. In this design, Lisa adopted the image of a charmingly naive panda and a funny Mickey mouse which are familiar to both Chinese and Americans. Besides, the paper cutting and cartoon style present distinctive cultural characteristics. The two posters are integrated into a whole unity with visual elements representing the diet culture of opposite sides, thus to express cultural integration and vitality infused through cultural interaction under in an international context. With precise positioning and dramatic composition, this design effectively expresses the core concept of mutual appreciation, respect, reference, and promotion between cultures. During the project, Lisa presented to me many times the information that she collected. She could grasp the theme accurately; she selected the starting point acutely, and finished the design with precise yet simple design methods and visual processing methods. I feel gratified for what she has done.

Section 3

学生作品及陈述与教授点评(美国)
Work of Student, Narrative and Professor's Evaluation (America)

基尔斯蒂·胡里根 | Kirstie Hourigan

设计陈述：

水作为最有力量的、最具破坏性的元素之一，常常激发我的好奇心，所以自然地，我想到可以用它来表现美国和中国文化的差异。

刚开始，我构思过程的处理速度很缓慢。我先在"蜘蛛图"（思维跟踪图）上分析看我能否搜集到与水有关的理念。经过多次尝试，我找到了基点：桥梁。这样我可以将两种观念综合在一起：水可以连接两种文化，但同时它也成为人们必须跨越的障碍。从"桥梁"的创意出发，衍生出文化优势的对比。

具有古老文明的中国，曾经用四大发明推动了世界文明，其中最重要的是造纸术和活字印刷术。在视觉处理上，我希望我的招贴能显示这些元素。因此，我利用一个跨越了活字印刷版的桥梁构成了招贴的主要画面，以此寓意古代文明与现在文明的连接。图像形成以后，我又把它处理成（与主题和内容相对应）木版印刷风格。文字设计得比较简洁有力，因为我希望招贴的焦点在图像上。标题部分，我选择了水的中文象形字，这是在中国文化中很简单却有力的符号。

美国招贴的设计更富有挑战性。为了与中国招贴有所区别，我想让美国招贴看起来更现代、更能让人想起文化的现状。美国并没有发明生活需求品，而是发展出一个始于计算机的技术世界。我想这就是表现两个国家之间对比的最完美的方式：一个国家发明了减轻手写工作的方式，而另一个国家则进一步发展，在新

设计陈述
Design Narrative

基尔斯蒂·胡里根
Kirstie Hourigan

千年里给世界提供了新技术。桥梁的部分,我选择了能代表时尚性和技术品质的金门大桥。而文字部分,我选择了简洁的尖体字,特别是"W"能让人想起埃及的象形字和今天文化的来源地。

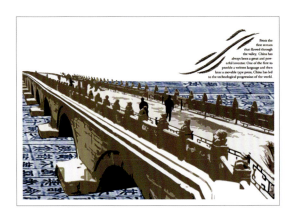

Design Narrative:

Water, being one of the most powerful and destructive elements, has always intrigued me, so naturally I thought that it could be used in a functional way to portray the two distinct cultures of the United States and China.

At first my process of coming up with a solution was very slow. I started with a spider diagram to see if I could brainstorm any ideas surrounding the idea of water. After a couple tries, I found my idea: bridges. From there I could piece together the idea that water can connect different cultures but it can also be a barrier in which people have to overcome. From idea of the bridges came the idea of comparing different advances in each civilization.

China, being the older civilization invented four things that has progressed the civilization of the world, two of the most important being paper and woodblock/ movable type printing. For my visual solution I wanted the poster to symbolize all of these elements. Therefore my image portrays the Lugou Bridge over the movable type characters as a bridge that can bridge the ancient culture to the present day. After the image was composted I wanted it to look like it has been cut out in a style of a woodblock print. As for the text in my poster, I wanted it to be brief but powerful, since I wanted my focus to be on the image. For the title I chose a pictograph of water or a stream, which is a very simple but powerful symbol in Chinese culture.

The poster for the United States was a bit more challenging. In contrast to the Chinese, I wanted my American poster to look very modern and reminiscent of the culture it has become today. Instead of inventing things that have been necessary for life,

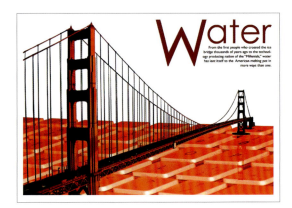

America has developed a world of technology beginning with the computer. I thought that this was a perfect way to contrast the two countries, one who has developed the way to produce written works and one who has gone farther and given something to the world that they use in this millennium. As for the bridge I chose the Golden Gate because of its modern and technological quality that it has. For the title I chose very simple and pointy fonts especially for the "W" which is reminiscent of the ancient Egyptian pictograph and where that culture has come from today.

教授点评
Professor's Evaluation

学生作品及陈述与教授点评(美国)
Work of Student, Narrative and Professor's Evaluation (America)

生命起源于水，生命离不开水。中华文明诞生于黄河流域。从两河流域文明，尼罗河下游文明到印度河中下游文明等，纵观历史上几大文明的诞生都与不同的水流域有关。Kirstie 来自具有多种文化氛围的加利福尼亚。太平洋的海风，加州的阳光培养了她强烈的求知欲和对事物的好奇心。课题进行中，她多次与教授交谈，阐述她的想法，并能敏锐地领悟教授的引导，完成对信息分析由浅入深，由繁到简思考的心路历程。每一次交谈中，她都能充满激情地逐步发展和完善其原始创意。文明属于全人类，不同的地域文化都是构成人类整体文明不可或缺的组成部分，正是由于各个部分的不可或缺性在历史形成中所起的重要作用，才使得人类文明不断地递进和完善。在她的作品中，桥作为时间纽带，连接了古代和现代；桥作为空间纽带，连接了人类不同的地域文化。经过透视效果处理的桥，预示着人类文明的不断延伸；活字印刷版和计算机键盘体现了时代文明在历史长河中人类文明递进的显著特征。中国篆字和简洁的英文字体更能体现一种强烈的时代感。其中中文"水"的象形字和看似波浪的英文"水"开头字母的 W 更显示了人类不同地域文化的相似性和异样性，具有震撼的视觉冲击力。在色彩上，来自中国古代文明的稳重基调和美国现代文明的豪放基调犹如交响乐中的不同乐章，彼此关联、交相呼应，奏响了人类文明历史的辉煌篇章。

Life originated with water and depends on it. Looking back at history, it is easy to find that all ancient civilizations had something to do with water, with the Chinese civilization originating in the Huanghe River Valley and civilization emerging along lower reaches of Nile River as well as lower-middle reaches of Indus River. Kirstie comes from California, a place of cultural diversity. It is in this distinctive regional cultural atmosphere that she develops a strong thirst for knowledge and great curiosity. During the design process, she discussed a lot with the professor, explained her own ideas and always showed quick response to instruction. With a sagacious perception and great passion, she finished the process from information analysis, creativity design to the final improvement; she finished the process from appearance to its deep connotation, from the simple to the complex. Civilization belongs to all human being, while different regional cultures all play an indispensable part in the whole human civilization. It is because of the influence exerted by different cultures that human civilization develops and progresses. In Kristie's design, the image of bridge acts as connection between the past and present in time, and a connection between different regional cultures in space. The bridge image was processed in a perspective way to symbolize a continuous extension of human civilization, while the typographic plate and computer keyboard represent civilization progress. Moreover, Chinese seal characters and English letters embody a strong sense of the times. The Chinese pictographic character of "shui" (water) and the initial letter W of "water" illustrate similarities and differences between different regional cultures, delivering an infectious visual impact. As for the color of the posters, a sedate hue representing Chinese ancient civilization and a bold hue representing American modern civilization act as different chapters in a magnificent sympathy, which presents a brilliant picture of human civilization progress.

Section 3

学生作品及陈述与教授点评(美国)
Work of Student, Narrative and Professor's Evaluation (America)

泰斯·琼斯 | Tyce Jones

设计陈述：

在这一设计中，我选择"忠诚"作为主题，我对如何表现出每种文化的忠诚所指很感兴趣，并希望在招贴中利用同样的构图方式进行两者之间的比较，我认为有足够的文化差异来形成对比，最后的视觉效果应该会很好地把它呈现出来。

在中国招贴里，我选择了戏曲舞台上的一个演员。他带着传统的面具，扮演刘备将军旗下，以勇气和忠诚闻名于世的大将关羽。面具上的红色代表了勇气和忠诚。

而在美国招贴上，我选用了典型电视迷，通常被人称作沙发土豆的形象，他身穿自己喜欢的球队的服饰。表达上，我使用了幽默的手法，使招贴有一种比较滑稽的感觉，用来增强两种文化间的对比。这样会不会更加轻松一些？

Design Narrative:

I have chosen the theme of loyalty for this project. The idea of portraying what each culture is loyal to seemed very appealing to me. I wanted the same layout for each poster to compare them and there are enough cultural differences to make a contrast. I feel that the final result turned out very well.

For the Chinese poster I have a Chinese Opera actor on stage. He is wearing the traditional mask for the warrior Guan Yu, who is known for his courage and loyalty under the general Liu Bei. The red in his mask symbolizes courage and loyalty.

On the American poster I have the typical couch potato wearing the colors of his favorite sports team. I decided to make this poster more comical than the previous. This creates even more contrast between the two cultures and, by using humor, it is done in a non-threatening way.

教授点评
Professor's Evaluation

学生作品及陈述与教授点评(美国)
Work of Student, Narrative and Professor's Evaluation (America)

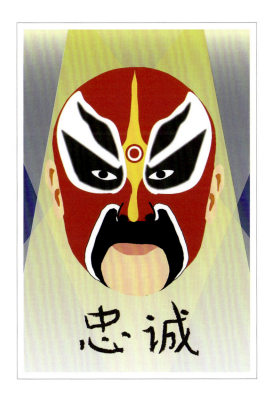

不同的文化都在各自不同的舞台上展现其独特的魅力。Tyce准确地猎取了能代表中美两国文化中对于"忠诚"的不同概念的认知，充分利用了中国历史戏剧舞台人物中有关"忠诚"的脸谱化艺术形象和美国现实生活舞台中球迷的典型形象作为不同文化背景下的"忠诚"的视觉化标志概念，准确地把握了目标受众的认知心理，充分调动了目标受众的形象记忆，将戏剧中的"忠诚"和现实中的"忠诚"融会贯通，交相呼应，从而有效地诠释了有关"忠诚"的理念，完成了精炼典型性格、典型人物、典型形象的哲学思考过程和概念设计，并采用对称构图方式，简洁明快的形象描述和具有地域文化特色的色彩构成，进一步强调了主题的严肃性和可识别性。

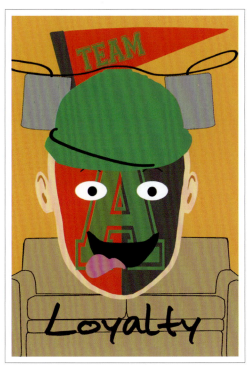

Different cultures show their distinctive charm on their respective stages. Tyce selected the most representative symbols to show different understanding of the concept "loyalty" in Chinese and American cultures. The facial type representing loyalty in Chinese Beijing Opera and a typical football fan image in American real life were chosen to illustrate the concept of "loyalty" in a visualized way, with the target audience's cognitive psychology and visual memory fully mobilized. "Loyalty" in opera and "loyalty" in real life are combined and integrated, which effectively interpret the "loyalty" concept. In addition, the design process is also a philosophical thinking process concerning typical characteristics, typical characters and typical images. While a symmetric composition and concise description together with colors full of regional cultural flavor emphasize the seriousness and recognizability of the theme.

Section 3

学生作品及陈述与教授点评(美国)
Work of Student, Narrative and Professor's Evaluation (America)

凯蒂·泊罗尼 | Katie Poloni

设计陈述：

我以节日为我的招贴主题。我选择中国的新年代表中国文化，美国的感恩节代表美国文化。这两种节日在各自的国家都非常的特别，并且在别的国家都不会有。

中国的新年是一年中最重要的节日，中国的农历决定阴历新年的日期。今年是中国的牛年，我把这一概念引入到我的招贴中，用一个动物作为招贴的核心元素，同时加入中国新年的传统红色、黄色、黑色，还有汉字、灯笼等常见的元素。

在美国,感恩节是非常重要的节日。朋友、家人们在这一天相聚一堂，回忆他们的爱，祝福，快乐，并为他们被赐予的每一件事而感恩。感恩节中最重要的事情是宴会。家人相聚在一起，享用所有的传统食物，比如番薯、土豆、玉米、馅料等，并以火鸡为主菜。我以火鸡为招贴的主要图形，因为它跟感恩节有最直接的联系。同时，我将所提到的主要字词作为招贴的背景。

Design Narrative:

For my posters I chose to do holidays. I focused on the Chinese New Year for China Culture, and Thanksgiving for American culture. Both of these holidays are specific for their country and are not found anywhere else.

The Chinese New Year is the most important holiday of the year. The lunar Chinese calendar determines Chinese New Year dates. This year, it is the year of the ox. I focused this concept into my poster by using the animal as the main focus point. I also used the traditional red, yellow, and black colors of the Chinese New Year, and used Chinese characters and lanterns which are very common also.

The Thanksgiving holiday for America is a very important holiday in the country. It is a time where friends, and families can meet together and reflect on their love, blessings, happiness, and be grateful for everything they have been given. The main part of Thanksgiving is the feast. Families meet together and have all the traditional foods as yams, potatoes, corn, stuffing, etc. They also have a turkey as the main dish. I used the Turkey as the main icon on my poster because that is what is directly connected with Thanksgiving the most. And placed the main words I talked about as the background of the poster.

教授点评
Professor's Evaluation

学生作品及陈述与教授点评(美国)
Work of Student, Narrative and Professor's Evaluation (America)

民族传统节日往往最具有文化特征，也可以称做地域文化的活化石。在凯蒂的作品中，中美元素的大量运用，充分体现了中国传统节日——春节的喜庆、热闹和祥和的浓郁气氛以及具有美国特色的感恩节文化。从构图、色彩和字体编排上准确地传达了人们向往美好生活的设计理念。

National traditional festivals can be the most representative in terms of cultural characteristics, which makes them deserve the title of "the living fossil" of regional cultures. In Katie's design, elements full of Chinese and American flavors were chosen to create a festival atmosphere, be it a joyful Chinese Spring Festival or a distinctive American Thanksgiving Day. What's more, the composition together with the arrangement of colors and words precisely conveys a design idea that all people pursue happy life.

Experimental Education of Intercultural Visual Communication Design

Section 3

学生作品及陈述与教授点评(美国)
Work of Student, Narrative and Professor's Evaluation (America)

卡米·塔布斯 | Cami Tubbs

设计陈述：

这两幅招贴展示了中国与美国的美丽的景观，以及促进两国发展的商贸路线。

我把长城作为对中国招贴的切入点。这个墙在早前是为了抵御外来侵略的，但是现在却成了美丽的历史标志。我把丝绸装点在长城的走道上来代表"丝绸之路"。丝绸之路是一条古代从中国延伸到亚洲内陆的贸易路线。不仅仅连接了商品和商人，也为文化和技术的交流提供了途径。那时丝绸是最重要的商品，但除此之外也有其他的一些商品。丝路对中国人民来讲非常重要。我选择了红色作为主色调，这是中国国旗的颜色，是勇气的象征。

美国招贴中，我重点展示了广阔开放的美国西部景观。特别是拱门国家公园内精致的著名标志性特色景观——拱门。我选用它的造型是因为它是一种当别的力量试图将它击败时却一直坚强地耸立在那里的象征。同时我设置了一条从拱门下穿行而过的高速公路，这是很有历史意义的66号高速公路。这条高速公路是移民西部的重要通道，特别是在20世纪30年代，它连通了伊利诺斯州的芝加哥和加利福尼亚州的洛杉矶。人们在沿路设商店，做生意，或者为游客提供服务，为人们摆脱经济大萧条提供了很大的帮助。同时，我还想展示国旗，因为国旗是我们得到自由的重要象征，所以我在招贴的下半部用蓝色表达了这个理念。

中、美两个国家都充满了美丽的奇迹，也都拥有让我们走到今天的路。从外表上看，美

设计陈述
Design Narrative

卡米·塔布斯
Cami Tubbs

国和中国是不同的，但归根结底，我们是在用不同的方式做着同样的事情。

Design Narrative:

These two posters represent China and America related to their beautiful outdoors and the routes of trade that have greatly advanced both countries.

 The Great Wall was my main point of focus for China. Although the wall served a great purpose in protection against attacks in its earlier days it now is more of a beautiful symbol of history. I chose to lay silk in the walkway of the wall in order to represent the Silk Road. The Silk Road is a route for trade; extending across the entire Asian continent, not only linked traders and merchants, but provided a path for cultural and technological transmission. Silk was the main commodity that was traded, but there were many other things were traded also. The Silk Road was very important to the people of China. I chose red as the main color for the poster because it is the color of their flag and because it is a strong bold color.

 The American poster I chose to emphasize the great open spaces of the Western US. Delicate arch, within Arches National Park, is a well know feature. I chose to use an image of it because it is an icon standing strong when the elements are trying to bring it down. I also chose to lay a highway that led through the center of the arch. This is a representation of the historic Highway Route 66. This highway was a major path of the migrants who went west, especially during the Dust Bowl of the 1930s. It originally ran from Chicago, Illinois to Los Angeles, California. People began to prosper by setting up shops and businesses along the road to provide services to the travelers. This helped people to bring people out of the great depression. I wanted to show the flag because it is a very important symbol of our freedom that so many people take for granted these days. I used blue to match it in the lower section.

 Both countries are filled with beautiful wonders and both are filled with routes that have helped us to get to where we are today. The US and China are so different on the outside but when it comes down to it we all do the exact same things, just in different ways.

教授点评
Professor's Evaluation

学生作品及陈述与教授点评(美国)
Work of Student, Narrative and Professor's Evaluation (America)

中国的丝绸之路打开了通向世界文明之门，建立了通往中东和欧洲之路，国际贸易和东西方文化交流日趋频繁，在中国了解世界的同时，也让世界读懂了中国文明。美国的高速公路不仅挽救和振兴了美国经济，而且也成为美国现代文明的重要标志之一。Cami 敏锐地捕捉到了这两个具有可比性的事件，巧妙地运用相应的视觉元素，营造了一个富有层次感和文化特征的视觉空间。在中国作品上所运用的长城、丝绸图案、梅花和汉字以及在美国作品上所运用的美国国旗、石拱门和高速公路等元素，不仅隐喻了中国古代文明的壮丽和美国现代文明的辉煌，更重要的是体现了人类总是在各自不同文化背景下"用不同的方式，做着相同的事情"的理念，并充分强化了主题。穿过石拱门的高速公路更加寓意了一个现代文明的里程碑，铺在长城上的丝绸犹如通向未来文明的红地毯。设计形式积极生动，细节充分，图像处理精致，字体选用准确，整体创意既在意料之外，又在情理之中。好！

Chinese Silk Road is a road leading to world civilization, a road connecting the Middle East area and Europe, and a road which facilitates international trade and communication between Eastern and Western cultures. It provides an access for China to know the world and vise versa. On the other hand, American highway does not only rescue and promote American economy, but also serves as one the most representative symbols of American modern civilization. In this design, Cami captured these two comparable events ingeniously. With relevant visual elements, she created a visual space that had a sense of depth and distinctive cultural characteristics. The Great Wall, pattern of silk and Chinese characters in Chinese poster symbolize splendid Chinese ancient civilization, while American national flag, stone arch and highway in American poster indicate brilliant American modern civilization. Furthermore, it delivers a concept that people are "doing the same thing in different ways" under different cultural background. The theme is cleverly emphasized when the highway passing through the stone arch acts as a representative milestone in human modern civilization and the silk spreading on the Great Wall symbolizes a red carpet leading to future civilization. In summary, this design is lively in style and fully detailed with elaborately-processed images and precisely-chosen fonts, while the overall creativity is so unexpected yet reasonable. Good job!

学生作品及陈述与教授点评(美国)
Work of Student, Narrative and Professor's Evaluation (America)

杰基·斯托达德 | Jacki Stoddard

设计陈述：

中华五千年文化中，舞蹈被用来表达很多东西。在这种文化中，舞蹈曾经被用以表达对神灵的崇拜。随着时间的推移，中国舞蹈已发展成为一种表达个人情感和激情的方式，也是一种将文化纳入象征意义的运动方法。中国舞蹈有其独有的"词汇"、"语义"和"组织结构"，这些可以帮助舞蹈演员用轻松而优雅的肢体语言充分表达其思想感情。

中国舞蹈最初始源于军队和民间两种截然不同的群体。他们使用不同的道具来象征并庆祝日常生活中的一些特定事件。军队舞蹈中，舞者携带着武器组成或大或小的方队，有秩序地前后移动。后来，这种舞蹈逐渐演进得更加独特且"随意"，比如人们以手舞足蹈来表达他们对自然和天地神灵的感激。中国的舞蹈因其表达人的情感而闻名，不管所表达的是快乐还是悲伤。每个原住民部落都发展出了不同类型的舞蹈，比如位于中国的大西南的苗族，发展出了一种载歌载舞的形式，而台湾的原居民会用举起的双手构成线条形的舞蹈作为丰年祭（一种庆祝丰收的仪式）的一部分。

当年轻人开始习舞时，他们一般首先选择芭蕾或者现代舞。当熟悉了这两个舞种后，他们会转向学习传统的中国舞蹈。在当今中国，中国舞蹈风格已经发展成了前所未有的主流角色。古典舞蹈依然流行，并且对现代舞蹈也产生了举足轻重的影响。

在美国，舞蹈被分化成多种风格。古典芭蕾在1933年被乔治·巴兰奇引进美国。他的理念是创作一种情节较少的芭蕾，"随乐而动而并非依照故事情节"，在美国人们把这

设计陈述
Design Narrative

杰基·斯托达德
Jacki Stoddard

种主流的、广为人知的风格叫做现代舞。爱多拉·顿肯、玛丽·威格曼、安摩挈·格雷汉姆都作为现代舞的先驱而闻名，他们反对古典芭蕾严格的教条束缚，更多专注于创作能够表达个人情感而非展示个人精湛技艺的舞蹈。现代舞"相对于芭蕾的刻板来说，是一种更为放松、自由的随心设计的舞步"。另外一种给现代娱乐带来全新风格的舞蹈是嘻哈舞，嘻哈起源于20世纪70年代的纽约，是非洲裔美国人和拉丁裔美国人首创的，这种风格的舞蹈也被称作霹雳舞。霹雳舞吸纳了"定格"的动作，它给舞蹈带来的巨大影响就是伴随着舞蹈音乐。说唱音乐和嘻哈的音乐舞蹈一般就是采用这种风格的舞蹈。歌曲中的节拍使舞者找到他们身体运动的节奏。

中美两国的舞蹈文化有相同也有不同。在这两种舞蹈中，化妆、音乐和表现形式等各方面都是不同的，但它们在表达个人情感及天赋等方面却是相同的。每种舞蹈，无论现在还是将来，对各自的文化都是极其重要的。

For the past 5,000 years the Chinese culture has used dance for many things. Respecting and honoring gods was one of the main reasons dance was used in this culture. Over time Chinese dance has developed into a way of expressing an individuals passion for something, and also a way to incorporate their culture into symbolic movements. "Chinese dance has its own unique vocabulary, semantics, and syntactic structure that enable a dancer on stage to fully express his thoughts and feelings with ease and grace".

Respecting and honoring gods was one of the main reasons dance was used in this culture. Over time Chinese dance has developed into a way of expressing an individuals passion for something, and also a way to incorporate their culture into symbolic movements. "Chinese dance has its own unique vocabulary, semantics, and syntactic structure that enable a dancer on stage to fully express his thoughts and feelings with ease and grace".

When young dancers are just beginning to learn dance they generally with study ballet, and modern dance. After these two styles are familiar with the dancer they then will go and study the syntax of traditional Chinese dance. In today's Chinese dance the styles have evolved into a much "bigger mainstream persona than ever before…". Ancient dances are still being studied, but modern dance has made a huge impact on the way this culture now views and performs dance.

In America dance has branched out into numerous types of styles. There is the classical ballet that was brought to America by George Balanchine in 1933. His idea was to create plot less ballets "where the motivation was movement in response to music rather than to a storyline". One of the main and most well known styles of dance in America is Modern dance. Isadora Duncan, Mary Wigman, and Martha Graham were known as being the early pioneers of modern dance. They rebelled against the rigid constraints of classical ballet and focused more on creative self-expression instead of technical virtuosity. Modern dance is "a more relaxed, free style of dance in which choreographers use emotions and moods to design their own steps, in contrast to ballet's structured code of steps". Another form of dance that has brought on a new sense of style and entertainment is hip-hop. Hip-hop is a cultural movement that was developed in New York City in the early 1970's. African Americans and Latino Americans were the first to develop these new movements. Another name for this style of dance is also called break dancing. Break dancing involved the movements of "popping and locking". One thing that brings a huge impact to this style of dance is the music that goes along with it. Rap and hip-hop music are most commonly used for this style of dance. The beats that are created through the song enable the dancer to find rhythms with their body.

Dance in both American and Chinese cultures has its similarities and differences. The costumes, music and representations that are portrayed are some of the differences that can be found in each. As for similarities, dancing to express ones emotions and talent is what they have in common. Dance is extremely important to each culture and always will be.

教授点评
Professor's Evaluation

学生作品及陈述与教授点评(美国)
Work of Student, Narrative and Professor's Evaluation (America)

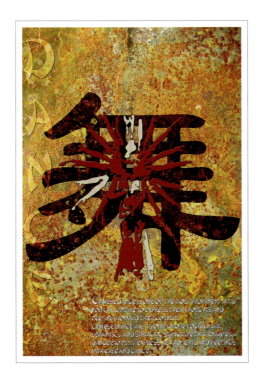

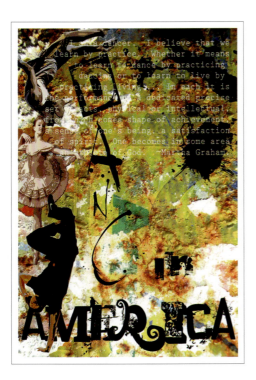

言之不足,歌之咏之。歌咏之不足,舞之蹈之。舞蹈是人类表达情感境界的最高方式。举手投足间体现了悲欢离合,婀娜多姿间展示了喜怒哀乐。从古代岩画和壁画上可以发现,舞蹈是古人一项重要的社会活动,是与巫术、宗教信仰和图腾崇拜密切关联的,具有强烈的地域文化特征。Jacki通过大量的研究和精确的信息筛选,采用中国古代岩画和美国现代街头涂鸦的视觉表现手法,既表现了舞蹈在中国文化中的历史感和在美国文化中的现代感,又分别诠释了舞蹈在人类文明中所体现的情感特征和时代特色的共性和个性,并通过严谨细腻的图像处理,营造出了一个强烈震撼的生动视觉效果。

When language fails to express one's exact feeling, songs come to rescue. And if songs are still not enough, you can always resort to dances. Dancing is the highest expression of human emotions with all the happiness and sadness embodied in every act and move. From ancient rock-paintings and mural paintings, it is easy to find that dancing was an important social activity for ancient people, which was closely related to witchcraft, religion and totemism and thus had distinctive regional cultural characteristics. Based on a great number of studies and a precise selection of information, Jackie adopted Chinese ancient rock-paintings and American modern street graffiti as visual elements to illustrate a historical sense that dancing reveals in ancient Chinese culture and a contemporary sense that dancing gives off in American culture. Besides, emotional characteristics of human civilization embodied in dancing, together with its general and specific features of different eras are further interpreted through a careful and meticulous image processing, which exerts an attractive and vivid visual impact on the audience.

Section 3

学生作品及陈述与教授点评(美国)
Work of Student, Narrative and Professor's Evaluation (America)

劳拉·普拉特 | Laura Pratt

设计陈述：
劳拉·普拉特没有提交设计陈述。

Design Narrative:
No Narrative was submitted by Laura Pratt.

教授点评
Professor's Evaluation

学生作品及陈述与教授点评(美国)
Work of Student, Narrative and Professor's Evaluation (America)

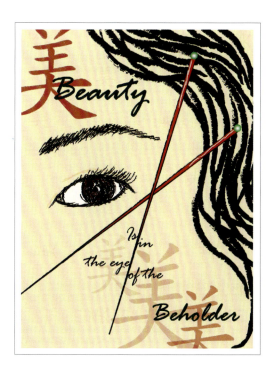

在课题进行中，Laura对教授的表述翔实充分，她表达的理念是"美"在不同文化背景下的定义。她想通过在作品中所出现的诸如中国的汉字、簪子、黑头发、黑眼睛和黄皮肤以及美国的头饰、金发碧眼和白皮肤等视觉元素的散点式组合，留给观众一个丰富的想象空间。我尊重她不提交设计陈述的选择，真诚邀请读者根据对作品的认识进行品评。

During the process of the project, Laura presented to the professor in detail her design concept that how "beauty" is defined in different cultures. In her design, Chinese characters, hair clasps, and the typical black eyes, black hair and yellow skin, together with the American headwear, a blond white-skinned America image were arranged in a splashed way, leaving the audience a vast space for imagination. And I respect her choice not to give design Narrative but welcome the audience's comment according to their own understanding.

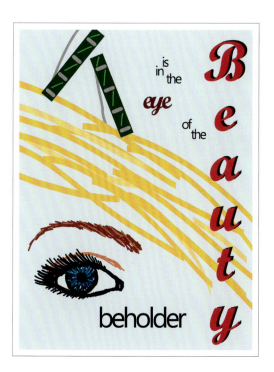

Section 3

学生作品及陈述与教授点评(美国)
Work of Student, Narrative and Professor's Evaluation (America)

布瑞塔尼・扬 | Brittany Young

设计陈述：

森林——这幅招贴的背景以蓝色向棕色的渐变为主，代表了天空向大地的过渡。森林二字，在处理上，使颜色和纹理都接近树的样子。用五棵"树"来表示这幅招贴的主旨是森林。文字部分用白色来突显。这幅招贴旨在说明树无处不在，并且在它们被砍伐之前你可以到林中散步。你永远不知道你现在看到的树，在以后会变成什么，它们也许会变成你的下一幢房子。

音乐——这幅招贴呈现出的是由音符组成的单词"music"。M，是一个16分音符，U是两个8分音符，S是高音符，I是双小节线，而C是暂停符。我将这些字母放在页首的五线谱上。显示出音乐本身具有的动感。文字部分是主体，写在表格中。最后一行的"音乐就是一切"不但与文字部分相承接，而且表示音乐存在于任何地方和任何文化中。就像乐谱一样，黑白构成了整个招贴的主色调。

Design Narrative:

Forest — The background of this poster is a gradient from blue to brown which was used to symbolize sky to dirt. The Chinese symbol for forest was taken and made to be colored and textured like trees. This shows that this is about forests because there are 5 "trees" shown in the poster. The body copy was done in white to make it stand out. The purpose of the poster is to show that forests are used for everything and that you should go out and walk in one before they are not there anymore. You never know what the trees you see will become. They may just be your next house.

Music — This poster is the word music made in musical elements. The M is made of a sixteenth note triplet, the U is 2 eighth notes, the S is a treble clef, the I is a double bar line and the C is made from the symbol for cut time. I then placed these 'letters' on a curved staff on the top of the page. This shows motion which is something that music itself has. My body copy is brief and written on a staff. The final line "music is everything" is to bring together the body copy and show that it is everywhere and in every culture. This poster is done in black and white because that is how music is written.

教授点评
Professor's Evaluation

学生作品及陈述与教授点评(美国)
Work of Student, Narrative and Professor's Evaluation (America)

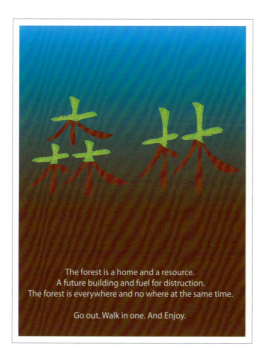

现实世界的环境和精神境界的音乐折射出了物质和精神两种不同的诉求。污浊的色彩和优美的旋律构成了一个矛盾重重、迷乱纷繁的乐章。Brittany试图通过对文字的形象诠释，去找寻已经迷失了的物质和精神相辅相成的和谐要素，深层次地传达了呼唤纯洁和净化回归以及"森林是家，是资源；音乐是一切"的主题诉求。

The environment in real world and music in spiritual world reflect different material and spiritual appeals, while mixed colors and a beautiful melody constitute a movement full of ambivalence and confusion. In this design, Brittany tried to find the lost elements that made material and spirit a harmonious unity through a vivid interpretation of words. In a deeper sense, she wanted to express an urge for purity and return to nature, as well as the thematic appeal that "Forest is a home and a resource; music is everything".

学生作品及陈述与教授点评(美国)
Work of Student, Narrative and Professor's Evaluation (America)

Section 3

查瑞蒂·怀松 | Charity Wysong

设计陈述：

美——关于这幅招贴，我有过很多不同的想法，最后我选择"美"这个字为设计元素。起初，我用红色的像古老斑驳的老墙一样的纹理来填充文字。后来，我听从了其他同学的建议，把它换成了一种花的颜色。上边的紫色代表了花瓣，下边的绿色代表了花茎和叶子，而靠近底部的一笔又变成紫色，代表着脱落下来的花瓣。我把这个字的最后一笔或者说是"花茎"放在最底部。并保留了裂痕欲碎似的纹理。这张招贴表达了每个人对美的看法是不一致的。而这样的不一致也存在于世界上各种文化和不同民族之间。我在处理这个文字细节上投入了很大的精力，而对于招贴的背景却只是用其他颜色做了简单的处理，这样就可将注意力放在主题文字上。

床——我曾为这个设计而不知所措。我只有很少的想法，而且让我喜欢的想法更少，所以我只能随意选择了一个。小写的"bed"很像西方风格的床的侧面。我调整了字母的间距让它们更紧凑从而形成一个完整的床形，然后选择木质纹理修饰床柱，中间的彩格图案使其看上去像铺着床单。我尽量使纹理看上去是平面而不是三维状态。它没有什么隐含寓意——寓意要直截了当。为了起到加固的作用，我加了些投影，并且把投影的缺洞填补完整，这样就可以显现出好像真的有一个投下阴影的床在那里了。

设计陈述
Design Narrative

查瑞蒂·怀松
Charity Wysong

Design Narrative:

Beauty— I had a couple of different ideas for this one, and ultimately chose the character for "beauty". Originally I just had the character in a more scripted looking fond in red bended with the texture from an old, crumbling wall. From the suggestions of my group in class I changed the colors to that of a flower. I made the top purple like petals and the rest green like a stem and leaves, along with the stroke near the bottom being purple representing a falling petal. I rotated the character so as the end of the bottom stroke or the "stem" was at the bottom. I left the broken, crumbling texture. The conclusion to this is that what is beautiful to one person may not be someone else. Many people think flowers = beauty, but there are many people who find the opposite attractive to them. This is true all over the world within individual cultures and between nations. As I put so much detail into the character itself I kept the background with almost no detail but some color to contrast and allow the focus to be on the character itself.

Bed — With this one I was stuck. I had few ideas, and fewer that I liked so I kind of just ended up choosing something at random. In lowercase roman letters the word "bed" resembles a western style bed from the side. So all I really did was decrease the kerning of the letters so they merged to form one object and blended a wood texture for the bed posts and a plaid design for the middle as if it were a blanket. I chose to keep the texture flat and not manipulate them to appear more 3D. There really is no meaning behind this – it's meant to be straight forward. I added a bit of a shadow for reinforcement. I also filled in the holes in the shadow that the word would leave as if it were really a bad casting a solid shadow.

教授点评
Professor's Evaluation

学生作品及陈述与教授点评(美国)
Work of Student, Narrative and Professor's Evaluation (America)

罗丹说过，生活中不是缺少美，而是缺少发现。不同的文化对于美有着各自不同的表述；不同的人基于时间、地点和环境的不同也会对美产生不同的和局限性的认知。Charity 在设计中借用轮廓线强化了人对于美的有限领悟和思维局限，同时在另一张作品中用相同的手法表现了人类行为的局限性，继而隐喻了不同语言和文字的局限性。这恐怕是她所没想到的。

Rodin once said that our eyes do not show a lack of sense of beauty, but a lack of observation. Different cultures have different definitions for beauty, while people of different times, places and environments have different and limited cognitions of beauty. In her design, Charity emphasized this limitation in terms of beauty appreciation and thinking by using contour lines. The same method was adopted in another poster to show the limitation of human behavior, which further implies the limitation of different languages. And this further implication effect might be something that Charity did not expect when she made this design.

Section 3

学生作品及陈述与教授点评(美国)
Work of Student, Narrative and Professor's Evaluation (America)

大卫·帕修斯 | David Pocius

设计陈述：

咖啡——第一个设计，我选择中国汉字来展示"咖啡"。首先，我将一幅从网上下载的图片置入 Illustrator 进行修改。一开始，我先绘制了字符的最后一个元素，使它比其他笔画更大一些，形状也区别开来。我想在视觉上展现出热气腾腾香气缭绕的感觉，所以我把字体制作的弯弯曲曲。接着，我在下边添加了一个咖啡杯的形状。我觉得咖啡杯是很好辨认的，所以我只是简单的画了几笔来暗示。我把这个图像放在招贴的正中间。因为要把注意力加放在招贴的中间部分，所以这也决定了对于色调的处理。

下一步，我把精力放在文字的处理上。从最开始，我就想引用与图像有关的名言。通过网上搜索，我选择了现在使用的文字。这句话很幽默，所以开始的时候我想找一些好玩的或者有意思的字体去体现它，但是后来发现没有特别适合的，于是我决定使用复杂而优雅的经典广告字体，这样就跟警句的语气形成了一个强烈的对比。最后，我需要一个美好的、独立的单词把招贴里的元素串联起来。标题"焦虑"，在很大程度上受到了警句背后所暗指的真正含义的影响。

吉他——第二个设计，我选择了中国汉字来展示"吉他"。首先，我将一幅从网上下载的图片置入 Illustrator 进行修改。我先画下了图像里的第一个元素。我认为这些线条与实际的吉他外形非常相像，于是我就从网上找到一幅吉他的图片，然后用 Illustrator 进行了处

设计陈述
Design Narrative

大卫·帕修斯
David Pocius

理。我把这个图像的方向、大小、透明度等进行了调整，然后置于汉字的下面，以此作为模板，来规划整个图像的线条轨迹。我觉得吉他的形状是很好辨认的，所以只用了简单的线条来暗示。我把这个图像放在招贴的中间，同时背景色的处理也把人的注意力引向这一部分。

紧接着，我重点处理图像的主体文字。从一开始，我就想引用一句与图像有关的名言。在网上搜索一番后，我最终选择了招贴中所使用的 William Christopher Handy, or W.C. 的这句话。Handy, 被誉为"布鲁斯之父"。Handy 赋予了音乐以现代风格，而且，是他将音乐从小城镇带入了美国的主流社会。这些信息在很大程度上影响了招贴的标题和颜色。在字体的使用上，也展示出了世纪美学的转变。

Design Narrative:

Coffee — For my first layout, I chose to incorporate the Chinese symbol for "coffee". First of all, I placed a picture of the symbol I found on the Internet into Adobe Illustrator. I was initially drawn to the last element of the symbol being slightly larger and of different shape than the others. I wanted to visually depict the element as hot and aromatic, and used a warp effect to twist and curve the shape. Next, I wanted to create a coffee cup shape underneath my previous work. I felt that a coffee cup is such an easily recognizable shape, and that I would only have to draw very few lines to imply the object. I chose to put the symbol in the middle of the layout. The symbol also influenced the color scheme, which was also used to draw attention to the middle of the layout.

For my next step, I focused on the body copy of the layout. Since the beginning, I wanted to make the copy a quote relating to the symbol. After researching quotes on the Internet, I chose the one I used for the final layout. The quote had a humorous tone, so I originally looked for fonts that were "fun" or "playful". None of these seemed to fit well, and I ultimately decided on a script font typical from ads portraying sophistication or elegance. I felt that this was a great contrast to the tone of the quote. Lastly, I needed a title for the layout. I needed a good, single word to tie together all the elements of the layout. The title "Anxiety" was largely influenced by the imagined mindset behind the quote.

Guitar — For my first layout, I chose to incorporate the Chinese symbol for "guitar". First of all, I placed a picture of the symbol I found on the Internet into Adobe Illustrator. I was initially drawn to the first element of the symbol. I felt that these lines strongly resembled shapes from an actual guitar. I then found a picture of a guitar on the Internet and included that into Illustrator as well. I put this image, which needed to be rotated and resized, on the layer behind the Chinese symbol, and turned the transparency down. I used this as sort of a stencil to trace the line used in the final layout. I felt that a guitar is such an easily recognizable shape, and that I would only have to draw a single line to imply the object. I chose to put the symbol in the middle of the layout. The background was used to draw attention to the middle of the layout.

For my next step, I focused on the body copy of the layout. Since the beginning, I wanted to make the copy a quote relating to the symbol. After researching quotes on the Internet, I chose the one I used for the final layout. William Christopher Handy, or W.C. Handy, was highly regarded as the "Father of the Blues". Handy gave the music genre its contemporary style that it's known by today. He also took the music from its roots in small towns in the south to American mainstream. This information highly influenced the title and color scheme used in the final layout. The fonts I used try to convey a turn of the century aesthetic.

教授点评
Professor's Evaluation

学生作品及陈述与教授点评(美国)
Work of Student, Narrative and Professor's Evaluation (America)

在不破坏汉字结构的前提下,David 通过使用平叙式构图,在汉字回归象形上进行了有益的尝试。少许简洁笔画的添加,不仅形成了栩栩如生并具有现代感的视觉形象,而且准确地传达了字词的真正含义。相应背景色彩的使用,在营造可视氛围的同时也使字词的含义更加鲜明。标题和警句耐人回味,从而加深了作品的思想性和内涵。

On the premise that the structure of Chinese characters was not destroyed, David adopted a planar layout and made an attempt to restore Chinese characters to original pictographic characters. The addition of simple strokes does not only create a vivid visual image with contemporary sense, but also conveys exact meanings of those words. The employment of background colors sets off a visual atmosphere on one hand, and on the other hand emphasizes the words meaning. The title and aphorism entail an intense aftertaste, and enrich the poster's connotation and ideological contents.

Section 3

学生作品及陈述与教授点评(美国)
Work of Student, Narrative and Professor's Evaluation (America)

多米尼·卡迪拉 | Dominic Cordilla

Design Narrative:

For my poster I chose to use two transitional seasons to create a multi-cultural learning experience. I wanted to communicate their meanings through hidden pictures and by the use of color choice. Along with expressing the poetic quality of both languages visually, I also included actual poems to coincide with each poster.

For my first poster I chose the word "Spring". A blossoming yellow flower behind a sky blue backdrop encompasses the feeling of a new beginning. Each of the letters of the word spring can be found hidden in the peddles. I chose a poem called The Enkindled Spring by D.H. Lawrence to express the words meaning in writing. A watermark of the Chinese symbol can be seen beneath the text. The symbol itself looks like a budding flower.

For my second poster, I selected the word "Autumn". Twin leaves in shades of orange lie on top of a pale yellow setting. If you adjust your eyes, Chinese symbols can be seen etched into the creases of each leaf. I picked a poem entitled Falls Crest by Edmond Neville. The last two stanzas conceptualize the feeling of fall. Neville writes, "What lay behind is beneath us, but what is to come is a greater puzzle." I like how both poems for each poster have an air of mysteriousness about what is to come next. Obviously it is easily understood that winter follows autumn and summer comes after spring but we still strive to see what will accompany the different seasons in our lives.

设计陈述：

在我的招贴中，我选择运用两个过渡季节来创造出此次多元文化的学习经历。我希望通过隐藏的图片和颜色的运用来表现他们的意义。除了表现两种语言文字视觉上的诗意，我还为每幅招贴添加了一首诗。

春——在第一幅招贴中，我选择了单词"春"。一朵开放在蓝天下的黄色花朵昭示着新的开始。Spring 的每一个字母都隐含在绽放的花瓣里。我选择了 DH Lawrence 的一首诗"燃烧的春天"，以文字的方式诠释这个单词，并且用一个中国字以水印形式呈现出来，这个字本身看起来就像一朵含苞待放的花朵。

秋——在第二幅招贴中，我选用了单词"秋"。橘色阴影下的两片叶子躺在浅黄背景之上。如果你调整你的视线，你就可以看出中国字蚀刻在叶脉里。我挑选了 Edmond Neville 的一首名为"瀑布之上"的诗，其中最后两小节形象地描述了秋天的感觉。Neville 写道:"经历过的是财富，而要面对的是未知。"我喜欢招贴里的两首诗,点出了未来的神秘。很明显,秋天过后是冬天，春走了夏天就来了，但是我们仍然想努力看清会有什么伴随着不同季节一起来到我们的生活中。

教授点评
Professor's Evaluation

学生作品及陈述与教授点评(美国)
Work of Student, Narrative and Professor's Evaluation (America)

鲜明的主题、浪漫的色彩、巧妙的造型、活泼的构图，营造出了具有诗意的情感氛围。使人仿佛听到了理查德·克莱德曼的钢琴曲"秋的私语"和约翰·施特劳斯的交响曲"春之声"委婉优美的旋律。成熟的秋色和盎然的春意透过必要的视觉元素和中、英文的交替使用，和谐有效地表现了两种不同文化的独特性和相通性的信息；通过文字的形象化表现不仅准确传达了秋和春的确切含义，还对其象征性进行了积极的和深层次的拓展，增加了受众在有限的空间里产生无限联想的可能性。

Distinctive theme, romantic colors, clever molding, together with a lively composition create a poetic emotion atmosphere. Looking at the posters, one seems to hear the beautiful melody of A Comme Amour by Richard Clayderman and Voices of Spring by Johann Strauss. The sense of mature autumn and lush spring revealed through relevant visual elements, together with an alternation of Chinese and English, shows the originality and connection between two different cultures. The visualization of words and characters does not only explain the exact meaning of autumn and spring but makes a deep understanding of its symbolized meaning, which provides the possibility of unlimited association in a limited space.

Section 3

学生作品及陈述与教授点评(美国)
Work of Student, Narrative and Professor's Evaluation (America)

伊恩·海尔南德斯 | Ian Hernandez

设计陈述：

我选用小时候曾抓捕过的蛇和鱼来做图形和文字。我曾跟爸爸一起到密歇根湖去钓鱼，所以这对于我选用这个中国字有很大的影响。当然，小时候我也常跟朋友一起去抓蛇。

鱼——在体现中国的招贴上，我只是描画出一条真实的鱼。我觉得如果再加一些表示水的蓝线，或者从鱼嘴里吐出的一两个泡泡会更好些。绕鱼身一周的粗粗的线条没有什么意义，我只是用此来突显文字部分。

蛇——关于蛇，我是拼写出单词 snake 作为蛇的身体。我发现没有办法把它做得很平滑，也没有办法给它上色。因为 Illustrator 不跟我好好配合，颜色工具不能正常运转了。我选择蛇，是因为我觉得它代表了力量，同样它也代表了防卫和危险最基本的两个面，同时它也是药物的标志。我的招贴的目标受众大多数是年轻人，他们应该对我选择的文字感兴趣。

Design Narrative:

I chose my symbol and word when I little I used catch snakes and fish. I used to be going fishing all the time with my father in Michigan, so that had to do a lot with why I chose my Chinese word. Also as a child, I would go catching snakes with my friends.

What I was trying to do with my Chinese symbol was just outline a picture of a real fish. I felt I could have done more with like add some blue lines to display water or as a bubble or two coming from the fish's mouth. The big black border around the text doesn't really have a meaning; I just used it to bring out the text.

With the snake I had an idea to just spell the word snake with the snake's body. I found it hard to make it smooth and color it. Illustrator would just not cooperate with me, the live color tool just wouldn't work for me. I chose the snake because it represents power, it also represents protection and danger, a double sides edge basically. It is also a sign for medicine. The target audiences for my posters would more likely be for young people. They are very playful with the texts I chose.

教授点评 / Professor's Evaluation

学生作品及陈述与教授点评(美国)
Work of Student, Narrative and Professor's Evaluation (America)

Fish

The fish was sacred to the Greco-Roman mythology, where it held symbolic meaning of change and transformation. In Christianity, the fish is a symbol of abundance and faith. Pagan traditions recognized the fish as a feminine symbol of fertility and an attribute of the Goddess. The symbolic meaning of fish dealt with knowledge, wisdom, inspiration and prophecy.

SNAKE

THE SNAKE OR SERPENT IS ONE OF THE OLDEST AND COMPLEX OF SYMBOLS. IT REPRESENTS STRENGTH, PROTECTION, AND REBIRTH. IT'S A SOURCE OF STRENGTH AND POWER, YET ALSO POTENTIALLY DANGEROUS. IT IS BOTH PROTECTIVE AND PART DESTRUCTIVE.

——个文化主题唤起了 Ian 对童年的美好回忆，同时也提醒了我们有关记忆和经验对于认知新事物的重要性，以及对生活方式的左右和对思维方式的影响。Ian 在这种纯真情感的驱使下通过具象和抽象的综合手法展现给受众一个充满童趣的文字演变过程。透过表形去表意，信息层次分明、连贯，具有很强的识别性。相关说明文字的添加更强化了作品寓教于乐的色彩，从而引起目标受众的共鸣。

This culture theme arouses Ian's beautiful childhood memory, and reminds us the important influence that memory and experience exert on absorbing new things, life styles, as well as thinking modes. Dominated by such a pure and innocent emotion, Ian integrated abstract and a concrete method to present the evolution of words which is full of children's interesting. Meaning is revealed through images, so that the relevant information is clear, coherent and identifiable. Besides, the addition of explanatory words strengthens the poster's characteristics of teaching through entertainment, which arouses the audience's great sympathy.

Section 3

学生作品及陈述与教授点评(美国)
Work of Student, Narrative and Professor's Evaluation (America)

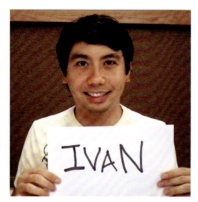

伊凡·格雷罗 | Ivan Guerrero

设计陈述：

龙是深深扎根于许多国家文化中的一种充满传奇色彩的动物。在亚洲的文化中，龙是力量和智慧的象征，而在欧洲，它却代表法术、权势甚至邪恶。我试图找到独特的手法来设计招贴，那就是用具有美感的版式来整合龙的文化概念。两幅招贴在视觉上都整合了龙的双关意义，并分别用中文和英文将带有神话色彩的巨龙生动地变化出来。

在"中国式"招贴设计中，双关意义在于将中文"龙"设计成龙的样子。手绘部分就是为了效仿中国书法的笔触。为了增强设计的文化概念，运用红底白字，同时文本部分是按从上到下、从左到右的顺序。招贴的文案以一首关于中国龙的小诗为元素。

"英国式"招贴中，视觉上的双关意义在于单词"Dragon"和威尔士龙的独特图解相结合。龙的这种特殊形状部分存在于凯尔特文献和国民的认同。红色的龙是威尔士国旗以及都铎皇家军队的主要特征，它是深深植根于亚瑟王和马比诺吉昂王朝的威尔士血统的象征。招贴试图展现威尔士国旗的布局和颜色。这个单词很难以老凯尔特式设计出相似的图案，底色只能用白色和绿色来展示。招贴的文案引用了最早的皇家宣布的具有国家目的性的龙的用途。

Design Narrative:

The "Dragon" is a legendary creature deeply entrenched in the cultures of different countries. In Asian cultures, the dragon was a symbol of strength and wisdom. In European countries it represented magic, power, and even evil. I attempted to capture these unique portrayals by designing posters that integrated cultural concepts of the dragon with artistic typography. Both posters feature visual puns that merge the word "dragon," as interpreted in English and Chinese fonts, with mythological graphic representation of the serpent.

For the Chinese poster, the pun occurs in the manipulation of the dragon-figure to resemble the Chinese character "long." This hand-drawn rendition was given particular care in order to emulate the brush strokes of Chinese calligraphy. To strengthen the cultural concept of the design, the character was rendered in white against red background, with text flowing from top to bottom, right to left. The poster's copy features a short poem about the dragons of China.

In the English poster, the visual pun occurs with the marriage of the word "dragon," with the uniquely graphic illustration of the Welsh Dragon. This particular type of dragon exists as part of Celtic literature and national identity. The red dragon is a prominent feature in the national flag of Wales, and the Tudor royal arms. It is a symbol of Welsh descent that has deep roots in Arthurian and Mabinogion legends. The poster attempts to emulate the Welsh flag in both layout and colors. The word/graphic is hand drawn in a similar manner as old Celtic design, and is laid out over a white and green background. The poster's copy cites the original Royal degree that proclaimed the use of the dragon symbol for national purposes.

教授点评
Professor's Evaluation

学生作品及陈述与教授点评(美国)
Work of Student, Narrative and Professor's Evaluation (America)

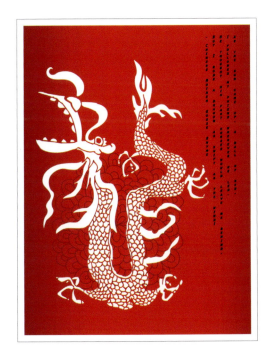

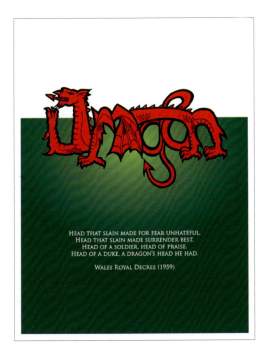

不同文化对于龙的理解以及赋予龙的抽象含义有着很大的差异,甚至是天壤之别。Ivan 准确的汲取了不同文化对于龙的认知要素,运用视觉双关语的手法,以中西文化中各自不同的龙的形象作为笔触构造出了中英文的"龙"字。并配合不同传统文化的典型色彩组合,书法艺术形式,传统图案和构图特征等细节刻画,强化了主题的情感诉求因素和文化氛围,淋漓尽致地传达了龙的确切含义和其所具备的文化特质。视觉效果干净利落,表述流畅,不失为成功之作。

Different cultures have different understandings of dragon and attach to it different abstract meanings. This difference might be as huge as can be. Ivan precisely grasped this difference and created Chinese and American images of "dragon" with a method of visualized pun. What's more, the employment of typical colors with distinctive traditional cultures, calligraphy, traditional patterns and composition strengthens emotional appeals of the theme and sets off a cultural atmosphere. In this design, the exact meaning of dragon and its cultural characteristics are thoroughly conveyed with neat and crisp visual effects and fluent expression. It can be considered as a successful work anyway.

Section 3

学生作品及陈述与教授点评(美国)
Work of Student, Narrative and Professor's Evaluation (America)

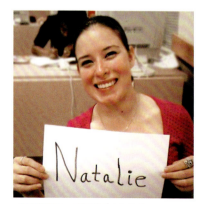

娜塔莉·莫雅 | Natalie Mora

是每个国家都要熟知并学着去拥有的态度。为了在招贴中反映中国和美国两种文化,我认为表现两国间的和平将是一个很好的想法。我用红色和黄色代表中国,用美国的和平标志代表美国。

这是一个很好的课题,它使学生有机会去感受不同的文化,并且让我们思考如何将两个国家不同的文化统一到两幅招贴上。

Design Narrative:

I chose my two words for my posters because love is an emotion I feel in my everyday life and peace is something that I believe should be practiced by everyone in our world today. I decided for each poster that I would put each word in English on the poster as well as the Chinese character for the word. These will not only help the viewer or consumer want to know what the meaning of the poster is but, it will represent the union of two cultures. These are very good poster because I think people do not take the time to experience other cultures and I believe it holds us back from living life to the fullest.

I started with the love poster and thought for a while about how I was going to represent love using the Chinese character. It came to me that I could take parts of the Chinese character for love and make the parts into a heart and a rose. The poster represents romantic love for the older viewers as well as love in our everyday lives that we have for our loved ones.

For my second poster I decided to represent peace to collectively relate to the word love. Peace is something that should be known and practiced in every country. But, since we decided to represent America and China in our posters, I decided it would be a good idea to spread peace between the two countries. I used red and yellow Chinese characters to represent the country of China. For America, I used the American peace sign.

This is a good project because it gives students a chance to experience a different culture and also, makes us think how we can unite the two countries that are different into two individual posters.

设计陈述:

我选择两个词作为我的招贴的主题,这是因为"爱"是日常生活中时时能感受到的情感,而"和平"是现代社会每个人都必须学会去拥有的态度。我决定在招贴中同时运用中英文来设计,这样不仅可以让看招贴的人一目了然知道招贴的意义,同时还能显示出两种文化的统一。这是很好的招贴,因为人们可以从其自身体会到两种不同的文化,并且它能充分地将您拉回到生活本身。

爱——我首先设计的是"爱"这个招贴,对于如何用中文表达"爱"思考了好久。最后,我想到了我可以将中文"爱"的局部设计成一颗心和一支玫瑰。招贴旨在表达对老人以及日常生活中我们所爱的人的浪漫之爱。

和平——对于我的第二个招贴,我决定完全将"和平"和"爱"联系起来。"和平"

教授点评
Professor's Evaluation

学生作品及陈述与教授点评(美国)
Work of Student, Narrative and Professor's Evaluation (America)

大爱无疆。爱是人类最美妙的语言，爱是呵护和平的基石。从 Natalie 的作品中，我们可以体会到纯洁的感情、善良的态度以及美好的心愿。作品构图形式的大气简洁，使得信息传达更加生动直接；视觉效果的极具震撼，令人怦然心动后进入更深层次的人生思考。主体形象中的相关文化视觉元素，在比照环境下实现了跨文化的无障碍认知，欢畅淋漓，最大程度地实现了招贴的媒介功能，使爱这个永恒的主题又一次在人们的心灵中留下感动。爱是 LOVE，PEACE 是和平！

Love has no boundary. Love is the most beautiful language and the foundation of peace. From Natalie's design, we can sense a pure emotion, a nice attitude and good wishes. The layout is magnificent yet simple which delivers the message in a more vivid and direct way, while the impressive visual effect induces the audience's deep thinking on life. As for relevant visual elements in the main image, they present a barrier-free cognition relating to cross culture realized in the contrast of different environments. The medium function of a poster is demonstrated to the full, while the eternal theme of love once again touches people's hearts. "Ai" is LOVE, and PEACE is "Heping"!

Section 3

学生作品及陈述与教授点评(美国)
Work of Student, Narrative and Professor's Evaluation (America)

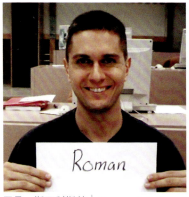

罗曼·斯瓦科斯基 | Roman Swiatkowski

设计陈述：

中国文化 —— 这个招贴是以制作背景开始的。我选择使用多角的星星，因为不管是在中国文化还是美国文化中星星都是传统的象征。星星的颜色我选用国际标准色卡1-5U。星星的多个角的颜色我选用国际标准色卡 DS 86-1U。这是最好的颜色选择，因为这些颜色都是温和的，并且在文本中不会太显眼。底色我使用渐变的方式使红色逐渐淡成白色。招贴中文本的主要颜色我选用的是黑色、国际标准色卡红 032C 和国际标准色卡 DS 1-5U。基本就是黑、红和黄三色。我设计的"统一"和"成就"这两个词就是人们所阐释的每个词的意义。我选用的是富兰克林哥特体。同样，我在"就"里添加了一个人。而我将统一这两字合二为一使其成为一体。这个招贴我差不多用了七个层次，并且使用优质纸和喷墨打印机打印出来。

美国文化 —— 和中国文化招贴一样，美国文化招贴的设计最初也是以多角的星星为背景。但是星星的多个角的颜色选用的是国际标准色卡 DS 211-2U。底色也是采用渐变过渡的方式使温和的蓝色渐淡成白色。这幅招贴中的文字也是采用富兰克林哥特体。文本的主要颜色是采用国际标准色卡红 032C 和国际标准色卡蓝 C。这些都是美国文化中的传统颜色。将中文的"竞争"设计成好像正在争斗的两个字。英文的"竞争"就好似为了空间而争斗，字母"E"控制着其他字母。"成就"两字被设计得特别大以显示其重要性，

设计陈述
Design Narrative

罗曼·斯瓦科斯基
Roman Swiatkowski

它选用国际标准色卡8645-C，是一种青铜色，设计的目的在于使其看起来像是奖牌。在英文"成就"的后面有一些人，他们举着中文成就好像是举着奖品一样。

Design Narrative:

Chinese Cultural — With this poster I began by creating a background. I chose to use stars on a chevron since this is traditional symbolism in both American and Chinese cultures. The color of the stars I used PANTONE 1-5 U. For the chevron I used PANTONE DS 86-1 U. These were good color choices since they are muted and do not stand out over the text. In the background, I also used a gradient mask to give the appearance that the background fades to white. The primary colors I used for the test in this poster were black, PANTONE RED 032 C, and PANTONE DS 1-5 U. These are basically black, red, and yellow. With the words unity and achievement I worked in the design that the letters are people illustrating the meaning of each word. The typeface used is Franklin Gothic Condensed. Likewise with the Chinese word for achievement, I worked a celebrating little person into the word. For unity, I united the separate symbols that make the word. For this poster I used approximately seven layers. This poster is printed on Premium Pearl paper using Pixma Printer.

American Cultural Poster — Like the Chinese poster, the American Cultural poster started with stars and a chevron as a background. For this chevron, however, I used the color PANTONE DS 211-2 U. This gave a nice muted blue, also fading from a gradient mask. This poster also uses the typeface Franklin Gothic Condensed. The primary colors used for the text are PANTONE Red 032 C and PANTONE Process Blue C. These are traditional colors in American culture. The Chinese symbols for competition are portrayed as fighting figures. Likewise with the English competition, the letters are competing for space. The letter E dominates the others. The word achievement is made substantially bigger to show its importance. It is colored PANTONE 8645-C, which is a bronze color, to make it appear as though it were an award or medal. Small figures behind the word are shown holding the Chinese symbols for achievement as though they were trophies.

教授点评
Professor's Evaluation

学生作品及陈述与教授点评(美国)
Work of Student, Narrative and Professor's Evaluation (America)

以汲取两种文化的共性视觉元素作为相互呼应的条件，以文字不同的排列组合方式和尺寸演绎文字本身的含义，通过画龙点睛的手法，借助字形所形成的有效空间，添加寥寥几笔便刻画出了不同表情的卡通脸的形象。这两个巧妙的细节使得整个画面变得生动、形象和有趣。简洁的文本添加不仅提供了相关的信息细节，而且使得视觉层次和信息流更加流畅和丰满，进而加深了受众的认知度和记忆。

In this design, shared visual elements were selected as a connection between two cultures and different arrangements and sizes of words adopted to explain the meaning and connotation. Besides, a few mastery strokes were added in the space resulting from the arrangements of words, to portray cartoon faces with different expression. These two clever details make the whole picture vivid, visual and interesting. The concise explanatory text does not only provide relevant information but makes the visual hierarchy and information stream more smooth and enriched, which deepens the audience's recognition and strengthens their memory.

Section 3

学生作品及陈述与教授点评(美国)
Work of Student, Narrative and Professor's Evaluation (America)

扎克·布鲁姆 | Zech Brumm

设计陈述：

美国文化设计中的"马"意在其讽刺意味，严肃但不失风趣，或者说是非现实主义。我将单词"马"设计得像马的模样，以便容易辨认。为了美观我加了尾巴、长鬃毛和眼睛"E"。我选择四四方方的字母并变成我需要的样子，同时将所有的字母连在一起。有些字母我做了改变，这样使其看起来更像马的样子。

我选择浅棕色作为马身体的颜色，马尾、长鬃毛和蹄子全为黑色，这本身就是一匹普通马的颜色。我将招贴的主题背景设计成字母的形状，这正是这幅招贴的艺术特征。我感觉背景会使这一概念趋近完美，那是景色非常优美的背景，就好像马儿在栅栏这边，后面是群山和平坦的荒地。插入的带有与主题相配的颜色的文字框解释了这一概念给我的感觉和它的象征意义及文字含义。

中国文化设计中，"马"的象征意义与美国文化设计极其相似。仍是意在其讽刺意味，严肃但不失风趣，或者说是非现实主义。我只是将"马"设计成中国文字的样子，将一笔一画以不同的角度组合使其真的像一匹马，同时添加了长鬃毛和眼睛以让人更加信服。马身体的颜色是简单的浅棕色，长鬃毛和眼睛为黄褐色。通过颜色你可以辨认出这是一匹马，而背景更加让你确信。我添加背景的原因跟美国式设计一样。通过使其更像是一种注解而设计，同时，设计将马儿放在之前提到过的层峦叠嶂的秀丽景色而又自由的环境中。文本框架也和美好时光遥相呼应。

Design Narrative:

The first design, the American cultural design of the word horse is meant to be like a satire, serious, yet funny or not realistic. I designed the word horse to look like a simple horse, so it was easy to read. I then added a tail, mane, hooves, and eye ("E") to complete the look. I took a boxier font and turned into a completely boxy font, made to the size I needed and connected all the letters together. Some letters I had to modify. This made it actually look like a figure of a horse.

I choose the simple color of light brown for the body and black for hair and hooves, which resembles a common horse colors. I added the theme background to the poster, to give it a character or carton look. All it is a picture that I added artistic features to. I felt the background finished the image off. It's a scenic background, as the horse is in a fence, but with the mountains and flat dessert land in the back. The text in the colored box, goes along with the color theme, explains what the image makes me feel and what that symbol or word means.

The Chinese cultural design of the symbol for horse is really the same as the first design. It's meant to be like a satire, serious, yet funny or not realistic. I just modified the Chinese symbol for horse, made different strokes and each line at a different angle to make it really look like a horse. Then, I added a mane and an eye to convince my audience. The colors are simply light brown for the body and tan for the mane and eyes. Colors you can see a horse, but also goes with the background. I added the background for the same reasons as first one. It completes the image, by making it really look like an illustration and it puts it in a natural environment with woods and mountains, the free environment that I mentioned in my text. The text box also goes along with the time.

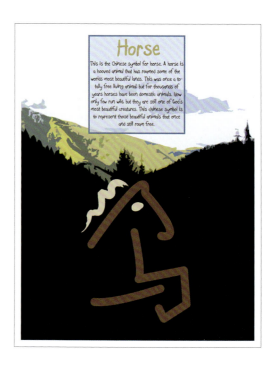

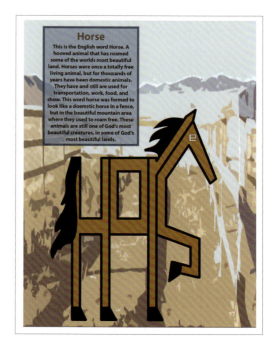

学生作品及陈述与教授点评(美国)
Work of Student, Narrative and Professor's Evaluation (America)

扎克用一种当代年轻人流行的手法对中、英文的"马"分别进行了妙趣横生的涂鸦恶搞，创作出了基于文字的形象造型。新的形象不仅没有改变文字本身的可识别性、基本结构和基本笔画特征，而且从某种意义上辅助了受众对其本意的理解，在瞬间完成了由表象到印象的心理活动。深厚的文化感和历史感借助严谨典雅的色调得以强调。有关场景的添加，使设计理念在得到有效延伸的同时也使主题更加具有戏剧性和浪漫色彩。

Based on the original words, Zech made a practical joke on the Chinese character "ma" and English word "horse" by a popular means among young people and created vivid images. While reserving the basic structures, basic stroke characteristics and the identifiability of original characters and words, the new images would facilitate the audience's understanding in a certain sense with the psychological changing process from appearance to impression finished instantly. What's more, a dignified and elegant hue indicates a deep sense of culture and history, and the adding of certain scenes effectively extends the design concept and adds a dramatic and romantic color to the theme.

Section 4
设计交流
Design Communication

设计交流
Design Communication

课程教学剪影(美国)
The Classroom Snapshots (America)

参考文献
A List of References

[1] 曹方，邬烈炎．现代主义设计．南京：江苏美术出版社，2001，8．

[2] 林家阳．设计创新与教育．北京：生活·读者·新知 三联书店，2002，11．

[3] 杜时钟．人文教育论．南京：教育出版社，2001，6．

[4] 邱运华，马固钢．中外文化概论．长沙：岳麓书社，1996，11．

[5] 关世杰．跨文化交流学．北京：北京大学出版社，1995，10．

[6] [美] 保罗·梅萨里．视觉说服．北京：新华出版社，2004，1．

[7] 柳冠中，王明旨．设计与文化．北京：国际商报社，1987，5．

[8] 罗宣．现代设计中的人文理念．江西财经大学学报，2000，5．

[9] 董小川．美国文化特点综述．东北师大学报，2002，(4)．

[10] 马振龙．招贴广告设计中的色彩定位．中国高等教育研究论丛，2001，(5)．

[11] 马振龙．创意与现代平面设计．天津轻工业学院学报，2001，(4)．

[12] 马振龙．浅谈广告创意在广告设计中的有效应用．中国高教论丛，2002，(4)．

[13] 马振龙，朱荔丽．从敦煌壁画的艺术表现谈现代平面设计，敦煌研究，2008，(8)．

[14] 马振龙．现代户外广告设计中的"游戏"思维．装饰，2009，(5)．

[15] 马振龙．逆向思维在平面设计创意中的有效运用．美术观察，2009，(5)．

[16] 张跃起，孙世哺．广告、策划、设计与印刷．天津：天津科技翻译出版公司，1996，5．

[17] 张跃起．张跃起概念设计作品选．天津：天津电子出版社，2008，12．

后记
Postscript

此书为天津市文化艺术规划项目《跨文化中艺术设计教育的人文理念研究》的研究成果，由中国天津理工大学、美国南犹他大学及美国普渡大学教授承担该项课题研究工作，编著历时一年半有余。课题进行期间，双方研究人员在充分调查、信息收集和研讨中、美两国高校艺术设计教育不同特征的基础上，共同规划与制定研究方案，并根据两国高校的相关课程，针对双方艺术设计教育中人文理念的特点，设定了既有共性亦有个性的设计课题，并通过两国高校的教学交流，最终以书的形式记录下来，抛砖引玉并与同仁共赏。

综观两国学生分别完成的课题作品，我们不难发现其中蕴含着学生们对课题表现存在着不同人文理念的理解。同时，也反映出了两国高校艺术设计教育的相同与相异之处，达到了本课题的预期研究目标，为今后两国高校艺术设计教育的发展做出了有益的尝试。

在本次课题研究进程中，得到了天津市文化艺术规划办公室、天津理工大学、美国南犹他大学、美国普渡大学等相关部门领导和工作人员的帮助与支持；也得到了天津商业大学孙建霞教授和普渡大学卡鲁梅特分校社会学教授艾伦·斯佩克特博士的无私帮助与奉献。在此，课题组全体成员向他们表示衷心的感谢！

《跨文化中艺术设计教育的人文理念研究》课题组
2010 年 2 月

This book is the achievement of the Tianjin Culture and Art Designing program "Humanistic Idea Research of Cross-Cultural Art Design Education." This program was undertaken by professors from Tianjin Polytechnic University, Southern Utah University and Purdue University Calumet. It has taken a year and a half to finish this book. During the project, all the researchers have conceived and designed the research methods after making abundant surveys, collecting sufficient information and discussing the different features in art designing education between Chinese and American institutions. And then they, according to the related courses in Chinese and American universities and the distinctive humanistic concepts for art designing education, determined both the Chinese and American art design topics which have similar and meanwhile different features to each other. Finally they recorded the exchange and discussion results between the two countries' universities so as to share the research achievement with other scholars in the same field and more importantly to stimulate valuable in this respect.

By reviewing the students' accomplished works, we can easily find that different students have different understandings of the project. In addition, this project has managed to reflect the similarities and differences between the Chinese and American art design education, thus meeting the expected goal of the project and what's more offering a successful example for the future development of the art design education in both countries.

This project could not have been achieved without the kind help and support of the related leaders and administrative staffs from Tianjin Culture and Art Planning Office, Tianjin Polytechnic University, Southern Utah University and Purdue University Calumet nor without the generous assistance and contributions of Professor Sun Jianxia of Tianjin University of Commerce and Dr. Alan Spector, Professor of Sociology at Purdue University Calumet. Now, we'd like to express our sincere gratitude to all of these people mentioned above on behalf of the whole research team.

The Humanistic Idea Research of Cross-Cultural Art Design Education Research Team
February 2010